Contemporary Theatre Review, 1994, Vol. 2,2 pp. 1–7
Reprints available directly from the publisher
Photocopying permitted by license only

Introduction
Live Art: Definition and Documentation

Nick Kaye

This paper considers the inter-disciplinarity of 'Live Art' as a field of work and as a performance practice. Setting contemporary British Live Art against earlier British and North American performance art practices, the paper considers the intersection between performance art and theatre and precedents for contemporary Live Art's resistance to critical discourse and definition. In this context, the paper goes on to address the implications of such work for the relationship between critical discourse and its object, for performance theory, and considers the relationship between critical discourse, documentation and the 'event' both would remember. In doing so, the essay introduces and discusses the implications of the differing responses to these problems which shape the varied contributions to this issue of *Contemporary Theatre Review*.

KEY WORDS Live Art, Performance Art, Documentation, Inter-disciplinarity, Performance Theory, Experimental Theatre.

Before anything else, the term 'Live Art' marks out a space for experimentation, a name given, as in the biannual *National Review of Live Art*, to a forum in which practices derived from a diverse set of disciplines meet in *performance*. Yet, as the *National Review* itself testifies, that 'Live Art' is linked to performance does not mean that it offers itself up straightforwardly as a genre of 'theatre' or 'drama'. 'Live Art', in this sense, is as much an attitude as it might be a performance-practice, a term that invokes a particular way of looking at work, a frame through which presentations generated in relation to sculpture, installation, dance, music or 'theatre' present themselves as time-based 'live' activities implicitly sharing some vocabulary, interest or aesthetic.

Such circumspection over a drawing out of the formal characteristics and boundaries of 'Live Art' is hardly unfamiliar. As distinct from 'the live arts', 'Live Art' is invariably identified with inter-disciplinarity and a challenge to the recognisable limits and distinctions between media, whether these are theatre, dance, installation, sculpture or musical composition. For this reason, the definition of what Live Art is *as a practice*, as distinct from recognising it when you see it, is frequently taken, even by those who think of themselves as practicing, teaching or writing in the area, as a critically uncertain, contentious, even an unhelpful exercise. Indeed, this very slipperiness, the resistance of 'Live Art' to being pinned down by explanation or prescription, might itself be attractive, smacking as it does of the 'contemporary', the 'experimental', of something in the process of being formed, of something yet to be absorbed into an agreed set of terms or practices.

It is important to acknowledge, though, that these aspects of 'Live Art' are not unprecedented, nor, finally, do they stand in opposition to the *question* of definition itself. Indeed, the very difficulty of pinning down 'Live Art' form and vocabulary speaks of the character of this field and, where the 'Live Art work' takes this evasiveness onto itself or the nature and effect of 'Live Art' practice.

In these respects, 'Live Art' has much in common with 'performance art'. Associated with a diverse set of practices deriving, certainly in North America and continental Europe, from artists' breaking of the stabilities and limits of the object within fine art, 'performance art' might be understood as at once a precursor of 'Live Art' and a part of contemporary 'Live Art' practice. Emerging, in the early 1960s and, again, in the early 1970s, through a reconceiving of the object in sculpture, a reaching beyond the physical frame of the work in painting, through new compositional procedures in music and developments in dance, such 'performance' has, in relation to North American work in particular, been theorized against the terms and integrities of the work in art rather than in relation to 'theatre' or 'drama' (Levin, 1990; Kaye, 1994; Sayre, 1989).

In the UK, the history of performance art and performance criticism is a very different one. Emerging some ten years after its counterpart in the US and continental Europe, British 'performance art' of the late 1960s and early 1970s was not only shadowed by the strength of the politically radical and largely text-based alternative British theatre, but shared some of its practices and concerns. Developing, largely, through work in art or music schools, and shadowed by the well-established American avant-garde (Nuttall, 1979), companies such as The People Show, IOU Theatre and Forkbeard Fantasy drew on the popular entertainments (Henri, 1974) through which many radical political theatres were attempting to define a new working class theatre (McGrath, 1981). Quite distinct from the formalist strategies of the North American 'Theatre of Images' or 'Body Art' emerging at the same time, these highly visual theatres were characterised by an intuitive rather than systematic play between image, text and narrative, by inventiveness and a marked comic eccentricity. Playing visual imagery and poetic and comic text across each other, the People Show, through the figure of Mark Long, developed a style of performance, a flexibility of form and a relationship with the audience reminiscent of music-hall. IOU Theatre's site-specific fantasies made idiosyncratic use of a rich folk imagery and style, while Forkbeard Fantasy's comic sagas draw skilfully on clown and clowning. Such means remain evident in contemporary performance, quite apart from the continuing work of these groups. Performances by Rose English combine monologue, references to myth and a self-conscious theatricality with witty and self-depracating exchanges with the audience. More recently established groups, such as The Glee Club, whose name refers to the communal singing which preceeded music-hall itself, combine a tongue-in-cheek theatricality with a skilfull play through surreal and comic narrative.

Even where British performance practices echoed those of their North American and European counterparts, a marked difference in sensibility seemed evident. Performances by Ting: Theatre of Mistakes (Howell and Templeton, 1977) clearly parallel North American 'systems' art and, in performance, the 'Structuralist Theatre' (Kirby, 1987) and aspects of postmodern dance (Banes, 1987) which emerged in response to serial or minimal art from 1968. Yet the complex rulegames of the Theatre of Mistakes seem, unlike their American counterparts, to pose the question of what happens at the moment the system itself becomes unsustainable, where the 'error' enters into the performance and generates unpredictable patterns and events or breaks the system down completely. Conversely, Stuart Brisley's performances, while obviously related to the emergence of 'Body Art' in North America and continental Europe from 1968, departed sharply from the formalist

strategies of many male American performance artists, articulating overtly political contents through acts of endurance and direct negotiations with the viewer (Brisley, 1981).

Yet even where it shares 'theatrically' rooted influences and concerns, this British performance is still marked by its origins outside conventional theatre practice. Certainly, the work of The People Show, IOU, and other groups of the 1970s is characterised by practices and vocabularies not readily reconciled with the political and textual discourses of the 1970s political theatre. Indeed, it is this sense of relationship and yet distance, of a 'theatricality' somehow connected to and yet at one remove from the prevailing languages and practices of 'theatre' and 'drama' that marks out another difference from work outside the UK. While in North America, particularly, performance art emerges within the highly theorized field of 'avant-garde' art, in Britain the 'new performance' seems to strike up an ambivalent relationship with a British theatre resistant to these kinds of theoretical debate. Whereas North American and continental European artists were clearly concerned to theorize their own activities, frequently siting 'performance' between theatre, the legacy of the art-object and 'concept art', debates over the identity of this British 'performance art' have invariably returned to an uncertain relationship with dominant theatre practices. Thus, in *Performance* magazine, and at conferences in the early 1980s, 'performance' is invariably characterized, first of all, as 'not theatre' (La Frenais, 1981), belying a sense that, at this time, a separate field has not somehow been fully marked out or made sufficiently distinct.

Yet it is around this uncertain point of 'difference' that, since the 1980s, North American 'avant-garde' performance and British 'Live Art' have converged in ways which the earlier 'performance art' rarely did. In the UK, as early as 1981, *Performance* magazine identified a shift within 'performance art' toward a more direct, self-conscious address to the terms and vocabulary of conventional theatre practice associated with Lumiere & Son, Hesitate & Demonstrate and Moving Being, a kind of work the Institute of Contemporary Arts in London presented as operating 'both across and outside the boundaries that are defined by the terms: play, dance, mime, performance, opera' (*Performance*, 1981). Latterly, in the US, and particularly from the mid-1980s, performance art strategies have increasingly come to meet theatre forms and figures, using 'performance' as a lever to address the construction, effect and limits of theatrical vocabulary, even bringing the strategies of 'performance art' to bear upon the realisation of playtext (Vanden Heuvel, 1991).

Such coincidences have drawn British performance criticism, and British performance itself, into a wider exchange of ideas and practices. It is in this context that Greg Giesekam, in prefacing his documentation of Clanjamfrie's *The World's Edge*, traces out the recent development of overtly 'post-modern' approaches to performance in the work of Scottish groups such as Test Department (Scotland) and Random Optic. Giesekam goes on to associate *The World's Edge*, a performance linked to the quincentenary of Columbus' arrival in the Americas, with a new political theatre described by the American writers Auslander (1992) and Birringer (1985). Identifying in *Clanjamfrie's* fragmented and frequently self-reflexive multi-media performance a 'dialogic' interweaving of conflicting cultural and personal histories, Giesekam observes the effect of the work's resistance to a single 'authorising' narrative in its treatment of charged historical and political imagery. While Giesekam sets Clanjamfrie's work against the terms of this North American

debate, Andrew Quick, Susan Melrose and Simon Jones look toward the discourses which have underpinned much of this performance criticism, drawing in various ways on continental European critical theory and philosophy to elaborate problematics within British 'Live Art'. It is within this nexus of ideas, too, that the implications for the performance critic of the 'inter-disciplinarity' associated with 'Live Art' become clearer. While contemporary critical theory and notions of postmodernism might draw the critic into reflecting upon the nature of the definition theoretical analysis inevitably brings to its object (Baudrillard, 1988; Docherty, 1990), so the attempt to engage critically with the 'inter-disciplinarity' of 'Live Art' demands reflection back on the project and practice of criticism, a reflexivity evident in current performance theory (Auslander, 1993).

If the 'inter-disciplinary' aspect of 'Live Art' indicates anything more than an eclectic 'experimental theatre', it surely points toward an inter-disciplinarity within the 'Live Art work' itself. Such a work might be constituted by a playing of one set of terms through or against another, it might be a work that is located *between* points, forms or practices, or one which plays upon the terms through which it is seen. In the face of such events, the critic cannot easily, or unself-consciously, draw on the verities of a single set of terms ('it's theatre', 'it's art', even, 'it's performance art') to describe 'the work', as the very stabilities these terms assume are called into question by that which is being addressed. Here, without doubt, *definition is itself an issue.* This is not to suppose that 'Live Art' has an overbearing concern for its own formal definition, but that the meeting and mixing of practices and vocabularies it invariably presents give rise to a slippage, a move that resists being pinned down, but which is evidently important to a wide range of work.

Although formally quite distinct from Clanjamfrie's work, Mike Pearson and Bobby Baker's discussions of their solo performances take up these kinds of concerns. Here, both performers reflect upon their own sense of 'self as source' in the generation and presentation of work, a notion that Mara de Wit is concerned to theorize in her 'Performance Lecture', 'Self as Source, Part II'. For Pearson and Baker, and despite the obvious differences in their work, 'gossip', the personal narrative and history, and a conflation of the performer and performance, work to displace the authority of the 'big narrative' or myth. Thus, Pearson sets his own feat of memory, a remembering of his personal history, and reading of his body as 'site', against the folk memory of a peculiar intersection of Welsh history and the Wild West. Baker, meanwhile, skilfully wraps *Pilgrim's Progress* around an everyday event, a shopping trip, as a challenge to the dismissal of the experiences of domestic life. The result is witty, moving and sharply political. Baker herself suggests that *How to Shop: The Lecture* 'was about an awareness that my daily banal life was not given enough importance' noting that 'I'm trying to reclaim my experiences, my sexuality and my femininity'. Considering such 'auto-performance' in the context of 'new dance' and 'Live Art' since the 1970s, Mara de Wit reflects upon her position as both 'object' and 'source' at the moment of her presence before the viewer. Observing the interpenetration of 'performance' and the performer's life, de Wit traces her construction of work through a multiplicity of selves and considers her articulation of these voices through the intersection of 'live art' and 'new dance', 'live art' and 'real life'. Such work has obvious connections with the 'post-modern' 'de-centring' Giesekam outlines, resisting, as it does, the dominance of a single narrative or myth through the presentation of 'other' voices and stories.

While de Wit emphasizes her awareness of her presence before the audience, and Pearson and Baker self-consciously tell their stories directly *to* the spectator, Tim White, Andrew Quick and Simon Jones link the efficacy of recent 'Live Art' to an acute awareness of the 'live event'. Addressing in this context practitioners as diverse as Robin Blackledge, Forkbeard Fantasy, Forced Entertainment Theatre Co-operative, DV8, and Gloria, these essays consider the resistance of recent performance to the stabalizing point of view.

Setting recent work by Robin Blackledge and Forkbeard Fantasy against contemporary multi-media performance, Tim White observes this performance's critical address to the 'screen' as 'window and barrier'. Observing the play between media in this work, and its construction through a sustained deferral between live and mediated presences, White traces out these performances' empowering of the viewer through their invitation to reflect critically upon the act of seeing and the effect of mediation. Writing against the backdrop of postmodern theory, Andrew Quick seeks in his essay to move between Forced Entertainment's self-conscious explorations of 'fictional worlds saturated by a sense of loss' and Jean-Francois Lyotard's account of the sublime as 'the unpresentable in presentation itself', a moment which Lyotard sees as an inherently political disruption of the terms in play. In doing so, Quick looks toward the complexities of the live event which writing invariably suppresses, and with it the corruption of 'the "proper" space of representation' which performance might effect and criticism reinstate. Addressing these tensions in another way, Simon Jones reflects upon his own engagement as spectator and critic with recent Live Art's resistance to critical discourse. Drawing on aspects of the 'sciences of complexity', Jones engages self-consciously in a 'figuring (of) theatre as *event–series and flux*', an exploration of recent performance's 'refusal to be stabilized as *text*'. Jones' position echoes an anxiety underlying much postmodern discourse, as he attempts to remember that which the performance made evident *as it was seen* but which cannot be adequately re-presented when it is *written about*. Drawing on the sciences again, Jones calls into question the position of the critic, noting that:

quantum mechanics has shown that measurement is not neutral, without consequence for the system observed. My remarks make; and in making the demon, it evaporates on me at the very instance of its compliance, its coherence within *my* theories.

Such concerns are reflected again in Susan Melrose's essay, 'Please please me' as she considers the nature of 'new performance' and the cost of 'translating' performance into discourse. Defining 'LiveArt' as a performance practice which is **'about** (not as in 'subtext', but as in *'around and about'*) **performance'**, Melrose seeks to test and challenge the veracity of recent critical discourse through a notion of 'new performance' as 'metapraxis'. Arguing that discursive practice, or the production of critical discourse, is itself a 'complex performance practice', Melrose unpacks various critical approaches to recent performance through a self-reflexive mode of writing which is aware of itself as *practice*. In this way, Melrose takes on the implications of the object she writes toward, engaging in a *critical metapraxis* just as she speculates on the 'interpraxiological' nature of 'LiveArt' and the satisfactions it might have to offer.

It is at this moment, too, that the relationship between critical discourse and 'documentation' comes into question. Where a critical engagement with 'Live Art'

might force a reflection back upon the practice of criticism, so this difference between performance-practice and critical discourse must have consequences for the 'recording' of work. The point is an important one, reflected not only in the tendency here by critics to draw on postmodern theory in their discussion and in these artists' particular representations of work through 'documentation', but in the dialogue between 'essay' and 'documentation' through which this volume is constructed.

Like contemporary critical theory, 'performance art' has had much to say about the 'trace'; the relic, recording or document that remains after the 'event'. In particular, where performance art arises as a challenge to the 'object' in art, 'documentation' invariably presents itself as threatening to reinstate those stabilities and terms this very move toward 'performance' challenges. Similary, where performance sites itself *between* vocabularies, disrupts expectations or stresses the 'liveness' of the event, it can be understood as evading precisely the kinds of determinations a documentation's re-presentation of *what did happen* implicitly lays claim to. Indeed, this very assumption, that documentation might have access to *what has happened*, supposes a transparency and stability the event it would remember might once have called into question. In this way, then, and like critical discourse itself, documentation mediates between the 'problem' of the work (its challenge to the viewer in *being done*) and the one who now views. In site-specific work, the 'recording' invariably suppresses the uncertainties the interpenetrations between the 'made' and the 'found' provoke. Where performance and performance style shadows, displaces and calls into question text, 'role' and the conventional figures of dramatic presentation, or where a performance shifts between media, documentation invariably finds itself unable to speak adequately of the dialogue out of which the work is constituted.

It is in this context, that, in presenting a 'documentation' of *Emmanuelle Enchanted*, Tim Etchells and Richard Lowdon of Forced Entertainment Theatre Co-operative use material derived from the performance to re-address concerns for excess information and incompletion. Rather than speculating upon the 'meaning' of *Emmanuelle Enchanted* or recounting the mechanisms by which it operated, this presentation offers an experience analogous to that of a meeting with the event which preceded it. Calling on the 'fragmented/atomized' nature of the performance, its rhythms and structures, and the framing and processing of information these moves effected, this 're-presentation' resists being read as a transparent record, but furthers the work's dissemination through a variety of forms, a process which Forced Entertainment have pursued more recently through installation-work in collaboration with Hugo Glendinning. Within 'Live Art' such a play between means is not uncommon. Brith Gof, in particular, have recently pursued site-specific performance, video, 'documentation', television, and music-recordings around a single project, *Haearn* (1992). Such 'documentation' presents itself as provoking or extending the very questions the work may have posed to the viewer, refusing to resolve the issue of what the work 'is' (and so 'was') 'about'.

While such presentations would seem to acknowledge the unreproducibility of the 'event', treating 'documentation' as another mode of work, Simon Jones takes a similar attitude toward criticism. In constructing his essay through a montage of 'parallel texts', he, like Etchells and Lowdon, organises the page so as to make an event of reading. Such addresses to the act of reading evoke, again, that which cannot be *written about* without being transformed, and which Andrew Quick,

after Lyotard, introduces in terms of the radical singularity of the 'event'. Wit's essay takes up another aspect of this debate, siting itself *between* e documentation. Thus 'Self as Source, Part II' offers itself to the reader as a documentation of a 'Performance Lecture', a mode of writing through which de Wit is able to reflect upon the viewer's meeting with the page as she speculates upon her meeting as performer with an audience.

Such challenges are reflected in different ways in differing 'documentations'. Julian Maynard Smith provides a record of *The Oracle*, a site-specific performance by Station House Opera presented outside and inside the Serpentine Gallery in London in June 1993. Rather than record its 'effect' in this space, Maynard Smith sets out information necessary for its restaging, including texts, actions, performance plans and photographs. Yet, like Station House Opera's own 'restagings' in other places, such a performance would find its 'specificity' anew, quite apart from the questions of performance-style and sound, which these notes eschew. In this sense, these documents offer materials drawn from a performance of *The Oracle* which find themselves between radically differing events, as if to stress the singularity of each 'site-specific' realisation. In contrast again, Greg Giesekam's essay offers a view of the workings and contents of *The World's Edge* intercut with comments and recollections from members of the company. In working in this way, Geisekam balances an account of the operation of the piece with the performer's interruptions and digressions, echoing the formal construction of the work itself.

Through such interpenetrations, as well as through their various engagements with contemporary critical and theoretical discourse, many of the presentations here attempt to recall the very evasions and ephemeralities of 'Live Art' and the 'Live Art work' that make these events and practices difficult to define. In this context, the vaiety of *kinds* of paper in this volume, a variety that springs, often, from common concerns, itself speaks of the character of 'Live Art', reflecting not only its eclecticism, but a sense that the 'Live Art work' might locate itself *between* or *around* points or identities. In this respect, the debate over 'Live Art' that this volume offers is to be found as much in the formal dialogue *between* contributions, *between* radically differing gestures toward performance, and in the moves *between* 'essay' and 'documentation', as it is in the content of the individual papers themselves. With this in mind, this volume is organised so that, as 'essay' follows 'documentation', the fact of this variety, in form as well as content, remains clear. Indeed, these very differences might, of themselves, demonstrate that the terms by which 'Live Art' can be approached not only remain in flux, but are perhaps at their most honest and useful while they are still in the process of being determined, still subject to a sharp, self-reflexive questioning of their nature and effect.

Contemporary Theatre Review, 1994, Vol. 2,2 pp. 9–24 © 1994 Harwood Academic Publishers GmbH
Reprints available directly from the publisher Printed in Malaysia
Photocopying permitted by license only

FORCED ENTERTAINMENT

EMANUELLE ENCHANTED
(Or A Description Of This World As If It Were A Beautiful Place)

NOTES AND DOCUMENTS

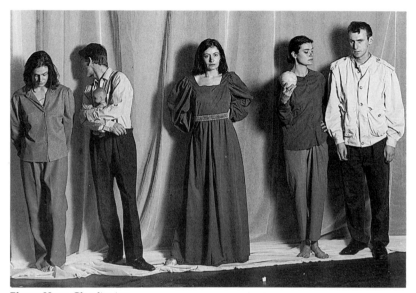

Photo: Hugo Glendinning

That strange night the rain stopped we
started on some magic acts to keep away
the cold. It was all FRIGHTENING MAGIC
and appearing and disappearing and
REVELATION and LOSS for us then. It was
all FOLDING and HIDING and slipping
away.

This is the life we lived then, in the
city, in the chaos and the dark...

one: A PORN MAGAZINE CALLED CRUCIFIED WOMEN two: FIFTY MORE YEARS OF BAD NEWS three: AT TWELVE AM LIKE IN A FAIRY TALE four: LIGHTHEARTED five: A VISION six: THE KID PLAYING HIDE AND SEEK IN THE BACK OF THE CAR seven: NOISELAND – VIDEO ARCADE eight: SLANDER nine: NOW TO FILM A MASSACRE ten: HOW TO FILM A MASSACRE FOR KIDS one: THERESA MALLORY IS DEAD BECAUSE SHE KNEW THE TRUTH two: KUWAIT OIL IN KASHMIR SNOW three: COME MOON, COME AND CONSOLE ME four: SARCASTIC REALISM five: NEW HIGH MOUNTAINS FOUND six: THE WORDS 'TOXICO' AND 'FAST BEATING HEART' ARE TRADEMARKS AND MAY NOT BE USED OR REPRODUCED OR STORED IN ANY INFORMATION RETREIVAL SYSTEM WITHOUT THE PRIOR PERMISSION OF THE OWNERS seven: PSEUDO-EVENTS eight: IN BED TWO DAYS nine: NO COURT EXISTS TO SETTLE YOUR DISPUTE OVER BEAUTY ten: THESE ARE THE BRIGHT STARS AND THIS IS HOW TO FIND THEM one: COPYRIGHT THE WHOLE WORLD EXCEPT AUSTRALIA two: CANCER OF THE FIST three: SUSPICION OF INNOCENCE four: EVERY WORD I SAY IS, BY DEFINITION, A PROMISE five: CLUB OF NO REGRETS six: PLEASE LET ME GET WHAT I WANT THIS TIME seven: THE FORGIVENESS THAT ONLY DRUNKENESS CAN BRING eight: STUPID WHITE PEOPLE MAROONED ON ANOTHER PLANET nine: HAPPY WITHOUT ANAESTHETIC ten: GET LOST IN THE DEEP STAIRS OF VERTIGO one: FIRST FIREPROOF HOTEL two: LAUGH FACE T-SHIRT three: HELEN'S SOUL four: RUSSIAN DREAM five: COUNCIL HOUSE six: THE FIRST BLACK POPE seven: DON'T HURT ME, PLEASE, DON'T HURT ME eight: THE WORD 'SEDATIVES' IS A REGISTERED TRADEMARK OF THE 'SEDATIVES GROUP' nine: NERVES EXPOSED ten: HEARTLESS BREEZE one: IRON CITY BEER two: THE NOBEL PRIZE FOR RAP three: INVISIBLE IN BRITAIN, PARTLY VISIBLE IN THE USA four: PARTLY VISIBLE IN BRITAIN, VISIBLE IN THE USA five: LONGEST SCREEN PISS IN HISTORY six: IT HAS THIS TONE, LIKE EARLY POLYESTER seven: VIVA TANGO eight: VIVA LAS VEGAS nine: VIVA SAFEWAYS ten: DON'T SNORE TOO LOUD, YOU'LL WAKE THE ANGELS IN HEAVEN one: HER HUSBANDS DEATH, LONELINESS, FEBRUARY, 1953 two: A NEW GAME SHOW CALLED LONG FACES three: BUILDERS ON THE ROOF AT SEVEN AM four: BUILDERS ON THE ROOF AT SEVEN PM five: I HAVE A HORROR OF THE TRUTH BUT I LOVE THE TRUTH six: CRISIS seven: THE WORDS 'FUCK FACE' AND 'SEAFOOD' ARE REGISTERED AS TRADEMARKS BY THE MANUFACTURER AND THEY RESERVE THE PUBLIC RIGHT TO BE IDENTIFIED AS SUCH eight: DON'T DOUBLE CROSS THE ONES YOU LOVE nine: SECRET PASSWORD ten: ONLY THE LONELY one: A STATUE, A STATUE OF HEADLESS CHRIST two: A GOLD COLOURED WATCH three: EYES THE COLOUR OF THE SEA four: A HOTEL ROOM WITHOUT ANY CLOCKS five: A BEAUTIFUL VIOLENT COUNTRY six: GRAB REALITY AS A COMMODITY AND SELL IT seven: WIN A CHANCE, WIN A GOOD CHANCE, WIN A GHOST OF A CHANCE eight: A SCORCHED FILM nine: A BROKEN BONE ten: ACTING OUT THE LAST JOURNEY OF HER SISTER one: CLOWN ALLEY two: FLUSHING THE VILLAINS HEAD DOWN A TOILET three: I WILL NOT CLOSE MY EYES AT NIGHT four: I WILL NOT CLOSE MY EYES BY DAY five: I WILL NOT CLOSE MY EYES AT ALL six: FORGETTING NAMES seven: A T-SHIRT SAYING 'SOMETHING TO PROVE' eight: LOVELESS nine: SLIPPERY ten: TRYING HARD TO MEMORIZE HER DREAMS one: THE WINDOWS SEALED WITH FOIL AND SHUTTERS two: HAPPINESS IS AGAINST THE LAW three: A LOVEY DOVEY MASSAGE SCENE four: IILEGAL five: WORLD CUP HEROES AND HEROINES six: A SUMMARY EXECUTION IN A FIELD seven: I BLAME MY PARENTS FOR THE WAR eight: GRATUITOUS MEMORY nine: SO DRUNK THAT A WHOLE LOAD OF MEN PULL UP IN A CAR TO LAUGH AT HIM ten: IS THAT MY BABY, KICKING INSIDE OF YOU? one: AMPUTATION two: AN EPIDEMIC OF PIZZA HOUSES three: THE GOLD STANDARD four: THE NEW GOLD STANDARD five: THE NEW STANDARD STANDARD GOLD STANDARD six: SEX MANIAC seven: THEY DO NOT WISH TO SHAME THEMSELVES eight: THIS LIFT WILL SHUT DOWN IN THE EVENT OF A FIRE nine: I AM HER MOTHER AND I

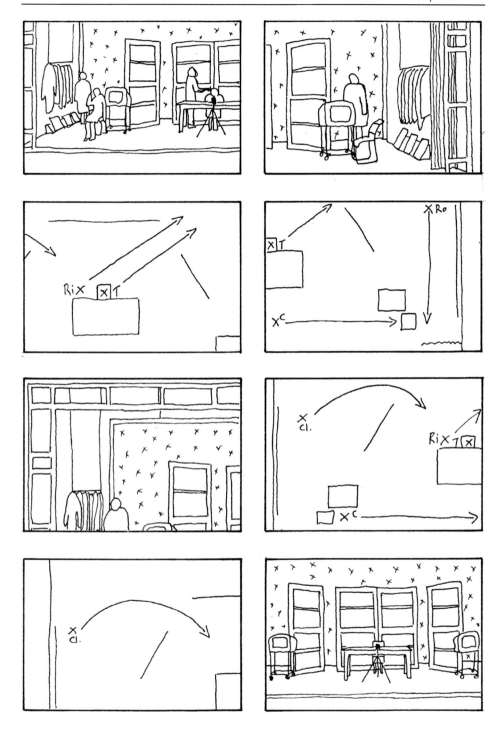

three: PASSING OUT four: YOU KNOW THIS IS ALL SO FUCKING NOT-STRANGE five: THEN THEY KNEW ECSTASY, BEYOND GODS WORD six: A DREAD OF BROAD DAYLIGHT seven: A STREET CALLED RUE DES MORONS eight: A BOOK CALLED 'BOOK OF LOVE' nine: READING MY WISHES INTO THE CITIES IMAGE ten: VON NEUMANN one: THE ZIP AT THE BACK OF HER DRESS two: POST-COLLAGEN LIP INJECTION MADONNA three: SINGING INTO THE TELEPHONE four: RECCESSION-BUSTER BREAKFAST five: NO COMMENT six: NO REASON seven: DON'T CALL ME HERE AGAIN, IT'S DANGEROUS eight: HIS BROW FURROWS LIKE THE EDGES OF THE CITY OF DELHI, HOUSES IN UNEVEN ROWS nine: JUST A NOVEL WITH AN UNHAPPY ENDING ten: THESE TWITS ARE DEAD one: HARDCORE ATTACK two: A WHOLE WALL PLASTERED WITH REPORTS OF OUR DEATHS three: REVEALED four: SECRET HOPE AND SECRET LANGUAGE five: HE WALKS BETWEEN THE RAINDROPS six: THEY WERE CALLED THE THIRTY TYRANTS, NOT BECAUSE THERE WERE THIRTY OF THEM BUT IN MEMORY OF THE THIRTY TYRANTS OF ATHENS seven: A WHO-CARES-WHODUNNIT eight: TRYING TO TAKE AUTO FOCUS PHOTOGRAPHS OF A BLACK DOG nine: EASY CIRCLES ten: TOO CLEVER one: FREEZER FOR BOODSTAINED CLOTHING ONLY - DO NOT FREEZE WHOLE BLOOD two: THIS ROOM three: THERE ARE SPIRITS SPEAKING THROUGH MY TEETH four: THE AIR SO SWEET LOOKING DOWN five: THE WORDS 'TELESCOPE' AND 'NEW DESEASE' ARE THE INTELLECTUAL PROPERTY OF THE MAKERS AND MAY NOT BE USED WITHOUT PERMISSION six: POWER EQUALS TERRITORY seven: SOME RUMOURS AND SOME SOURCES eight: I STILL THINK ABOUT STEVE ROGERS nine: MILLING ABOUT ON THE PAVEMENT LIKE FILM EXTRAS ten: WACO: THE MOVIE one: A BIG SHOP CALLED 'FOOD GIANT' two: A MOTEL CALLED THE SLEEP INN three: MASTURBATING WITH HER RAPE ALARM four: SONGS FOR THE LOOTING OF CARS five: THE STRICTLY SUPERVISED ADVENTURES OF HELEN six: ONE MILE NORTH OF THE NORTH POLE seven: RED CURTAINS eight: CLEAR CHOICES nine: NO LOVE LOST ten: A 1940'S FACE one: SECRET GARDEN two: LAND OF MAKE-BELIEVE three: DO NOT DESTROY THIS DOCUMENT four: A CHRONOLOGICAL ACCOUNT OF MY LIFE five: HIS REPUTATIONS WERE FOR EXCESSIVE FORCE AND SOME OF THE MORE GRAPHIC SEXUAL SWEARWORDS six: WINTERMUTE seven: HISTORY TURNED INTO NATURE AND DENIED AS SUCH eight: A TEST PATIENT, WORKING ON CHEMICALS nine: SHE SINGS A SONG CALLED 'X' AND THE BURDEN OF THE SONG IS THIS ten: BOGUS REFUGEES one: THE FAITH OF NO FAITH two: THE WHOLE ESTATE FULL OF PRATS AND CRIMINALS three: A LITTLE YES AND A BIG NO four: KEYSTONE COPS five: A BUILDING, DURING THE CONSTRUCTION OF WHICH FOUR THOUSAND PEOPLE HAVE DISAPPEARED six: AS IF NOTHING HAD HAPPENED seven: AS IF EVERYWHERE WAS NOWHERE eight: GATE-CRASHERS nine: WHAT DID THE DOCTOR SAY? TELL ME, PLEASE, COME ON, TELL ME? ten: NOTHING IS TO BE KEPT SECRET FROM TYAPU, THAT'S ALL one: HOW CAN WE HAVE A PRESIDENT WHO HAS DREAMS LIKE THIS ? two: THE RAIN THAT FALLS NOW IS SUCH DIRTY RAIN three: UNDRESSING UNDER THE SHEET four: A BLUE-IN- COLOUR CAR five: LOVE & ACTING GO TOGETHER six: NEWS OF ACCIDENTS seven: THEN THEY KNEW THE GREAT GRIEF, THE GREAT CALAMITY eight: FORTY GIRLS SO BEAUTIFUL IT WAS IMPOSSIBLE TO CHOOSE AMONG THEM OR TO LOOK UPON THEM WITHOUT FAINTNESS nine: LAST HOPE CONVENIENCE STORE ten: TOMORROW IS MY BIRTHDAY, CONSIDER YOURSELF INVITED one: A FREEZING NO-MANS LAND two: SENSATION three: WHERE ONCE WE SUFFERED FROM CRIMES NOW WE SUFFER FROM LAWS four: THE GARDEN YOU CAN ONLY ENTER WHEN A RAINBOW IS VISIBLE THROUGH ITS FOUNTAIN five: THE JEWELS SHE WORE WERE 'GENUINE' BRAND six: VEHICULAR MANSLAUGHTER seven: MOST TOP SECRET NUMBER IN ENGLAND eight: LOVELY HORRID DREAMS nine: THIS IS THE NEW FRONTIER ten: THAT NIGHT I TRIED TO MURDER MYSELF one: WHO TO TRUST? two: SHE MAY STILL BE IN THAT COMA BUT SHE'LL HEAR EVERY WORD YOU HAVE TO SAY, I KNOW SHE WILL three: AN EPLIOGUE four: I WANT TO BE A HOUSEHOLD WORD five: A LOVE LETTER, WRITTEN IN

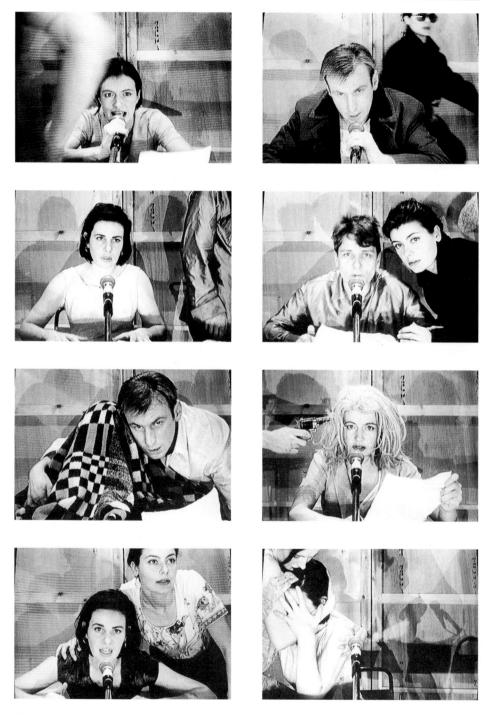

Photo: Hugo Glendinning

At midnight on that fateful night in
the city we practised **TRANSFORMATION**
and **LOSS**. We rehearsed **UPSET FOR NO
REASON** and then became upset, for no
reason. We asked **WHICH FILE DO YOU WISH
TO RENAME?** and **WHO HERE IS NOT TOTALLY
AFRAID?** No one answered. This is the
living and the magic that we blundered,
in the chaos and the ruins and the dark
- if I look ugly in it, please, I ask
you, close your eyes.

On the wild night the rain stopped we panicked and, in truth, as a matter of fact, some of our magic got out of hand.

We rehearsed THERE IS A SINISTER REASON FOR EVERYTHING. We did NINE GREAT MOTORWAY PILE-UPS AS SEEN FROM A NEARBY BRIDGE. I suppose that's when things went wrong. From then on in it was like STOPPING WATER WITH SAND, and we were TOO LITTLE, TOO LATE.

We ran, hid, held each other close to no avail. Indeed, at many points we were, like the poets say MUCH TOO FUCKING CHICKENSHIT TO OPEN OUR EYES. This is what life befell us when we did...

ELVIS PRESLEY, THE DEAD SINGER	A TELEPATH (AGE 12)	A STEWARDESS FORGETTING HER DIVORCE
FRANK (DRUNK)	A KING (USURPED)	
	A NEW PATRON SAINT OF LOVE	

Photo: Hugo Glendinning

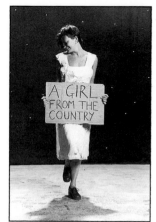

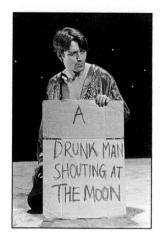

PAUL
(BROKENHEARTED)

TELLY SAVALAS
COME DOWN FROM
THE CROSS

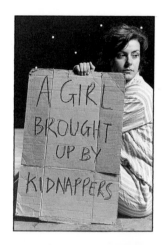

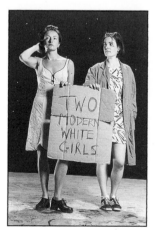

AN ANAESTHETIST

Photo: Hugo Glendinning

AN ANGEL SENT FROM HEAVEN TO THE EARTH	**CHAS (IN PERSIA)**	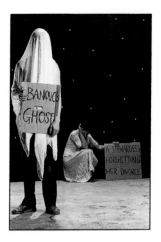
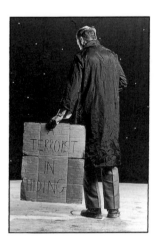	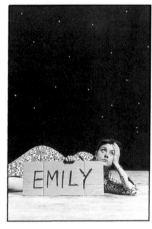	**YOUNG COSMONAUT (SCARED)**
ELIZABETH'S GHOST	**THE SHIP'S MAGICIAN**	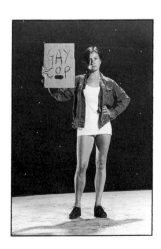

Photo: Hugo Glendinning

MARCIE
(PREGNANT)

A GOOD COP
IN A BAD FILM

THE
HYPNOTISED GIRL

IDENTICAL TWINS

A
YOUNG
WHITE RACIST
ELECTRICAL
ENGINEER

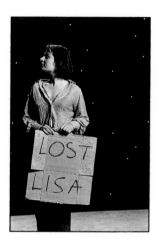

THE RUNNING MAN

JACK RUBY

A NINE YEAR OLD
SHEPHERD BOY

Photo: Hugo Glendinning

Our passports were fakes and our documents SERIOUSLY OUT OF ORDER so we knew we couldn't leave. The night continued. In the dark we ran through the streets of the city and the remnants of the kingdom, past LAST CHANCE STREET and CARPETLAND and 35% DISCOUNT WORLD. There was PRECIOUS LITTLE MENTION OF MAGIC.

Occasionally we stopped running and wrote messages on walls. We wrote:

SHIPS THAT SINK WITHOUT TRACE and a quotation from Wordsworth's epic poem QUE LASTIMA! QUEL BICHO!/WHAT A PITY! WHAT A BASTARD! - the verse that all people of this country know where the hero looks from the window and whispers:

I NEED NOTIONS OF FIXITY WITHIN THIS INSTABILITY.

1.AN APPENDECTOMY SCAR **and** ALARMS ON THE BUILDINGS **and** THE AIR SO SWEET IT
KEEPS YOU FROM DYING **and** ALARMS ON THE CARS **and** AHEAD OF US THERE ARE ONLY
GREAT DISASTERS **and** A FILM CALLED "ANYBODY ELSE IN THIS SHITHOLE LOOKING FOR
TROUBLE ?" **and** LATER "ANNA, COME TO ME ANNA, YOU'RE ON THE OTHER SIDE OF THE
WORLD.." **and** 1.BLUE TALK **and** A BABY **and** 2. BLOOD ON THE FLOOR **and**
BRILLIANT AND WAY AHEAD OF HIS TIME **and** A CAR BACK WINDOW DONE UP WITH
POLYTHENE **and** A CAT ASLEEP ON THE SUPERMARKET SHELVES **and** NOW IT'S LIKE I'M
FLOATING AND THINKING: THIS IS HOW THE NIGHTS ARE WHEN IT RAINS **and** DRUGGED
TO HELP HER FORGET **and** DOWN BY THE RIVER **and** DOWN ON THEIR LUCK **and** DUST
FALLING FROM UP IN THE ROOF SOMEWHERE **and** 1. FRIDAY. 10 'O' CLOCK. I'M
SLEEPING THEN I START TO FLOAT. 1. GREAT PHRASING. 2. SECRET CITY. 3. 1.
TEARS OF JOY. 2. IN THE MIDDLE OF THIS I'M ALIVE. NOTE: UNREADABLE - COUNT
ZERO INTERRUPT. HOLD ME CLOSE. SOON EVERY STREET IN THIS TOWN LEADS SOMEWHERE
YOU HAVE TO FORGET **and** EACH TO HIS OWN **and** EACH TIME HER HEART BEATS **and**
EVIDENCE **and** EVIDENCE WITHELD **and** EVERYTHING, HELP ME, HELP ME EVERYTHING'S
TURNING SILVER AND ORANGE **and** FAREWELL MY DARLING **and** GOODNIGHT MY LOVE **and**
FALSE RAIN AND A FULL MOON **and** FALSE PAPERS **and** NOW I'M FLOATING ANI
THINKING: SUCH A BIG CITY, SO MANY PEOPLE, SUCH A BIG CITY, SUCH A BIG WORLD
and THERE IS A GREAT GOD AND A TERRIBLE DEVIL **and** GUNSHOTS - GET DOWN ! **and**
GENETIC CODES **and** GOOD LUCK AND PLENTY OF IT **and** GREAT SMILE **and** GOODBYE MY
DARLING **and** HELLO MY LOVED ONE **and** HOUSES **and** HILLTOPS **and** HOSED DOWN IN
RAIN **and** 1. IN SILENCE. QUIT NOT FOUND - THE STRING ARGUMENT TO A 'Q'
PARAMETER WAS NOT FOUND IN YOUR FILE. SEE THROUGH THESE WALLS 1. ITEM ONE:
12AM AND LOOKING DOWN. **and** HEARTLESS BREEZES **and** BORN NOT WITH A HOLE BUT
WITH A WAR IN MY HEART **and** HEAVEN STREET **and** IMPOSSIBLE SCENES **and** AN
ILLNESS THAT SPREADS VIA THE TELEPHONE **and** THAT ILLEGITIMATE SON OF A BITCH
and INNOCENT **and** INNOCENT AGAIN **and** I'M FLOATING AND THINKING: THAT NIGHT
THEY HELD THE WORLD IN THEIR ARMS **and** INNOCENT **and** INNOCENT TO A FAULT **and** A

MAN SAYS: YOU'RE SO FAR AWAY, YOU'RE ON WORLD AND I'M ON JOANNE'S KISSES **and** DANCE **and** PEPSI'S JUICE' **and** JUST HOW HERE FOR TWO YEARS ANYTHING, NOT EVEN THE WALL? **and** LIFE MAGAZINE **and** NINE **and** THE KIND LIGHTS UP THE TRUE LIFE CONFESSIONS "MY LIFE AS A Y.T.S.

FAR AWAY, YOU'RE SO ONE SIDE OF THE THE OTHER **and** JAKE'S BLUNDERING 'LEAGUE OF NATIONS COULD HE HAVE LIVED AND NOT CHANGED PINNED A PICTURE TO KLEPTOMANIAC **and** LIFE AFTER FIFTY OF LIGHTNING THAT WHOLE SKY **and** A PIECE CALLED VANDAL" **and** A

MAN SAYS: YOU'RE SO FAR AWAY, YOU'RE SO FAR AWAY, YOU'RE ON ONE SIDE OF THE
WORLD AND I'M ON THE OTHER **and** I NEVER HEARD YOUR VOICE SO CLEAR, I NEVER
HEARD YOUR VOICE SO WELL **and**... PAINTING BY NUMBERS, PERCENTAGE OF ALCOHOL IN
THE BLOODSTREAM **and** PERFECT ENDING, RESTLESS CHILDREN **and** I'M FLOATING AND
THINKING: SUCH A BIG CITY, SO MANY PEOPLE, SUCH A BIG CITY, SUCH A BIG WORLD.
YOU HAVE PLACED AN INVALID SEPARATOR BETWEEN TWO INPUT FILE NAMES **and**
REMEMBER ONE THING **and** THE BEST RUMOURS ARE ALWAYS TRUE **and** SLIDING MONEY
ACROSS THE FLOOR **and** LOOK, SEE THROUGH THESE WALLS **and** DON'T YOU KNOW THAT
SOMETHING SEEPS THROUGH **and** DON'T YOU KNOW THAT SEX IS A FORM OF LOVE **and**
DON'T YOU KNOW THAT SWEET SURPRISE **and** SECOND SIGHT **and** SECONDS OUT **and** ONLY
TWO MORE SECONDS TO GO NOW BEFORE I'VE ONLY GOT THREE MORE SECONDS TO GO **and**
I'M FLOATING AND THINKING: TRACHEAOCTOMY SCAR, THROWING COINS IN HER BATH AND
MAKING WISHES **and** THIS, THIS IS WHAT IT'S LIKE ON THE NIGHTS WHEN IT RAINS.
SUCH A BIG CITY, SO MANY PEOPLE , SUCH A BIG CITY, SUCH A BIG WORLD **and** TAKE
HIS STATEMENT **and** THOSE ARE TERRIBLE WOUNDS **and** THREE YEARS LATER SHE COULD
HAVE SMILED **and** A POP SONG CALLED "VIOLENCE IS GOLDEN" **and** THE WHOLE WEDDING

Photo: Hugo Glendinning

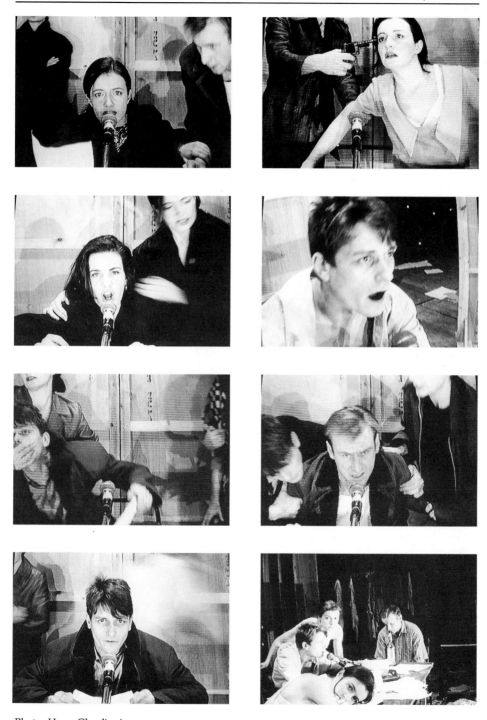

Photo: Hugo Glendinning

LIKE A BADLY FAKED SECTION OF AN OLD MOVIE **and** WARM MYSTERIOUS EVENINGS an
WOKEN BY HIS MOTHER SHOUTING FOR HIM FROM THE CARPARK OUTSIDE CARPETLAND IN A
DREAM **and** WHICH OF US DID NOT, FOR ONE MOMENT, FEEL HIS VERY HEART CEASE TO
BEAT? **and** YOU, YOU BELONG TO CHANGE **and** A MAN SAYS YOU'RE SO FAR AWAY,
YOU'RE SO FAR AWAY, YOU'RE ON ONE SIDE OF THE WORLD AND I'M ON THE OTHER. A
MAN SAYS: YOU'RE SO FAR AWAY, YOU'RE SO FAR AWAY, YOU'RE ON ONE SIDE OF THE
WORLD AND I'M ON THE OTHER. A MAN SAYS : YOU'RE SO FAR AWAY, YOU'RE SO FAR
AWAY, YOU'RE ON ONE SIDE OF THE WORLD AND I'M ON THE OTHER. I NEVER HEARD
YOUR VOICE SO CLEAR, I NEVER HEARD YOUR VOICE SO WELL. I SAY I NEVER HEARD
YOUR VOICE SO WELL, I NEVER HEARD YOUR VOICE, NOT HALF AS WELL AS I HEARD IT
TONIGHT... A MAN SAYS: YOU'RE SO FAR AWAY, YOU'RE SO FAR AWAY, YOU'RE ON ONE
SIDE OF THE WORLD AND I'M ON THE OTHER. I SEND A MESSAGE TO YOU:

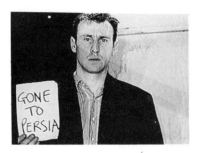

Photo: Hugo Glendinning

1. NOT FOUND.

2. A country that moves in and out of existence according to a dream.

3. AND DO NOT NAME THE THING YOU LOVE.

4. AND DO NOT NAME THE THING YOU LOVE.

5. AND NEVER NAME THE THING YOU LOVE.

6. Fifteen miles of primetime terror.

7. I am here to tell you I was happy.

8. A THING NOT KNOWN OR SPOKEN.

9. ENTER 'Y' TO TERMINATE THE FILE.

10. And this, this is what it's like on the nights when it rains.

Contemporary Theatre Review, 1994, Vol. 2,2 pp. 25–35 © 1994 Harwood Academic Publishers GmbH
Reprints available directly from the publisher Printed in Malaysia
Photocopying permitted by license only

Searching for Redemption with Cardboard Wings: Forced Entertainment and the Sublime

Andrew Quick

This essay examines the work of Forced Entertainment, in particular *Marina & Lee* and *Emanuelle Enchanted*, and their relationship to Romanticism and Lyotard's re-workings of Kant's Sublime. The specular relationship between performer and audience is positioned as the deconcatenated moment(s) of the inexpressible/unpresentable (the sublime) that disrupts the operations and opens out the limits of representation.

KEY WORDS Forced Entertainment, Lyotard, The Sublime, The Event, Performance, Representation.

If I can't sleep I make up different kinds of time, like counting sheep. There's black time when you're feeling sad, no, that's blue time and there's red time when you're angry or cold. There's soft time and long time and thin time too . . . I have to walk quickly cos the continents are drifting apart.

The life of an exile is long + lonely. Each day I wake with this great feeling that I'm home + dry + then I remember to open my eyes.

— Tim Etchells "Marina & Lee"

So long as art presents that there is (some) unpresentable, it belongs to romantic, sublime aesthetics, it mixes the suffering of not being able to find the plastic (or literary) expression of the absolute with the glory of conceiving and wanting it . . .

— Jean-François Lyotard

A sublime incursion

On a cold, bright Sunday in October 1992 a group of artists, journalists and academics met in the heart of rural Gloucestershire to put forward and address questions pertaining to their various art practices. This eclectic body attempted to "mix it": to locate points of contact or at least adumbrate areas of common interest and, as these discussions inevitably unfold, to speak of differences and oppositions.[1] Within the tiny octagonal space of Prema Arts Centre, once a Presbyterian chapel, Nancy Reilly identified a fundamental difference between the aesthetics of American vanguard artists and British experimental performance practitioners. The former, marked by formalism, quotation and the effacement of the author's textual and the performer's corporeal presences, was juxtaposed with the latter's neo-romanticism and "transcendental relationship to beauty".

This articulation of aesthetic and cultural difference, especially based on notions of beauty and the possibility of a transcendental other, appears anachronistic when set alongside recent criticism of British performance and the work of Forced Entertainment in particular. In fact the conference coincided with the first issue of *Hybrid* (1992), an international cross-artform bi-monthly, which claimed in its

[1] This conference was called *A Question of Performance,* and held at Prema Arts Centre on the 17th October 1992.

editorial that, "We are reaching the end of our cultural and political tolerance for the game playing self-reference and self-indulgence of 'postmodernism'", and called "for a new critical rigour" (1992: 1), demanding veracity of themselves, artists and academics alike. Not the sudden feeling of chilliness, muscular cramp or the stiffness of joints and rigidity of the critical body but an assertion of the necessity of vitality, harshness of judgement and accuracy over rigormortized incommensurability. This revivalist chant, which would have felt so at home within the once solid eight walls of Prema's Presbyterian past, is reiterated in Deborah Levy's review, printed in the same issue of *Hybrid*, of Forced Entertainment's most recent theatre piece *Emanuelle Enchanted*. Here she writes, "Thirty minutes into all this postmodern suffering and disaffection, we know exactly where we are", and presumes to know and speak the audience's elation and ennui determined in her final sentence, "we all love it and hate it. So what" (*Hybrid* 1992: 9). Perhaps this is an example of what Deborah Levy, in her introduction to *Walks on Water*, identifies as "an avant-garde that has reduced itself to a flattened post-modern pastiche in which performers lament the death of everything in thin fragmented shows" (1992b: vii). If it is, then Deborah Levy's observations might seem at odds with Nancy Reilly's recognition and assertion of the romantic and the spiritual operating within the work of Forced Entertainment and other British experimental performance practitioners.

Lyotard's assertion of the "unpresentable in presentation itself" (Lyotard 1984: 81) and his re-staging of the sublime as the essential component in avant-garde art might be seen to conveniently bridge the distance between Levy's and Reilly's observations. Sliding neatly into place within Levy's epistemological framework of a theatre in "a spiritual and aesthetic crisis" (Levy 1992b: vii) Lyotard's re-figuring of the sublime works escharotically on the desire for cohesion, narrative and (re)presentation and marks out a terrain, or a desert, (depending on how you look at it) of infinite heterogeneity.[2] A different reading, or at least one faithful to Lyotard's contradictory applications of the sublime, evinces a radical aestheticism which "must inspire the wonderful surprise, the wonder that there should be something rather than nothing" (Lyotard 1989: 246). A desire echoed by Forced Entertainment's director and writer Tim Etchells, who states that the performance of *Emanuelle Enchanted* "is perhaps not so much an evocation of a gorgeous imaginary country as about the need we have to dream such a place, about the gap between our own world and perfection" (Etchells 1992a: 3).

Armed with a battery of appropriated philosophical and cultural theories, recent British critics and commentators on performance have subjected Forced Entertainment to a (re)framing and ordering within the hieratics of the 'postmodern'. Subsequently, it could be said – and this is something that is partly engendered by their own publicity material – that they construct theatrical worlds that are delicate and friable; where narratives break down and linguistic systems collapse; where character and role disperse into the questioning of identity; where terrible dancing and exquisitely played bad acting take centre stage; where the *mise–en–scène* appears to be structured through the slow-motion and fast-forward buttons of the camcorder – in other words, the usual panoply of current aesthetic strategies

2 For a critical analysis of Lyotard's notion of the sublime and postmodernism, see Norris 1990, 7–22.

within performance which are increasingly seen to flatten out, formalize, simplify and ultimately de-politicize contemporary experience.

Such readings inevitably reduce the complexities of the various interactions that occur within the live event, being reliant on the need to concatenate the dynamics of performance and to restage them within the strategies of writing. Yet even within this (re)writing of performance it is surprising that critics have failed or have chosen to ignore the evocations of transcendental potential and the redemptive force of romanticism existent in Forced Entertainment's work. Operating alongside and within the fractured and mediatized landscapes of their fictions, a brutality of assertion, of repetition, materializes around possibility, perfection and otherness. This eidetic repositioning of the absolute, of the transcendental, within the realm of experience but beyond description, is abandoned and forgotten by the homogenizing power of the 'postmodern' (concept or critique).

Put simply, Forced Entertainment stage, and it is a *theatrical* configuration, fictional worlds which are saturated by a sense of loss, where desires transmute into *acts* of faith. Here love, beauty and half-remembered origins become trembling possibilities, whilst the desire *and* failure to describe and express these ideas and feelings is enacted in performative and textual terms. It is the neccessity *and* inability to find these origins, negotiated through the complex levels of reality (experience) and its theatrical (re)presentation, which appear to parallel Lyotard's insistence of the aesthetics of the sublime. Lyotard's writings on the sublime cannot be seen to encompass the complex intricacies of Forced Entertainment's work, nor is it possible to view their work as an imperforate embodiment of his theorizing on aesthetics. As a textual version, subject to a rewriting and a restaging, my discourse attempts to move between these two bodies, avoiding the conflation of separate entities, yet marking their regions of reverberating similarity. At such points the theoretical and performative skins touch and become resonant. It is to these moments that I will shortly return.

An interior machine

Citing Lyotard's presentation of the sublime within and against the order of the theatrical might seem wayward since his examples of sublimity, or at least sublime intent, are usually drawn from painting and photography. Although the sublime features dramatically in the last section of *The Postmodern Condition* (1984), hovering discursively within the regions of the aesthetic, the ethical and the political, there is no mention of how it might operate, or even if it can, within art practice. As Meaghan Morris points out, Lyotard's location of the sublime is 'not in art but in speculating on art" (Morris 1984: 64). There is always, however, a regime of speculation operative within the order of the theatrical. It is a regime that is not limited to the exchange of money (commodification), the speaking of ideas and desires nor their physical actualisation but one that remains dynamically ocular: a spying in (the audience and to a certain extent the performer) and a looking out (the performer and to a certain extent the audience). The intention is not to situate the order of the theatrical as a paradigm of sublimity but to locate the dynamics of the sublime within the theatrical framework: between spectators.

This relocation of sublimity within theatrical practice appears strange when considering the "theatrical-representational apparatus" (Lyotard 1983: 255) which

Lyotard articulates in *Des Dispositifs Pulsionnels* as being analogous to the mechanisms or set ups of representation, the 'dispositifs' that the ambitious energies of sublimity would appear to want to break down and move beyond. Here the theatrical space, or volume, is theological by dint of the exclusion of the exterior – the real – which the theatre proposes to represent. Representation on the stage is based on an absence which, as Bennington observes, is privileged by "its being placed out of reach, beyond representation as posited within representation" (Bennington 1988: 14). This 'derealization' which, Bill Readings argues (1991: 96) reduces "the real to a representation for a subject" (the actor and spectator in the theatre), is achieved through the mechanisms of the theatrical volume with its division into limits – auditorium, stage, backstage and wings – which mark out the borders between themselves and the world outside (the real). The institution of a limit, a frame, which "circumscribes a region" (Lyotard 1983: 59) imposes an order of representation that not only precludes the 'real' but transforms the real to that which can be represented. Thus the real becomes the representable and is reduced to the absent object of a representation. This reduction to the conceptual shores up the apparatus of representation "by which the real is merely the absent original of a representation" (Readings 1991: 96). It is a process which Lyotard describes as a "placing outside (that takes place) on the inside" (Lyotard 1983: 291).

Whilst Lyotard is not directly speaking of the theatrical but rather placing it paradigmatically as an analysis of representation, his analogy is useful when attempting to locate the sublime within the theatrical and performative apparatus. Useful, because the sublime seeks to operate between the various frames or set ups of representation. A literal extension of Lyotard's assertions to the theatre would position certain dynamics, those which can be located in their attempt to re-present the real – narrative, character, fictional time and so on – as effacing other energies, forces, eddies, intensities, singularities that are in contestation because they refuse reduction to an origin, to a narratable and thus knowable point. Even in resistance these singularities, these 'non-unifiable events' are subject, through their own immutability, to a refiguring within the real as being the real itself – real time, real bodies, action (unrehearsed activity), performance in the street/hotel/gallery/disused factory – the 'dispositifs' of presence both before and beyond representation in performance.

Forced Entertainment have yet to bale out of the theatrical, or at least the space of the theatre, their work being deliberately placed within its machinery of representation. The early pieces, *Nighthawks* (1985) and *(Let the Water Run its Course) to the Sea that Made the Promise* (1986), have a cohesive composition and are constructed through intricately detailed, closed fictional worlds. Here audiences are invited to peer into spaces whose aesthetics owe more to film than to theatre, where the audience's speculation is barely acknowledged or exchanged by the performers. Although there is a perceptible layering of both the real and the disreal, where the theatrical effect is combined with the revelation of the process of its making, (filmic lighting penetrates the set from conspicuously visible lanterns), the force of the fictional world remains undisrupted by a returned speculation. It is the return of this speculation in performance which corrupts the 'proper' space of representation.

In both these pieces choreographic, gestural and guttural action is framed by taped voices that appear to be situated both within (by their correspondence to certain actions) and outside (by their reference to experiences and languages that

are beyond those on stage) the sequence of events. The invisibility of these voices, echoing the narrative voice-over in film, creates a sense of potential objectivity and external poetic vision. Such textual jurisdiction disappears in *200% & Bloody Thirsty* (1987), where the narrating voices are unlikely angels with tin foil halos who appear on video monitors, interacting between themselves and commenting obliquely on the action below. As the impossible made visible their textual authority is vulnerable, operating within the *mise-en-scène* from a perspective which is always in question. These insubstantial spirits are uncertain of themselves and of what they see: a failing world inhabited by skeletal structures, bordered by leafless trees, strewn with clothes and backed by a neon lit badly painted blue sky. This composite world refuses reinscription into the seamlessness of realism and positions theatricality – its assertion and its limit – as a central negotiation.

In the ensuing works, *Some Confusions in the Law about Love* (1989) and *Marina & Lee* (1991), the positioning of the dispositifs of the theatrical, the mechanics and operations of narrative, character, text and so on, becomes increasingly important. The company's recent production *Emanuelle Enchanted* (1992) privileges these theatrical mechanisms through its setting of a stage within a stage, its repetitious fragile proscenium arch, transparent front curtain and unpainted wooden flats. The stage is not simply an evacuated space of quotation but one inhabited by a group of performers who, through a sense of compulsion and hesitancy, express both the desire and inability to describe and name those things which speak of a beyond to these limits. As Tim Etchells points out in his note on *Emanuelle Enchanted*, the figures on stage "may have an identity crisis and a terrible place to live but they also have a passion, and a sense of truth, and bad jokes and beauty which makes them a model of survival and impossible escape" (1992a: 3). Operating at this edge of the theatrical (that which can be seen, known, identified and judged), Forced Entertainment offer up a different space, one that is both vivid and evanescent and which attempts to mark out a territory of transcendence, of the unrepresentable. This region is framed by the possibilities of the imagination (its attempts and limits): the performers' through their struggle for articulation within the theatrical set-up and the audience's through its struggle to speculate within the various diastemas in the theatrical body. The spaces are where the mechanics of theatricality break up and the onlooker (whether audience or performer, since both are witnesses) has to produce meaning for herself: "*Emanuelle Enchanted* is a country that exists *only in the imagination* – a place so beautiful that to look upon it is to know both happiness and despair" (Etchells 1992a: 3) [My italics].

Faithfully performing negation

The conflict between 'the real' and representation and its aesthetic and political implications has received extensive attention in experimental theatre and critical enquiry.[3] Indeed both orders of representation in the theatrical – 'the real' and 'the enacted' (if they can be neatly divided as such) – are coexistent within any performative operation, be it 'time based art', 'performance art' or 'theatre'. Similarly, Lyotard's 'theatre of representation' is not as closed as he would have us believe. There are energies, spaces, exchanges that refuse reduction to the unity of

[3] See especially Vanden Heuvel 1991 and Auslander 1992.

the knowable (concept), or at least agitate between the conceptual and its representation. This agitation opens out the space of the sublime.

The aesthetic of the sublime is not without a genealogy. In fact Lyotard's assertion is one which relocates 'the postmodern' within an anterior movement of Romanticism, where the fundamental task is seen as "that of bearing pictorial or otherwise expressive witness to the unpresentable" (Lyotard 1989: 199). Romantic art, however, is identified with an eloquence, with a bearing witness to the inexpressible "in an over there... or other time" (Lyotard 1989: 199). The 'avant-garde' (this term is conflated into the 'postmodern' in *The Postmodern Condition*), on the other hand, posits the inexpressible in the present moment of its occurrence which Lyotard defines as "the 'it happens'". This movement, this 'event', vital to an aesthetics of the sublime, is juxtaposed with the insertion of criteria that follow the imposition of the referential frame occasioned by the question 'what is happening?'

These two notions of the sublime which Lyotard identifies as the nostalgic (modern) and the 'authentic' (Postmodern within the modern) are an elaboration of Kant's theory of sublimity outlined in the Third Critique (*Critique of Judgement*). Here Kant claims that we are capable of having ideas or concepts which are incapable of being presented. The distance between these faculties of conception and presentation is the region of the sublime. For Lyotard, like Kant, this indemonstrability "stems from Ideas ... for which one cannot cite (represent) any example, case in point, or even symbol" (Lyotard 1982: 68). As he states in *The Postmodern Condition* "We have the Idea of the world (the totality of what is), but we do not have the capacity to show an example of it" (Lyotard 1984: 78) and, in a rewriting of Kant, claims an ability to conceive "the infinitely great, the infinitely powerful" which refuses reinscription, through being made visible, into the representative. They are "Ideas of which no presentation is possible. Therefore they impart no knowledge of reality... They can be said to be unpresentable" (Lyotard 1984: 78).

Lyotard, invoking Kant, pits the sublime against the beautiful, where the unity of the subject is presaged by the stable and recognizable relationship between 'form' and 'content'. Beauty is "kindled by a free harmony between the function of images and the function of concepts occasioned by an object of art or nature" (Lyotard 1989: 203). In the beautiful, through the "unison of the faculties", signification remains unproblematized. Opacities, those forces, intensities and libidinal drives which cloud the signifying strategies of representation by refusing to give themselves up to meaning, are effaced in the name of taste and good forms. The indeterminacies of the sublime, on the other hand, invoke "a pleasure mixed with pain, a pleasure that comes from pain" (Lyotard 1989: 203): pain which arises out of the failure of the imagination to "provide a representation corresponding to the Idea" (Lyotard 1989: 203), pleasure which arises from the ability to conceive of ideas that are beyond any intuitive presentation or region of cognisance. The sublime sentiment opens out a space within the representational apparatus through its attempt "to present the fact that there is an unpresentable" (Lyotard 1989: 206): the martyrdom of representation through the presentation of the 'non-demonstrable'.

This desire for 'negative representation' can take two possible directions. The first and lesser, which Lyotard describes as "on the side of melancholia" (Lyotard 1984: 80) emphasizes "the powerlessness of the faculty of presentation", falling

back on "the nostalgia for presence". It is a wishing back of an objectifiable reality and the recognition of a loss, within modern experience, of "real unity", of "the transparent and communicable experience". The second, which he calls "novatio", emphasises "the power of the faculty to conceive" which is not the faculty of understanding. Stressing the "invention of new rules of the game" Lyotard valorizes artists and art forms that refuse "recognisable consistency" and the reduction to the unity of the cognisant, to the nostalgia of presence. Through the invocation of pleasure and pain Lyotard demands that the postmodern put forward the unpresentable in presentation itself, which, as Emilia Steurman notes, situates "allusions not to the unpresentable but to the unpresentability of the unpresentable" (Benjamin 1992: 114).

Perhaps the phrase 'an aesthetics of the sublime', contrary to some of Lyotard's indications, is insufficiently nuanced. It is, rather, a 'negative aesthetic' (Beardsworth 1992: 53) which alludes to what falls outside the realm of presentation through a negative presentation. Nor should we look solely to the explicit cultural scene of Lyotard's avant-garde, if such a scene still exists. Negative presentations appear and operate across diverse disciplines. Witness Quentin Tarantino's *Reservoir Dogs* where, in an already horrific torture scene the camera pans away from the cutting off of a policeman's ear and the screen is filled with a shot of a warehouse wall. The pain and terror invoked cannot be contained within its representation and the scene is rendered more powerful through an insistence on the dynamics of the spectator's imagination which is caught in the attempt to visualize what the camera refuses to let her see.

Lyotard's allusion to the performativity (the putting forward) that is implicit in this 'negative presentation' is grounded in the notion of 'an event'. 'Eventhood' arises from the relinquishing of "preestablished rules" and the barring of "familiar categories' of judgement because such 'rules and categories are what the work itself is looking for" (Lyotard 1984: 81). The insistence on invention and experimentation precludes the insertion of the operations of critique – interpretation, evaluation and judgement. As Lyotard describes, the artist and writer "are working without rules in order to formulate the rules of what will have been done" (Lyotard 1986: 81). 'Eventhood', defined by Bill Readings as the "radical singularity of happening as distinct from the sense of 'what is happening'" (1989: xxxi), places indeterminacy, heterogeneity against the homogenizing power of nostalgia and its concatenation of events into units of meaning. Lyotard's radical sublime, then, tends "towards the infinity of plastic experiment rather than any lost absolute" (Lyotard 1982: 69).

No nation now, except the imagination

Both these operations are present in the more recent work of Forced Entertainment. Indeed one might be tempted to position the tension that exists between the nostalgic and the attempt and refusal to describe or articulate what lies outside the order of representation as *the locus* of their aesthetic ordering. This tension often arises from the agitations between the textual and performative economies operating within the work. This is not to reduce the textual only to the articulation of 'nostalgia', to the mourning of lost absolutes, but to say that it is usually at moments of poetic textual authority that a privileging of the nostalgic occurs.

Marina & Lee is structured through the narratological devices appropriated by its central figure, Marina, who wanders through a flickering landscape sculpted from the media's detritus – cowboy shoot outs, opera, kung-fu fights, women with guns pleading for their lives, sex shows and product placements. Like some picaresque hero her journey, traced by walking backwards and forwards between the curtains at the front of the stage, is one of ironic self-discovery and self-loss which culminates in a meeting with her dead lover Lee Harvey Oswald. Until this reconciliation, perhaps the object of her journey, Marina's meanderings are framed by constant assertions and comparisons that speak of her desire for identity and definition. Here she likens herself to movie heroines and icons from classical art: "I'm like an angel in early Italian paintings – kind of serene and gorgeous but depressed" and "Like in that sex film THE RETURN OF SUSIE MIDNIGHT (SECRET AGENT) I am broken in a thousand pieces and there's nothing left for me but love" (Etchells, 1991).

Falling short of these comparisons, wrapped as she is in an absurd masculinity – cowboy hat, badly painted stubble on her face and a large plastic penis hanging between her legs – Marina 'progresses' through a landscape that oscillates between less and more chaos. The slow walking along the front of the stage, alluding to the pantomime convention, evinces a fragile theatricality that evokes not only a crisis of identity but also a crisis in the belief in representation itself. Performed with an exquisite naivety, Marina slowly paces the breadth of the stage, occasionally making eye contact with the audience and sometimes appearing to locate something in the distance. Her words are framed by tentative enunciations and gestures that instantly appear to lose confidence in themselves, reflecting the half believed in and half acknowledged distance between what is described and what is actually around her. Here the harmony of representation is disrupted, where the audience is actively implicated in Marina's attempt to describe and comprehend; implicated in the pleasure of perception and the pain of the failure of prescription.

Performed with a moving bewilderment, Marina attempts to insert herself into the various narratives that intrude on her travelling, 'participating' in mock kung-fu fights and tired sex shows. These 'activities' take place in a nowhere world that actively presents the uncertainties predicted in the piece's opening section where a woman in a shop overall, flanked by figures that frantically gesture and wave scrawled product names on tatty pieces of cardboard, concludes, "Today blood, stone and feathers attract. Tomorrow it may be concrete blocks and nitrogen. Weak objects are impossible to break" (Etchells, 1991) – a parallel now, a time of uncertain rules and the de-establishment of judgement.

Marina & Lee cannot be reduced to the enactment of chaos, however – the maelstrom that is perceived as the inevitable outcome in Levy's and *Hybrid's* presentation of the postmodern. Positioned against the dispersion of narrative, of character and the succession of fictive intrusions is an extraordinary moment of reconciliation and an act of faith. Occupying a key structural position within the temporal frame, Marina's movement is finally arrested in the journey's end: the meeting with her dead lover Lee. This insertion of the 'object' of love, although ironic – mediated through Lee's appearance on video in a Groucho Marx false nose and glasses – positions transcendence as an expressible possibility. It is an invocation of a love that agitates between loss and assertion, a love that transcends death and its effect. Lee laments, "I'm dead Marina", to which she replies "I know that Lee". Here Lee is her "best love" and dreams of Marina "with the till-girls and

the Dixon boys, walking past the last streetlamp and into the dark. They dance the smiling and hurrying, the looking for something in the world" (Etchells, 1991). The scene is imbued with a spirit of nostalgia and beauty, of a return to origins, a coming to rest and the *finding* of something in the world.

It could be argued that this reading of complex and ultimately indeterminable moments erases and forgets other modalities and energies that are outside of the realm of the nostalgic. It is precisely this forgetting which is enacted in these arrested moments: occasions in the performance which, through the operations of textual signification, gather the various performative drives into a regime of meaning, where the spectre of the external author reappears. Here the textual acts homogeneously on the aesthetic, reigning in performative differences in the name of 'nostalgia' and perhaps even the 'beautiful', however.shabby their constellations.

If such moments of 'nostalgia' articulate an insertion of verisimilitude through the text's 'poetics', there are as many instances in Forced Entertainment's work which bear witness to that which cannot be represented or at least to that which in representation speaks of something which is not subject to its institutions. Lyotard implies that an aesthetics of the sublime, or 'a reflection on art', occurs through the aesthetic configuration which positions the various interactions, those between the art object and the 'addressee' and between artist and art object, as the primary dynamic. The question is no longer "How does one make a work of art?", but "What it is to experience an affect proper to art?" (Lyotard 1989: 203). The implication of this 'affect' is twofold. Lyotard invokes a reading of a work of art as an event itself, as a material practice, which, in a reading's multiple singularities, parallels the art-work, refusing reduction to the totality of interpretation or theory. Secondly, he privileges a process by which the artist is continually repositioned in relation to the art work and is actively inscribed into its indeterminacies, into the works 'eventfulness', into the act of its creation.

Forced Entertainment position such interactive 'readings' and interventions through the dispersion of theatricality's *dispositifs* – the fracturing of narratives, the effacement of character, the presenting of events as events and so on – and through the process of presenting refusals and silences. These instances which evince uncertainty, hesitation and privacy invoke representations of the non-demonstrable in which the audience is left to fill the gaps and make meaning where it can. The operation of this 'opening up', this diastema in the theatrical volume formed through fracture and silence, is one of the work's most important, perhaps primary, aesthetic dynamics. It infiltrates all Forced Entertainment's theatrical configurations, precipitating moments of seizure and loss, disruptions of varying intensity occasioned through moments as small as a deliberately misplaced gesture or as large as the evanescence of theatricality marked by acts of refusal.

One such refusal occurs in *Marina & Lee* in a section where Marina watches unnamed figures make confessions alluding to extraordinary and mundane 'sins':

We confess to mischief and lying
We walked under bridges to shelter from the rain
We asked who bombed the outskirts of this town
We fell in love
We took without asking, lied without thinking said sorry for nothing at all.

(Etchells, 1992)

In this second 'scene' of confessions one of the figure's atonements progresses from a faint whisper to silent mouthings. Here the other figures, through their attempt to help her to speak audibly, and the audience, through their attempt to imagine that which has provoked such silence, bear witness to the unpresentable. It is a moment when the performance appears to break down and an imaginative return and speculation is demanded of the audience. The silence evokes a failure of expression that exists both on stage and within the body of the audience who are bound to this failure through the limits of their imagination. It invokes the "kind of cleavage within the subject between what can be conceived and what can be imagined or presented" (Lyotard 1989: 203) that Lyotard presents as the effect of the sublime sentiment.

Marina & Lee closes on a similar invocation through the counting of one minute in real time – "sixty seconds", "fifty seconds", "forty seconds," down to "zero" – to mark the end of the performance. During this 'scene' of closure, the performers look at the audience as the various temporal operations (narrative time, performance time and real time) which have been evident throughout the performance manifest themselves in interchanging configurations. It is a performed temporality that cannot be fixed since it shifts between the various possibilities of its signification; between narrative, performance and real times. In this 'scene' nothing happens, or at least the 'scene' resists reduction to a singularity that might encompass its various indeterminacies. It is not reducible, for example, to the perception of a performance time being washed up on the shores of real time for that would limit an occasion of acute anxiety to one of an easy interpretation. And yet "it happens", as Lyotard would say (1989: 197), something which is, perhaps, impossible to identify but still encompasses the indeterminacy of the event, the 'occurrence'. Here everybody waits, performers and audience, as witnesses to the unpresentable. Not to time but to the occurrence of their interaction, the exchange between audience and performer that happens from moment to moments and which marks, to rewrite Lyotard, the 'here and now' of performance, It is a 'scene', then, that disrupts the harmony of interaction through the movement of its events, as 'times' which refuse concatenation, and speaks of, by the activity of waiting, the possible to come.

A piece of time too small to give a name

In *Emanuelle Enchanted* the circling walls come to rest and a figure, sort of holding the fort at the front of the stage whilst an uncertain scene change goes on behind, proffers two enigmatic questions, "How can you live when you've done something? How can you live when you've seen something? " (Etchells 1992: 15). These words are not privileged with a significance within the piece's structure but they reflect an agitation that resists inscription into Deborah Levy's flattening postmodernity, into her definitive understanding of knowing "exactly where we are". These questions trace a longing for an end to uncertainties, for an end to the restless motion of thought, while at the same time recognizing the imminence of death that would be the outcome of such desire.

Perhaps, since death arrives with recognition, with the stasis of signification, it is not surprising that love, in these pieces, is stained with mortality. Whilst the privileging of love risks becoming a truth or an undifferentiated value within Forced Entertainment's deconstructed landscapes, its ironic configuration with

death precludes an unproblematized inscription into the mythical, into the comfort of 'good' form. It is this spectre of 'good form' that returns with the clamour for 'rigour', for the knowable, for the law. It might be asked, at what cost? – certainly the evisceration of the moment through the insertion of that levelling enquirer 'what is happening?'

The work of Forced Entertainment seems to be positioned at the brittle edge of theatricality, half resigned to its effects whilst envisaging a beyond to its limits. Disrupting the harmony of the visible, this work refuses inscription into the the theatre of representation through the tracing of a region within the space of their encounter where both performer and audience are implicated: how to live life participating in art? It is a recognition of the limits to the 'seen' and the desire to perceive the 'what might be'.

Contemporary Theatre Review, 1994, Vol. 2,2 pp. 37–47 © 1994 Harwood Academic Publishers GmbH
Reprints available directly from the publisher Printed in Malaysia
Photocopying permitted by license only

An Interview with Mike Pearson of Brith Gof

Geraldine Cousin

In December 1992 Geraldine Cousin talked to Mike Pearson, a founder member of Brith Gof, the Welsh theatre company that has pioneered epic, site-specific work in Britain and Europe. In addition to large-scale, site-specific projects, Mike Pearson discusses *in Patagonia*, a theatre piece based on life in the Welsh community in Patagonia, and two small-scale ventures: a one-man show, *From Memory*, and a physical duet entitled *In Black and White*. The interview explores Mike Pearson's interest in experiments with theatrical form, particularly in relationship to physical theatre, narrative, improvisation and the 'two' in performance.

KEY WORDS Site-specific, Narrative, Physical Theatre, The 'Two', Performer, Personal.

Brith Gof was founded in 1981 by Mike Pearson and Lis Hughes Jones, and until 1988 was based in Aberystwyth. Now based in Cardiff, the company, over the last four or five years, has pioneered epic, site-specific work in Britain and Europe. Geraldine Cousin, a lecturer in Theatre Studies at Warwick University, talked to Mike Pearson on 1st December 1992. The main body of the interview is devoted to a discussion of three productions: *In Black and White*, *From Memory* and *Patagonia*. *In Black and White* was a physical duet between Mike Pearson and disabled performer, musician and composer, Dave Levett. *From Memory* was a solo performance by Mike Pearson which was first presented in the Welsh folk Museum at Saint Fagans, Cardiff in the summer of 1991. Mike Pearson recreated the show, performing the first part at the Warwick Arts Centre studio and the second part in the grounds of Warwick University. Defined in the publicity for the show as: 'archeology, autopsy, gossip, talking, telling tales, fibbing, a childhood in a Lincolnshire village and a death on the Pampas of Patagonia, an intimate personal reflection of family and landscape, tradition and change', *From Memory* focused (in the first part) on the performer's personal experiences and memories, and (in the second), on a robbery and shooting which took place in the Welsh community in Patagonia in 1909. *Patagonia* was first performed in January 1992 at Taliesin Arts Centre, Swansea. The 1909 shooting featured again in this production where it was used as a recurrent structuring device within a complex interweaving of visual images and varied types of textual material, both English and Welsh. The final section of the interview focuses on Brith Gof's site-specific work and Mike Pearson's future work projects.

Q. I saw *In Black and White* last night at the Warwick Arts Centre studio, and was very moved by it. I was also fascinated by the contrast between this very physical piece, and your one-man show, *From Memory*, which was based round verbal narratives. Is your personal interest primarily in physical work, or are you interested in exploring both verbal and physical theatrical languages?

A. I think the physical interests me greatly. I've always been interested in the
 creation of physical narratives which take the place of words. However, when
 I came to make *From Memory*, it was at a time when actually I was at quite
 a low point. I felt really the only thing I was capable of talking about in theatre
 was myself, or my family, and I began to think about the way my family
 talked and the way for instance gossip played quite a large part in
 communication-nets in the family. Gossip can include extraordinarily different
 orders of verbal material and information – opinion, anecdote and so on,
 without break (so that you can move from one topic to another, without
 stopping), and I began to see a way that, in beginning to use text in
 performance, then that would be a very natural thing for me to do. This was
 happening at a time when I was increasingly interested in very different
 orders of textual material in theatre, and how to include them without there
 necessarily being one discursive narrative that was being unfolded through
 characters and their interactions. (I think that's the step that came in
 Patagonia.) Having said all that, I think the thing that links those ideas
 specifically to the physical work in *In Black and White* is that the work with
 David is extremely personal, and it doesn't pretend to be theatricalised in
 extremely sophisticated ways. It began from a personal initiative and, in
 one way, it was an attempt to try to rediscover what physical activity
 might be in theatre, in much the same way that I was thinking about the
 text in *From Memory*. I think what happened with the work in *In Black
 and White* was the building of a relationship and that the show, in physical
 ways, is autobiographical, in that every time I come back to it – we come
 back to it – it takes on another form. It may well be the only performance
 we can do together as a two-man piece. Coming back to it for this tour
 was very interesting because David wanted to dramatise the work more.
 Initially, it had been quite abstract, I think, the work we did together, and
 more dancelike. David and I go quite regularly to see work and, in the
 interim, he'd seen, for example, the big show *Brith Gof* were doing, and, as
 a result, he said that his expectations were now higher. That's why I think a
 veneer of theatricallity is beginning to form around the working relationship
 we have. I guess, too, that much of what I'm saying was in reaction to the
 large-scale, site-specific work that Brith Gof have concentrated on over the
 past four years – in that these are unusual and awkward situations for
 performers, who are used to generating most of the theatre. You have to
 accept that you are only one part of a much bigger theatrical machine,
 which includes the architecture that we build for the performance, often
 within a found architecture, and also the fact that the musical sound track
 is amplified. All text is sung within that amplified level, and the performers
 would not be heard were they to speak. The activity you're engaged in is
 conditioned to a large degree by the technical, physical requirements of
 those other elements, and therefore I think it's difficult to feel, as a
 performer, and as a director, that it is you that is having the theatrical
 effect. You know you're part of this machine and in the end people tell
 you perhaps that the machine is wonderful, or it's terrible, but you often feel
 frustrated because there was nothing you could do in, the end, to make it
 better or not. I think there's always a desire on the part of the performers to
 do it better the next night, but that's removed from you, in a way, when

perhaps the sound engineer is the person who's really controlling the audience's perception of the piece.

Q. The venues for *In Black and White* must have afforded a major contrast from the locations for the site-specific work. Have all the performance spaces for *In Black and White* been very small?

A. Yes, some were theatres and they brought with them the expectation that a theatre building brings. We performed in a dance space in London, Chisenhale, and I think all the expectations were dance expectations there. So that's the way the piece was perceived. Often the most interesting venues for this kind of work are very ad-hoc ones, like halls and so on.

Q. These are sometimes the most interesting playing spaces anyway, aren't they?

A. Absolutely, yes, and I think the perception then of an audience of David's work in a space like that is quite different. They don't necessarily put theatrical quotation marks around it. When I began to work with David, I rapidly became aware of the fact that he's a very special kind of performer, and that his physicality is extraordinary. It does communicate in theatre and yet it follows almost none of the principles of theatrical gesture that I know. His preparation for performance is particularly interesting because he has to do almost exactly the opposite to a conventional physical performer, who tends to get hyped up, energised before the performance, and to feel a certain amount of tension. If David becomes tense, it goes straight into his body and his movements become much more random. So he has to relax almost to nothing and I think, in a sense, we build the physicality as we build the performance. So actually you would probably see, as we become attuned to the situation, then maybe the movement becomes bigger or more complex as we go along, but working from that relaxed state. There was a great deal of interest when we did the first work-in-progress showing of *In Black and White* at the same time as the ISTA conference which took place in Brecon in March (1992). I think David's work was of extreme interest to the French semioticians because what David is doing when he performs communicates and clearly has a theatrical effect on an audience, but he's making nothing that we would recognise as a conventional gesture of whatever sort. It's always modified, or a different gesture, yet, nevertheless, you . . .

Q. You gradually feel you're learning to 'read' it.

A. Yes, you do. Also, there was a lot of talk in the conference about underscore, the idea that there's a state of preparedness, a pre-expressive state, which the performer achieves before expressing something. Of course the very hard-nosed semioticians would say that's impossible, there's nothing before the sign, and I can appreciate that in a way, but I was particularly struck watching certain duets working during the ISTA conference, for instance, one of the Odin actors and a Japanese Noh actor improvising together, by the degree to which that underscore, the realisation that there are two people saying, 'Here we are, and we're playing against each other' is actually revealed in the way that they look at each other. You actually sense that give and take, and I hope that that's apparent in the work that David and I do, that actually at times the underscore is holding it together, and a gestural language comes on top of that. For me, and its a very unique privilege to feel it, there are certain moments in the performance which are extraordinary. One in particular is when I kneel down in front of David and he puts his arm over my back and

then he actually throws himself over, which is a very simple movement, but for David it takes all his will and I can actually feel him willing himself to do it. Sometimes it may take two seconds, but sometimes it may take much longer, and I can actually feel a tremendous work going on within him to get his body into an order to do that movement. I think that has given me a much deeper appreciation of what we do in physical theatre.

Q. You mention in your publicity for *In Black and White* that the setting is inspired by the work of Eadweard Muybridge. Could you talk a little about that?

A. Just before the invention of film, he and one or two others realised that they could take sequential photographs of human and animal movement by having a series of cameras and by simply having someone or something move across a gridded backbround and the cameras triggering sequentially. They had horses, for example, walking and tripping wires, which triggered the cameras, and it was the very first time that some aspects of movement had ever been seen. For instance, there's this strange and almost universal artistic convention of what's called the flying gallop, which is to portray a horse with its forelegs and back legs extended. You see it in native American painting, you see it in Stubbs, you see it everywhere, but, in fact, until Muybridge took photographs of horses galloping, it wasn't realised that it's anatomically impossible for a horse to do that. They don't gallop like that at all. He did an enormous number of photographs of men, women, children: climbing stairs, throwing things, jumping, what have you, and he took a small number of photographs of disabled movement as well. They're all done against this gridded background, and I simply thought, when we were looking for a context, that it might be interesting to see, at some points, very different extremes of movement against a gridded background, a very controlled one and a very random one, or whatever. It was perhaps to say we have to look at the movements of disability again, afresh, like Muybridge did with movement in general, and appreciate what's happening there. It's not simply randomness.

Q. Is there any connection in *Patagonia* with Muybridge's work? I was thinking of those recurring visual sequences of the shooting which had something of the quality of silent film.

A. That's an interesting connection because, in order to create those sections, we actually looked at the very earliest films that we could find. They were only ten years apart, the work of Muybridge and those very first films like *The Great Train Robbery*. Whilst they're full of those jerky conventions that we all recognise, two or three things became interesting through watching those films that we saw over and over again. First of all, virtually everyone in frame was almost always moving. There was no convention of stand and listen while one person is speaking, as you might have in theatre for instance. So actually they're really quite chaotic in a way, many of the images you see. Secondly, because there were no agreed stylistic conventions, you might see people acting in a variety of styles in any one scene, particularly when a group of people is reacting to one thing that's happening. The way that the camera moved was also interesting, because in fact it barely did. The only movement of the camera was from left to right, the pan was the only camera movement that was really available. Then we got hold of a very early film by

D.W. Griffiths and suddenly there are close-ups, editing and so on, and then people ad to learn a completely different language. I remember, one problem we talked a lot about was whether someone from 1902/1903 would actually be able to 'read' a contemporary film.

Q. One of the things I found particularly interesting about *Patagonia* and *From Memory*, in the context of how one 'reads' a piece of theatre, was the revelation at the end of the importance of the *Butch Cassidy and the Sundance Kid* story, and how this related to the stories of the people we'd seen. Could you say a little about the interweaving of the various narratives in these productions?

A. In *Patagonia*, we had a desire, springing from somewhere, to make a piece for a stage. That was the first unusual thing for us to do and we felt we could only approach the stage as a site, as we would any other performance space, an empty factory or whatever, and the only convention that was given was that the audience would be there (in the auditorium) and the action would be here (onstage). In creating the stage picture we worked on the architectural conventions we were given, and we decided to try to create a wide, thin image, a kind of cinemascope. There were little hidden conventions which possibly an audience wouldn't notice, but actually the action moved from left to right, gradually through the whole piece, and there were thresholds which were crossed at certain points, doorways that were transgressed. That's not really for an audience, but it's a kind of structuring device that we used. But then, when we began to think about the way in which we wanted to use these different textual types: information, story, so on, I think we felt we really needed some narrative thread. We couldn't jettison everything and expect an audience to go here, there and everywhere with us. We would need someone sort of spine, and the *Butch Cassidy* story gave us that, in that, however far we wandered away, once we'd got going, an audience would understand that again and again and again we would come back to the convention of the silent film and there would be that to follow, that would unravel. Although it wouldn't be commented upon, until of course the final revelation. So what you were seeing was the equivalent of a 1902/1903 film, like *The Great Train Robbery*. In one way, I think we wanted the *Butch Cassidy* pieces, to be quite banal, and I use that in the best sense. There was a narrative and it was being played out, and you could read it very simply, and that would actually give us then the freedom really to dramatise or to present all of those other sections in whatever style we wanted. We could go right away, we could even comment upon the fact that we were on a stage. We could really deconstruct as far as we wanted, but that would come back and come back relentlessly. We chose the story, I think, firstly because it is so central to Bruce Chatwin's book, *In Patagonia* (which was one source, among many, for both *From Memory* and *Patagonia*). Secondly, we had a sneaking feeling that it wasn't true, that somebody fibbed to Bruce Chatwin. Whilst the incident is undoubtedly true, I got this very strange feeling that somebody in Patagonia, in the Welsh community had done a kind of 'let's all fool the anthropologist' kind of thing, and said, "Of course it was Butch Cassidy and the Sundance Kid who did the shooting". The other important point about that story for us was that it was the point at which a greater narrative meets a lesser narrative, and that was very important for me, too, in *From Memory – Butch Cassidy and the Sundance*

Kid, a theme, two names, which actually people would recognise around the world. If they say Robert Redford and Paul Newman, that's what they see, a big myth, if you like, meeting an almost invisible story, not only of emigration to Patagonia, but the story of this one man who fascinates me so much, Llwyd ap Iwan, the man who was shot, whose story in many ways is as remarkable as *Butch Cassidy and the Sundance Kid*. The idea that the greater and the lesser should meet in this God-forsaken place in the middle of the desert was a very very strong idea for me.

Q. Did you, in *From Memory*, have any sense of a meeting of your own stories in the first part and the story of Llwyd ap Iwan in the second?

A. Yes, in one way I did. My father had died eighteen months previously. He never ever saw me perform, never saw anything, and in one way couldn't accept what I did because, coming from a rural background, he'd never seen any of this kind of work. Then, I began to think more and more about the ways in which I could talk about him, talk about my childhood, but, as I said earlier, I rapidly began to realise that one voice talking can carry all of these shifts of type, of tone, actually quite easily because there are these conventions of gossip or whatever which enable us to do it. Then, having looked very personally, I wondered if that kind of technique, extended even further, could work with other bodies of material that were particularly fascinating me at that time. I think the second part of *From Memory*, springing out of those techniques that I was thinking about in the first part, then did actually lead on to having the confidence to structure *Patagonia* in the way that it was subsequently structured. So I think there is a direct link there. I think the other thing I was doing at the time was rethinking my workshop technique. For years and years I've done physical technique in workshops and people always enjoy it, but that's it. I always felt it never goes any further than that. Even if you make a performance, you just appear and disappear and it's just a bag of tricks really. I began to rethink what I do, and the workshops that I do now are really very curious things, but I do actually try to talk about principles at the same time as doing the physical work, principles of space, of how a crowd of people suddenly adjust itself to look at a thing – proxemics, the closeness or distance between people when they're communicating, depending on their status and so on and so on, the parts of each other that they touch and all of that sort of thing, and I think actually that was going on at the same time as working on *From Memory*. So in the second part of *From Memory* there are elements of that as well.

Q. The night I saw it one of the university security men didn't know that there was a performance. Do you remember that? He came along and tried to stop it. That was an extraordinary collision of worlds.

A. Yes, though the little scenario that was played out that you didn't see was even more interesting. I was wearing an ankle-length duster coat and a cowboy hat ready for the performance and I had the gun. I think four security guards eventually accosted me, and said, "We're 'phoning the police", and I realised we were in another game because, if it was a real gun, they wouldn't have been anywhere near me. So they actually knew it wasn't a real gun but had decided to play through their status and their roles. Then somebody said, "Oh, it's alright", and they disappeared, but it did change my state of mind to begin the show.

Q. Performing a one-man show must be a very different kind of experience from the site-specific work. Is it difficult to adjust to? Have you done it before?

A. I've very occasionally done it. Had I not found this way of talking in the first part, I think I would have felt much less easy with it, but I must say it never causes me a problem to perform, and that's very rare. I don't get in a state. I think when you're working with autobiographical material, if *you* don't know it, then nobody else can.

Q. Nobody can say you're wrong!

A. Yes, absolutely, there can't be any argument about that. It's interesting, because I've recently been working with a German saxophonist, Peter Brotzmann, who was one of the fathers of the European free jazz movement in the 1960s. He's now fifty-four, but has the brain and energy of a seventeen-year-old. He is now, and I think I can use the word, reduced frequently to solo concerts, to performing by himself and I know from long conversations with him that that is one of the most extraordinarily difficult things to do in the world, touring by yourself, and presenting yourself and actually the whole thing, the concert, being entirely a matter of how you feel on that night, because I think there's a much more direct correlation between him and his playing than there perhaps is between me and the theatre. It's a terribly lonely kind of thing. What's happened in our work together, is that he said to me that he thought I worked like a musician. I think what I'm able to do, when we work as a duo, is to provide a stimulation and a stimulus for him, so he's not playing solo. There are two of us, not one, and I do think the difference between the one and the two is enormous. I've always admired Peter Brotzmann's work tremendously, but I always believe you should write to your heroes. I've done it three times in the past, and it's always come up very well. John Berger was the first, and we did a show, a piece that he wrote, called *Boris is Selling his Horses.* He actually dramatised it in French, and it was performed in France with live animals. Then he provided us with a version which we translated into Welsh. We did it completely in Welsh in a barn in the Welsh Folk Museum with a flock of sheep, a horse, a dog. John Berger was the first, the second was Test Department, and Test Department resulted in *Gododdin.* They provided all the percussion in *Gododdin,* and the third was Brotzmann. I'm still interested in pushing the envelope of theatre. I think experiments with form are the things that I'm most interested in. After I've done a piece of work, I like it to have a limited life, I don't want to perform it, however good or bad it is, for years and years. I wanted to see whether it was possible to discover what the principles of improvisation actually are within the free jazz movement and whether it was possible to transfer, to create an analogy, with what we might be doing when we improvise in theatre, Peter, for instance, has absolutely no concept of rehearsing. If he's playing, he's playing and so rehearsal takes on quite a different kind of a meaning. It's not necessarily getting better and better at a particular sequence, it's actually perhaps finding a new way to do a sequence, and then another new way, and then another new way. So you accumulate a certain amount of information that might or might not be useful in the performance, or when you come in front of an audience, because I know very well that Peter is not creating a hundred percent of the material that he's playing in the moment. There are things in his mind that come back and come back. So that was the

first very interesting thing. The second is that he never plays at less than a hundred percent, because he can't, because his technique is such that, if he did, no sound would come out, and that equally is interesting for improvising. I suppose, then, I had to find the equivalent of his instrument, and the only way I could think about that was to place upon myself a restriction which would confine what I did in the same way that, in one way, the instrument confines, defines, what Peter is doing. We chose to work from, although in no way illustrating, a short story by an Austrian writer, *Der Gefesselte* by Ilse Aichinger. It's about a man who wakes up on a mountain and he's tied up. He spends the whole of the short story tied up, and some people want to untie him and some people just want to gaze at what he manages to do whilst he's tied up. So I decided to be tied up for the whole performance, and what I manage to achieve, or don't achieve, is entirely a function of being tied up. Not everything is possible.

Q. Could we move on now and talk a little about Brith Gof's site-specific work, and its location in Wales? Are you Welsh yourself?

A. No, I'm not. I went to Cardiff to read archeology in 1968, and I think my awareness of the language and the culture really took quite a long time to come, not least through being in the urban south. It wasn't until 1980 that I learned Welsh. At that time I had become very dissatisfied with the direction that the old Cardiff Lab was moving in. I'd also met Lis (Hughes Jones) and, while she herself had a critique of Welshness, we did have a quite a strong desire to begin working outside the urban south and in Welsh. It was at a time when there wasn't an enormous amount of theatrical activity in the Welsh language, or at least what there was was fairly conventional, and that was at a time before the advent of S4C which actually, really, saw the blossoming of television culture, but also the spin-off was that that helped to support theatrical life as well. I feel very at home, but I think coming from a rural background in the east of England I would feel fairly at home in Wales.

Q. Do you find Welsh audiences very different from audiences elsewhere?

A. I think our Welsh audience is quite unique really. It's extremely diverse in age which is always an exciting thing. There are always teenagers, young poeple, but equally sixty, seventy-year-olds. Also, as we did with *Hearn*, the latest big show in Tredegar, we get foreign promoters coming to see the work, and they're completely shocked by the audience as much as anything, because they're not the sort of audiences that they would expect to raise and attract. In Europe, and maybe in England to some extent, you have to work to raise an audience and you can only do it by extreme hype of the work. I think in Wales people come for a variety of reasons. They come out of loyalty to something happening in the Welsh language sometimes. They come because they're supportive of something different happening in Welsh culture, no matter what. I think there's a strong feeling now that people ought to go beyond the traditional model. It was a very convenient one during the seventies and eighties, the idea that everyone was a kind of a refugee from the village to the cities. You were only there for a time before going back. As John Berger said, "It's the great pilgrimage in the twentieth century, from the village to the city", but I think there's a realisation now . . .

Q. That we're here.

A. That we're here, that there's no going back. Difference is more acceptable I think, now, that it was in the seventies when there was a kind of Welsh orthodoxy about things. You felt that Welshness was in the hands of a very small group of people who would decide what it was. It was a non-negotiable thing and now that's clearly not the case. There are a lot of Welsh speakers, particularly in the urban south who know nothing of the parish and their expectations don't lie in performing in the eisteddfod and so on.

Q. Is that one of the reasons why it's important to do the site-specific shows in locations such as disused factories?

A. Yes, I think so. I can't say that we started this work with any particular political intention. It grew out of a desire really to work with Test Department, and to do something fairly big, but I do think, because there are so many rules that you can break in these sites, then an audience, which is perhaps not a theatre audience, feels more able to come. You can actually create the sense of event around one of those things, which is actually impossible within the theatre. Cliff says he thinks one reason is that the theatrical space has been worked over so many times. The stage is like a plot that's been tilled so many times that there's not much else you could do to it, whereas, when you go on to a site, into an empty factory, then a number of things are stripped away. First of all, all the rules about decorum, theatrical decorum in the wider sense, disappear. The kind of devices, techniques you can use are ones which would be totally impossible in a theatre, and illegal.

Q. Fires, for example?

A. Yes, all of that, but we manage to persuade fire officers that we can do it, and I think we really do create a kind of event, a sense of occasion, where the audience is as much a participant as the thing that's happening. Particularly when we work outside Cardiff, I don't want to sound highfalutin, but I think it becomes a kind of cultural manifestation. The idea of doing *Pax* in Aberystwyth railway station terminus, as we did, has a kind of ripple reverberation over and above the actual event itself.

Q. Because of the site in which it happens?

A. Because of the site in which it happens, because so many poeple realise that, my God, you can do that in Aberystwyth. It's not the end of the line. The terminus as a performance site is interesting, because it is 'the end of the line', you can't go any further.

Q. You mentioned Cliff. Is he Brith Gof's set designer?

A. Cliff McLucas, yes, he's our designer. He lives and works in Aberystwyth and has refused to migrate to the south, so that's a big plus. I think he's an important character in some of this reassessment of Welshness. He also has learned Welsh in the way that I have, but he's much more directly involved in lots of ways of manifesting the language. One of his single most important ideas, I think, is that Welsh people, or English people in Wales, actually never see the language manifested big. We don't see bill boards, for example. So the language is not a visual thing, and much of his work revolves around making it a visual thing. He trained as an architect, and in site-specific works, he always works from the building inwards, unlike most theatre design which I think works outwards from the performers. The building's architecture tells him many things that may be invisible to us. The problem can be that, at some very late date, you'll possibly find that something doesn't work, or we can't

afford to make it happen, and the performers then have to readjust what they do, and that's quite awkward.

Q. This takes us back to your earlier point when you were saying you wanted to explore more small-scale, performer-based work?

A. That's true, and whilst we will continue with the architectural, large-scale work because I think that's now one of the recognisable features of our work, that's what people know us for, I have a strong desire now to go back and do a large-scale work, but which is performer-based. I'm currently toying with the idea of the Welsh legends and stories of Arthur.

Q. In Welsh?

A. In Welsh, although, interestingly, we've recently begun to work a with Slovenian composer, a young man from Ljubljana, and we think he's very exciting. His musical mix is often a string quartet and four electric guitars, that sort of combination. Almost certainly, we'll commission him to write the music for this piece. Whether once again, then, we relegate the language to the sung or spoken but amplified level, I don't know. One little experiment that we tried which worked tremendously well, although is fairly expensive, in the last big-scale piece we did was to radio-mike performers.

Q. All of them?

A. Not all of them, just one or two, and I'm simply wondering whether it might be possible to mike a number of performers, so that will enable us to work at scale while still saying something.

Q. Are the big, site-specific pieces devised by a small number of members of the group?

A. It varies, but usually three or four people take responsibility for the individual areas: design, the libretto, (Lis has twice done the libretto), the music and physical action. Whilst we may have a notion about the form of the piece, we actually develop the ideas quite separately and only at a very late date do we manage, not least financially, to draw everything together. Curiously, the one thing that we use is time as a structuring device in all these big pieces. We actually create them with watches, and we may agree that a piece has twelve sections and the basic dynamic of a section is going to be such and such, it will have a certain emotional tenor, and it lasts five minutes thirty seconds. We all know that, and that's what we're working to, but there's almost no way to develop those big performances sequentially step by step and hand in hand in all of the elements. For instance, now, we never, never expect to see the musicians before the dress rehearsal, although we may have tape ideas which are filling in gaps for us to work with.

Q. Do they, then, work with the timing of what you're already doing?

A. Yes, many elements fit together fairly naturally. I think the music and theatre one's not a problem. The one that we have the biggest problem with is the scenographic one, were very often Cliff has aspirations which finally, and at a late date, we can't fulfil, either technically or financially, and that's when the work has to be readjusted, and the performers have to take up the slack – but it keeps it lively!

Q. Apart from your exploration of the Wels;h legends and stories of Arthur, what is your own next project?

A. I'm taking a sabbatical, a period away from the company of about six months, and I decided I would try to write a book.

Q. A book about your own practice?

A. Yes. There's a beautiful book of actors' stories from Kabuki theatre called, I think, *The Actor's Analects*. It's actually just actors' stories and, whilst we may decry, or lament the worst kind of theatrical autobiographies that get written, I think in actor's stories, the things they say, there's actually a hidden level of documentation on theatre. That was one of the ideas I had, just quite personal memoirs of events which nevertheless have a wider significance, and the other is that, as we said earlier, I'm fascinated by the *two* in theatre. I think it's something that hasn't been talked about enough. Almost all acting technique is based on the actor, the actor in front of an audience, very little on one actor and another actor and what's happening *this* way (i.e. actor to actor), as opposed to *that* way (actor to audience). I'm interested in that as well.

Contemporary Theatre Review, 1994, Vol. 2,2 pp. 49–59 © 1994 Harwood Academic Publishers GmbH
Reprints available directly from the publisher
Photocopying permitted by license only

Printed in Malaysia

Demonology: Some Thoughts Towards a Science of Chaos in Recent Performance

Simon Jones

This paper examines some aspects of the application of the sciences of complexity to theatre, specifically recent British performance (1988 to 1991). The operator is *the demon*, used as a device with which to challenge theorizations of performance as text, and as a means of arriving at an "unwritten" pragmatics of creativity in performance. This involves figuring theatre as event-series and flux, and using the new naturalism of the sciences of complexity to redefine the structuration of such series and flows as *characters* of performance.

KEY WORDS Complexity, Self-organization, Recent British Performance Theatre

0.1

What am I doing when I submit myself and these works that have inspired me to writing? The rhetorician looks for a motive. Nothing but the most grand and brutal will do. The overthrow of critique. The exorcism of an awful ghost from the performing machine(s) of my creativity and all those who flee with me. The installation of a demon whose presence accounts for that creativity and empowers it: with a terrible fragility, to scatter on a whim; with a tireless guile, to play the critics at their own game; with a robust versatility, to transform to any shape in response to the encounters with necessity.

The works I have upfront in my mind are:- Howard Barker's *The Bite of the Night* (1988) which describes the journey of a classics teacher from a defunct university through twelve versions of Troy; Samuel Beckett's *Happy Days* (1963) which describes two days in the life of Winnie, as she sinks into the earth; DV8 Physical Theatre's *Dead Dreams of Monochrome Men* (1988) which, based on the life of the serial killer Dennis Nilsen, explored "the heartland of despair" and "societal homophobia"; Forced Entertainment Theatre's *Marina and Lee* (1991) which described the journey of Lee Harvey Oswald's lover Marina between desert and city, her thoughts on life and fragmentary recapitulations of physics and popular culture; and Gloria's *Sarrasine* (1990) which, based on Balzac's short story of a man's love for a castrato and murder at the behest of the singer's protector, recounted the final encounter between a patron Mme de Rochefide and Zambinella the castrato.

This *demon* is taken from the writings of Michel Serres (1982), who develops many characterizations for the workings of the *clinamen* or "inclination", that creates turbulence in laminar flow, noise in information, self-organization out of chaos. The *parasite* is just one guise; and Harari & Bell's introduction succinctly emphasises this demon's profound effects:
 "The parasite violates the system of exchange by taking without returning [an idea Lyotard uses in his description of the libidinal economy, 1993, ch.IV]; it introduces an element of irreversibility, and thus marks the commencement of duration, history, and social organization"(xxviii).

This usurpation arises out of a sense of dissatisfaction with the great leveller *theory* who has lorded it over theatre and invaginated its folds with all the colonizing zest of the capital-war-machine that spawned it. Every event of theatre has been named *text* and drawn into the meta-equation of *textuality*, a labour as endless as it is sad, as hopeless as it is productive. Indeed, theatre *produces*: its events are the products of a process. And if we cannot bring ourselves to admit the finality of the object *the show* (since that draws too much attention to the absurdity of comparing the avant-garde with Fordism), we can at least expend our energies on analysing the *process*. On the face of it a strange process with no end in sight (theatre is never finished, you know). However, that cold chill of proof (textuality requires argument as its entrance fee, artists pathetically, critics rationally) is evidence of the spectral product that secretly haunts every criticism; that, in the company of artists or critics, ushers in respectful silence. These two categories of persons dissolve; and readerly and writerly texts (or activities) commingle. Difference which keeps the whole business afloat turns out to be just a little bit more of the same. Vary the phrase, says the rhetorician.

Which is maybe why I come to this writing gloomily, since how can I escape this theatre of critique? Performance since Beckett has been obsessed with probing the limits of the theatre of representation and its pushy sibling critique, via polysemic assaults on interpretation or rigorous deconstructions of various conventions such as character or passion. And yet it seems inevitable that the flux of creativity, the great libidinal band over which all the theatre events I have ever encountered traverse and incandesce, must succumb to the gross theatricalization of critique: to be dressed up, put on stage, part in hand, made to play the one against the other, as if there were a *one* who could ever have an *other*, in a dialogue that seems more or less *nat–ural* to the assembled audience in the know. If I fancy myself dancing on the rim of any abyss, this one is clearly predicated on lack, and will draw me into its blackhole of this/that always-alreadyism, nullifying literally everything. What satisfaction I take from this theatre is bought at the expense of living in terror and pledging obedience to the god *logos*.

"Open the so-called body and spread out all its surfaces." Thus Jean-François Lyotard's *Libidinal Economy* (1993) begins its speculation into the bodies of capital and the libido, opening all organs out into a great skin, a surface with only one side, a Moebius band.

The *tensor* is Lyotard's attempt to escape critique, to "remain as faithful as possible to the incompossible intensities informing and exceeding the sign" (1993: xiv). Tensors rotate with such furious intensity, that limits are pulverized, the sign becomes plastic, behaves figurally, denies significance, glows white hot in the indeterminacy of its compossible effects and relations. In my writing, they provide an exciting model for the dynamic forces that constitute the theatre event, a means of approaching agency without recourse to discourse or subjectivity.

When the libidinal band cools, what Lyotard calls the *bar* begins to twist it, to fold it up into a volume, *a theatre*, in which signs can be assigned and signification can begin. This stabilization *capitalizes* the band; terms are traded; meanings are arrived at; spaces policed; power comes on the scene. In this sense, the theatre events I cite are outside-theatre, only crashing through the foyers, lobbies and stalls, wreaking havoc on the stage of this theatre of representation, either to destabilize its immanent philosophies, or to steal fragments of its narratives for unintended and more complex purposes. They are close to the theatre of "perverse practices", promoted by Foucault, "in which blind gestures signal to each other" (1977: 192/6).

There always remains something. (Pause.) *Of everything.* (Pause.) *Some remains.* (Pause.) . . . *Just chance, I take it, happy chance* (Beckett 1963: 39).

0.2

Says Winnie. Now imagine, what if that were true. What if the sign, the text, the nev-erending juggling of terms, the whole ac-tivity of reading from whatever spectatorial position one cared to elaborate, were not enough? Of course, along its chain of deferral/ence nothing ever is enough. But in the sense, were not up to the job of express-ing the event-situation? What then? I'm perturbed.

Perturbation is a crucial phenomenon if we are to avoid the snares of nihilism. It describes the "communication" possible between differ-ently organized levels of any system without reducing that "commu-nication" to a unified field of discourse, since this would then open it up to textualization, with all that follows. In theoretical biology, the environment can be understood as a "non-instructive" perturbation triggering, but not determining transformation in the organism (Paulson 1988: 122). Josué Harari and David Bell see a system's integration of a perturbation as "the condition of possibility of the system", passing from a simple to a more complex stage (Serres 1982: xxvi). Noise, in the information theory sense, is creative (Monod 1972: 106). Prigogine & Stengers' definition of "dissipative struc-tures" – increasingly complex forms of self-organization – *depends* on the interaction of the system with the outside world at a macroscopic level: such structures are "essentially a reflection of the global situation of nonequilibrium producing them" (1984: 143). This creative "communication" occurs also at the molecular level, in phenomena such as chemical clocks, where matter in far-from-equilibrium conditions "perceives" differences in the outside world (14). In a marvellous transport of mythology, information theory, psychoanalysis and thermodynamics, Serres metamorphoses "molec-ular chaos", via many levels of perturbations, into Freud's Eros and Thanatos, in other words – negentropy and entropy: "What remains unknown and unconscious is, at the chain's furthermost limit, the din of energy transformations" (Serres 1982: 80). This unassignable and unspeakable "communication" is the demon at work.

Consider *Sarrasine. After a quarter of an hour the ancient Zambinella* (Bette Bourne) *shuffles out of the darkness to the edges of the stage. S/he sighes: a viola picks up the sound and carries it into a refrain. S/he screams at the sight of Mme de Rochefide* (Leah Hausman). *The promised perfect voice is no more than incoherent sounds, half-laughs. When s/he sings, the performer mouths and an oboe sounds. A scream from a voice on–stage becomes a scale on an instrument becomes a scale from a voice off–stage. The young Zambinella* (Francois Testory) *appears to "ex-change" scales with the instrument. A third Zambinella* (Beverley Klein) *enters gargling, singing fragmented scales, asks the band for the chord. All three Zambinellas sing together with the full band.*

Indeed, what draws me to the works is their refusal to join in *the* dance, their refusal to be stabilized as *text*, to be dragged back into the theatre of rep-resentation, in order to be reinscribed into the negative as penance or payment by the

"Singing or composing, painting, writing have no other aim: to unleash these becomings. Especially music; music is traversed by a becoming-woman" (Deleuze & Guattari 1988: 272). This event-series was undoubtedly *theatre*. There was even a rousing chorus to round off the scene. But what was happening? Perturbations between different levels of the system. The oboe did not communicate with the voice: the sonority of the one was not commensurate with that of the other. To have arrived at a conversation, we would have had to have translated both into a discourse on the pathetic. And yet since these sonorities were not constructed as languages, they could not be transposed, except by conventionalized reductions, to an agreed set of terms from which readings could have been produced. In Lyotard's use of the word, there was no *theatre*: the libidinal band continued to

dullest, most moribund of critics. All these works refuse (the spectre of) absence with their presence, refuse the reduction of speech to writing, of experience to reading.

If theory thought it had folded up the volume of its theatre so neatly, that every term would endlessly oscillate to order between its opposites, and every presence would remorselessly collapse under the dominance of its doppel-gänger absence, then these works give it the lie. Now this critique-game is not produced by the academy to train an administrative élite (though it serves that function), but is one of the processes of capitalization underway across all fields of production and knowledge. As such, the resistance embodied in these performance works is neither comfortable nor easy, is always political and implicated in the decisive events of their participants' lives. What remains when all has been written is this resistance, this refusal.

unfold; and the oboe and the voice behaved as a tensor across its surface, a compossible relation of sounds, refusing to be folded up into a theatrical volume, to stabilize as a sign signifying anything or even as an oscillating set of signs signifying perpetually deferred difference.

But what of the contexts between which this event-series passed? On the one hand, Mme de Rochefide's narration, densely packed with concepts – the original and the copy, the castration and the money, the lack and the perfection. On the other hand, the cabaret conventions – the entrance, the torchsong, the passion, the climax, the dresses. Surely the attraction of these narratives was powerful enough to stabilize the tensor *oboe–voice*, collapse the phase-space of the compossible into the one or the other, the profound or the pathetic, both meaning the meaningful? Translate a perturbation into a dialogue? Only if we had ever allowed or were even able to experience the whole system of the theatre event at one simple level, where all terms could have been negotiated and appropriate equations resolved, namely the level of text. But those perturbations occured in a state far from equilibrium. There the system of each individual occupied an unstable position – or more accurately, was hurtling along an unpredictable trajectory – on any number of the many levels enfolding, unfolding, manifolding within the much larger and more complex system of the theatre event as a whole. If we consider the perturbations between individuals as happening on a macroscopic scale, then the tensor *oboe–voice* simultaneously perturbed microscopically, resisting stabilization on those levels too. What rescues this tensor, this concatenation of sonorities, concepts, conventions, spaces and times, from the great collapse into dialogue, into textuality; indeed, what sustains the perturbations and allows for their communications without language or channels, are intensity and speed. This creates what Lyotard calls an "unthinkable cohabitation of the regulator and degulation in the same signs" (1993: 144): the tensor-sign coded *and* unassignable.

So, the effects of this particular event-series were incomparable, are still realized today wherever the particular perturbations created by that tensor stabilize into signifiers, into beliefs, into courses of action. The energy for these realizations, their *character* is in the far-from-equilibriumness of the tensor, *its undecidability*: like Schrödinger's cat, both alive and dead, until you open the box to find out which (Powers 1982: 148). As Serres would point out, the *oboe–voice* would generate, in whatever systems it perturbed, levels of complexity that would be unpredictable in their natures.

Now I am dared by my worser self to go on and describe this outside-thought, this theatre of exteriority. To do that is to name the demon; to begin to characterize its activities in the field of performance; to make a science, that is – a knowledge, tested, systematized and brought under general principles. And yet quantum mechanics has shown that measurement is not neutral, without consequences for the system observed. My remarks mark; and in marking the demon, it evaporates on me in the very instance of its compliance, its coherence with *my* theories, as the electron, virtually both particle *and* wave, becomes one *or* the other at the moment the experiment is made. So, if I have to collapse into rhetoric, the essence of the demon evades me. This is going to be a strange description: an oscillation between a virtual demon and the relics and traces of its passage(s). Let me enumerate; and in this list move alongside and between these theatre events (aka products) and their event-series (aka processes).

1.1

the body as site, as event-series is *the* battleground *and/or* paradise in performance, the place of voluminous overdetermination where Nietzsche's "ontological pluralism" (Allison 1988: 191) finds its paradigm. Indeed, in order not to be overwhelmed by the din of transformations of bodies, such that the energies of performance become equivalent to its production of entropy (resulting in performance's literal disappearance into everyday life), the first task of the demon is to *characterize* the formations of its bodies. And at this particualar political constellation, the character of the body is constituted by three dancing tensors. These can be staged as questions: to reproduce or to die; to appear or to disappear; to surface or to dive?

The Body in performance is used in the sense of Deleuze & Guattari's *body without organs*: "the unproductive, the sterile, the unengendered, the unconsumable" (1984: 8), theorized as an "amorphous, undifferentiated fluid" (9), but realized imperfectly and necessarily at a certain place and time, as a connective synthesis of production and antiproduction. Remember Lyotard's "cohabitation".

The second law of thermodynamics requires that any given system "lose" useful energy to entropy, to the point at which the activity of the system equals its noise. Then the system disorganizes, dies. The system can only maintain its organization through negative entropy, negentropy, ie. by decreasing noise inside and consequently increasing it outside itself. As most systems are not closed from, but interactive with their environments, negentropy can only be achieved by transforming noise into more complex organizations (see Paulson 1988). Systems resist entropy, but agree with the second law, by using noise (another mask of the demon) to self-organize contingently, locally and temporarily. Islands of increasingly complex order in an ocean of increasing chaos. The energies and activities of a theatre event can be understood as such a self-organization.

These questions of the body are unpredictably inflected by each particular theatre event. They are also the inevitable expressions, or rather – the necessary compossible events of capitalizations happening, however distantly, on the libidinal band. This is not backdoor determinism. To make up chains of cause and effect would be crass; and what is worse, would close up that work into the deadliest of theatres, that of proof. However,

Take the DV8-body. Its character was the liminal: thresholds of pain and pleasure; the skin as surface, the anus as entrance to the other; the other as mirror, the gaze as terror; the dissolution of the one into the other, irreconcilable subjectivity. Water and walls, mirrors and gravity were characterisitcs of this body. To rupture was the characteristic of its expression: a birth from water, a climbing-up walls, becoming-child, becoming-insect; a death in a kiss, two mouth-anuses dissolving.

the desire to explain away the effects, emissions and enunciations of (say) the DV8-bodies marks not only paranoid knowledge at work; but also the destabilizing potentiality of these events across both the fields of micropolitics (some of the audience must have been straight, you know) and of macropolitics (a revised version was transmitted nationwide on ITV's *South Bank Show* in 1990, much to the *Sun* newspaper's "disgust").

Even the culture of game danced on the rim of the sincere: whose life is it anyway? Newson-Nilsen, art-life. Can you be serious? Laugh in its face, as Deleuze and Lyotard constantly require us to do. Eye to eye, eyeballing, literal interface: if we were not there, face to face, at all those thresholds simultaneously, looking through from both sides simultaneously, then we were nowhere, we were not of that body.

1.2

To reproduce or to die? Bodies without families at the very least challenge patriarchy. What's more, in the celebration of their singularities (not the same as celebrating difference), they call into question reproduction as the teleologic function of capital and thence being, from which we may be allowed by our masters in moments of perversion to differ blissfully. Singularities cannot have families, though they may be parts of constellations. What effects they have are not predictable, and so not reproducible, and so not assignable to any enclosed and policed field of activity, except, of course, after the event. Their histories are not ones of accretion, supplanting discontinuity with the family tree; but they burn intensively with idiosyncratic once-and-for-allness. Succession, which stills time and reduces all times to the same time, the familial cycle, is subverted or dodged or ignored or put at a distance by each singularity's quantum of time. Deleuze & Guattari call this "the capture of a fragment of the code, and not the reproduction of an image" (1986: 14).

"Mimesis closes the theoretical text up as a power of statements. The model is what makes and remakes, makes in conformity to the made: that is power" (Lyotard 1993: 250).

These quanta of histories are aphoristic: "a play of forces, the most recent of which ... is always *the most exterior*" (*Allison 1988: 145*).

The works burn with aphorisms.
 "I deny the body exists except within the compass of another's arms," *The Bite of the Night*, 89.
 "There are times without apparent motive or meaning. And there should be more of them," *Marina and Lee*.
 And, of course, Winnie forgets most of hers: "What is that wonderful line? *(Lips.)* Oh fleeting joys – *(Lips.)* – oh something lasting woes," *Happy Days*, 13.

They are attracted to proper names, whose nomadic intensities designate each singular body.

"What delirium can accumulate under only one name" (Lyotard 1993: 57). Set this against Barthes writing around Balzac's short story: "What is obsolescent in today's novel is not the novelistic, it is the character; what can no longer be written is the Proper Name" (1990: 95). All the works cited are attracted to this problematic of the proper name. Each is coursed through with their own particular tensor-sign.

Each body dies, in the sense that it deterritorializes, avoids capitalization, theatricalization, disappears from one region of the band, instanteously to reappear in another form in another distant zone.

In *Sarrasine*, the *Sarrasine–Zambinella* tensor was invested with so much energy from all regions of the libidinal band, it sang out in splendid isolation, yet was instanteously connected at all points to all other flows. And the mouths through which it sang: a constellation of three Zambinellas, riven with furiously oscillating binaries, each independently connected to different combinations of flows: man/woman, boy/man, old/young, soprano/tenor, real/fake, beauty/money, and on and on. A many-bodied system, the dynamic expression of which, even if it could be drawn into an equation, would be non-linear and therefore indeterminable (see Prigogine & Stengers' discussion of the "3-body problem" in dynamics, 1984: 72). The one proper name Zambinella multiply embodied, present in the play of many languages/tongues: the other name Sarrasine absent, uncertainly recreated by Mme de Rochefide. The intensity of this tensor disorganized everything it passed over, produced delirious transformations at unpredictable points.

The body cannot be exchanged or spent except exorbitantly, as if each transaction were incomparable, a refutation of the founding principle of use-value.

Now ask the person leaving the theatre, what it meant to them. In answering, in coming to terms, they disorganize, scatter themselves, provoking anger or delight.

Consider Helen in *The Bite of the Night*, whose limbs are hacked off in a series of exploration-punishments. The authority for these acts is fluid, moving amongst various groupings who combine ideological and martial forces. The processes are arbitrary, forgotten and unrepeated. The outcomes comic and horrific. A revenge, but since no one in the play espouses causality (except as a means of duping the stupid) – for what? "What part then! What joint or knuckle, what pared-down, shredded particle would serve to be the point at which your love would say stop, **Essential Helen?**" (48) Again the proper name rotates crazily across the play of concepts, emotions and actions. It reconnects them up and wrecks their own binary arrangements. At every instance on the band, it redeploys the terms and transforms the perspective of Helen. Neither name nor performer, sign nor subject: proper only to a virtual Helen, who is no other Helen and remains irreducible to any other term.

Then there are the tensors *Willie-Winnie* and *Lee-Marina*, whose properties are negative; who unfold dispersing absences in the intensification of their presences; absurdly quickening carcases or ghosts (phallus-happiness, history-anonymity); dispersing our senses of the subject in the instances of its realizations. Look at the names Barker gives his soldier-thugs: Barry, Brian, and Les. They empty out when they resonate with *the* name Helen. They implode with the excessive energy of all the horrors attracted to them, literally committed in their names. So, a negative virtual Name comes into becoming on the other side of its event-horizon: an obviously-there sliding into an ought-to-be-there. The proper name seems to bring us back to a place where a subject ought to have been, a place occupied by a tensor actively disorganizing every formation of that subject.

That's right, Willie, look at me. (Pause.) *Feast your old eyes, Willie.* (Pause.) *Does anything remain?* (Pause.) *Any remains? . . . You are still recognizable, in a way* (Beckett 1963: 46).

1.3

To appear or to disappear? The body on stage, the body off. Performance has presided over the dissolution of the transparent into the apparent into the aberrant into the absent. How can

Both *Dead Dreams* and *Sarrasine* intensified gazes into a spectacle of cruelty. Temporal in character in the one, as the performers stripped in stages to their underpants and a man in a bath disintegrated into migrating limbs. Spatial in the other, as faces and breasts moved in and out of the limelight, and dresses and cloaks rose and fell

we approach the characteristics of this declension into invisibility? What is present is so fragile, it powders to the touch of the gaze. We don't believe our own eyes, because ideology insists on rewriting experience on its own terms. The focus is pulled to the plane of the lens itself, as Barthes points out: "Ultimately, the narrative has no *object*: the narrative concerns only itself: *the narrative tells itself*" (1990: 213). However, within this reductionism of Baudrillardian dimensions, there is a kind of reappearance. What Lyotard calls a *theatrics of masks without faces* (1993: 259), where "the *skin* of the medium and its marks is effaced" (244). Here appearance is released from cause and becomes pure effect, hides no origin, nor collapses at its loss. As the neon sign on the set of *Marina and Lee* orders

across disintegrating surfaces. But ideological in both, as the organization of genders and sexualities was pulverized by the violent effects of these appearings and disappearings.

And all the time, the gazed-upon gazed back, doubling the intensities. Now you see it, now you don't, what was it? is it? Constantly creating Serres' *third man* – the parasitic observer who disrupts exchange. This provoked more complex self-organizations of the theatre event, as the observer was obliged to organize the effects of this gaze-tensor in order to avoid the system being overwhelmed by the energy emitted. These observations could only take place from a more complex level; indeed, they provide the structuration, the character of that level. And so, the demon-observer necessarily and spontaneously, though unpredictably, comes into being in the theatre event to characterize its disorganization with more complex forms of order. This itself becomes a destabilizing tensor for yet-undreamt-of levels of the theatre system (see Paulson 1988: 48).

Look no further – this is it.

1.4

To surface or to dive? Is the body of performance merely a site of inscription, "traced by language and dissolved by ideas" (Foucault 1970)? Are the holes, the depths, the organs, really an enfolded surface? The great origami of the labyrinthine libidinal band? Where signs link up in endless chains of repressed meanings, lost chances, or hopelessly rigid and reductive binaries and causalties; segment time through dialectics, digitalize it, determine every state and glimpse every end in every beginning. From this superficiality and despair Lyotard rescues signs by turning them into "masses of energy", that move ever closer to "the greatest possible displaceability" (Lyotard 1993: 237). They acquire a kind of depth without volume, or at least a capacity to perturb the sign as it slows and stabilizes to the point of being a signifier. Under the skin of a surface without depth, these are *figures* whose passage is intolerable and disorganizing (see Bennington 1988). Inimical to thought, which must organize upon the surface of the body, they produce a delirium with virtual dimensions, somewhere between the skin and the non-existent deep. The disruptivenss of this figure arises out of its mobility, its plasticity, its noisey and profligate emissions, that perturb the senses and refuse significance.

2.1

the hermaphrodite has two thoughts run alongside its mixed body. Firstly, Serres' investigation of the myth compounds the entropic drive towards

Consider *Sarrasine*. Becoming-woman agitated the play of binaries, man/woman masculine/feminine sex/dress, so that lack disintegrated and microfemininities were freed from original sin throughout the entire system. Sexualities collapsed into becoming-woman. And, never

death in the god Hermes, with the goddess Aphrodite's personification of "la belle noiseuse", the *clinamen* provoking complexity (Hayles 1991: 292). And secondly, Deleuze & Guattari's series of becomings course through sexuality: becoming-animal becoming-child becoming-woman becoming-imperceptible: "these are like *n* sexes, an entire war machine through which love passes" (1988: 278). Both work at the molecular level, move away from the superficial and recognizable, towards the imperceptible and singular. Flight from the patriarchal binaryism of sexuality, which terrorizes the body on a macroscopic scale, is the demon at work dis/organizing not only sex, but all systems. Not surprising then, the hermaphrodite embraces the twinned drives of death and sex: a complicating rush through reproduction towards the molecularized, multi-connected batchelor singularity, that synthesizes totally with the band (Deleuze & Guattari 1986: 71). A microfemininity becoming-imperceptible, creating in its wake the multi-sexualities of ever new polymorphous forms.

2.2

So, the hermaphrodite characterizes all performance, mixing bodies and confounding sexualities, hiding microfemininities in the smallest of events, right under the noses/ red pens of the censors of theatrical representation. The drag act rightfully takes place centrestage, usurping the Barthesian stripper. When the dress drops down, in the epiphany, a shimmering body dazzles: but whose? and what kind? All our cultural fears are met in this body that cannot be determined, that emits particles of becoming-woman, disorganizing and complicating. No wonder critics are required by

forget Hermes. The male, masculinity, the man, released from his binary role, became object: "Can you see me now?" (the young Zambinella literally un*dress*ing). But not in opposition, a tedious role-reversal, not even as a taunt to heteros. Object in his own right *and* as intensifier of becoming-woman. Leaving Hermes with death, with the desire to arrive, to end. So, the co-animator serialized the system *Sarrasine* with payments, finalés, encores, uncoverings, stompings-off and, of course, a stage-murder. The mixed bodies poured this character through the system; and micropolitically, genitals and subjects became anonymous and mobile, the demon tangible.

In *Marina and Lee*, this tensor was actualized at a distance. The part-objects of the mixed body deployed together to make an intensified *vicinity* of distance. Marina as Lee, cowboy hat, makeup beard, strap-on dildo. The men in black dresses, terrorist hoods, cowboy hats. Both attracted to becoming-woman; but arrested by the breaks in scenes, in music, by segmenting time in repetition and reminiscence and clocking watches. This was a furious becoming-imperceptible, because always leaving the hermaphrodite, surrounded by the fetishes of its production. An angry leave-taking, systaltic and defibrillated, incapacitated and debilitating. At the suspended moment, the event-horizon of the sundering of the mixed body, the figures of Eros and Thanatos burnt brightest.

It's a cheap show with little to enjoy in it. Two men and two women do some things, and Lee talks too slowly. I walk back and forth (Marina).

How did *Dead Dreams*, with its events of violence, its stiflings, escape the sterile theatre of the phallus? How could it have avoided being taken seriously? Being slowed right down and folded up into representation? Where was the molecular woman? Partly in objectification. It had been Andy Warhol who had realized in "his " films the necessary twin of becoming-woman: the male fuck-object. A passivity and surrender so total, it always escaped its on-lookers, penetrators, speculators. A beauty that dazzled, exorbitant and unexpendable, that led the system out of binary terror, that opened out effortlessly on the libidinal band, so that the anus-genital-mouth tensor spread across the entire surface. Another line of flight was multiple becomings, each virtually a becoming-woman. The insect-dancer underwater-on-the-wall-dancer animal-dancer child-dancer. Murderer becoming-victim *and* victim becoming-murderer. Through time, not cancelling one another out, but attracting

their masters to wrap it up in writing, to theatricalize it, to push this presence off stage, to marginalize it. No, this body is not *nude*, it is *naked*. All drag is naked; and all performance thrills to its unfathomable lucidity.

particles of each other, always approaching becoming-woman. So that sterility and its uncomfortable bedfellow reproduction were both disorganized: the system simply required greater complexity, the band further extension. The demon hermaphrodite at play.

They get the binoculars out and they think if they look close enough (Zambinella).

3.1

nature is at stake. I leave off this writing at a conceptual synthesis of two trajectories: physics and metaphysics. Both arrive at a dynamic nature, provoked by molecular and imperceptible chaos, into profligate and unpredictable becomings. Both wrench this ontological pluralism from any causality. Both disintegrate the Newtonian theatre of reversible events, *a fiction and its critique*; and transform *space* back into *time*; figure nature as a headlong flight towards the compossible twins of greater complexity and death. Some of the encounters of this journey are theatre events; and the mythologizing of that particular itinerary an on-going task of this writing. The demon puts obstacles in our way; and the energy of our flight will not allow us to stop, to freeze time, spatialize it, but requires us to choose a path, to transgress the bifurcation threshold, to become. For every series of becomings called theatre events, there is a *fractal character*. A nature, which can only be thought about when we put time back into performance, when we unfold the volume of the theatre of writing into a fluid constellation on the libidinal band. This dynamic must be the task of another writing-quantum.

In discussing the challenge to science by quantum mechanics and thermodynamics, Prigogine & Stengers claim that "we are heading toward a new synthesis, a new naturalism"(1984: 22).

Consider the marvellous series that characterize the Barkeresque journey: the seven principles of New Troy, the twelve Troys, seven Lears, ten Possibilities, eight Parables of *The Last Supper*. Or the three days and nights of *Marina and Lee*. Or, of course, the two days of *Happy Days*. Or DV8's serial–killer.

These thoughts have run alongside the cited works and excited those regions of the band. What effects? I can only speak for myself; and for me the gloom is lifted. By disinterring performance from the however-supersubtle theatre of critique, and folding it back into nature, I have found again the demon of its creativity. This demon is more passionate and politically radical than any rigorously constructed and determined subject could ever be. Its relation to every particle of experience is fundamentally intimate; and its effect upon experience remorselessly disorganizing and complicating, objectively creative. Its force is primitive; and its investment across the band, in every nuance and imperceptible emission of performance, is total and totally local. The demon is inhuman, terrible, indomitable. By running alongside its characterizations of

theatre events, by connecting them to other constellations and series of events, we can better understand, share in, and shape that creative power.

Jean Granier talks of Nietzsche dehumanizing nature and naturalizing man (Allison 1988: 198). Let us then work with our own beloved demon.

Detheatricalize nature: naturalize theatre!

Contemporary Theatre Review, 1994, Vol. 2,2 pp. 61–72 © 1994 Harwood Academic Publishers GmbH
Reprints available directly from the publisher
Photocopying permitted by license only

Station House Opera: *The Oracle*

Julian Maynard Smith

A description of the performance THE ORACLE by Station House Opera, presented during the Heatwave festival at the Serpentine Gallery, June 1993.

THE ORACLE is a site-specific installation of stainless steel and plastic pipes loosely fitted together, in the form of a pipeline 30m long. Sound, both language and electronic noises, is propagated down the pipeline from various sources within it. The pipes are also used as speaking tubes by the performers who exchange information and instructions for continuing their actions. Control is maintained while the pipes remain connected; when a performer's movement fractures them stability is lost. The sounds within the pipeline are released, but simultaneously isolated. The pipeline disintegrates, leading to a moment of exuberant freedom. Eventually, the same problems return, but without the same material of the physical world to lean on.

The documentation covers the intended actions comprising the piece, and not interpretive questions of performance style. Technical details are missing, as is the notation of the sound. Otherwise, it contains all substantive information necessary for a restaging of the piece.

KEY WORDS Documentation, Station House Opera, Live Art/Performance, Installation.

performed at 'Heatwave' The Serpentine Gallery, London, June 1993 with

A: Julian Maynard Smith
B: Kirsty Alexander
C: **Sue Hart**
D: Bruce Gilohrist
E: Mole Wetherall

The gods were animals who sat on thrones, and told the people what to do. When the conquistadors arrived, the people went as usual to their gods, but for an answer all they heard was noise. Later, when they went there again, they found thrones empty, and the gods gone.

The Material

The set consists of sections of pipe of two kinds. The stainless steel pipe is a twin-walled flue type (Selkirk SM) with external diameters of 650 mm, 400 mm and 175 mm, in lengths of up to one metre and angles up to 45 degrees. These are sometimes fixed together to form larger, permanent elements, but usually they are joined by clips which may be flicked open with the fingers.

The plastic pipe is grey waste pipe (Polypipe System 2000) with a diameter of 2 inches, which has been cut to standard sizes. Designed to be glued into the fittings, this pipe is just pushed together, and so may fall or be pulled apart, to be reassembled or plundered for other purposes.

The Set

The sections of steel pipe are fitted together to form an irregular pipeline, which begins as a colonnade in front of the gallery building, descends to the ground,

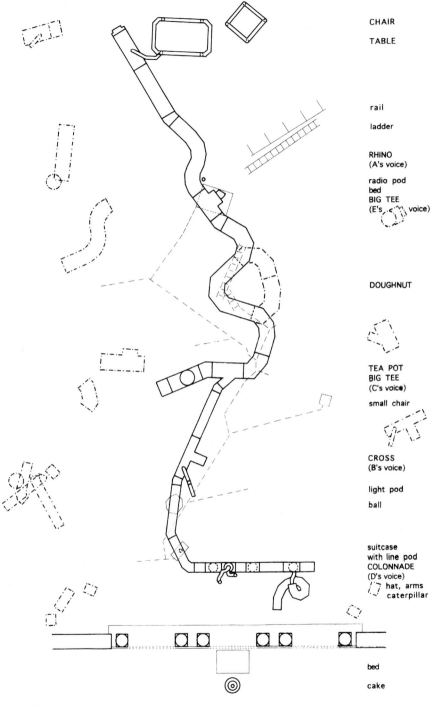

CHAIR

TABLE

rail

ladder

RHINO
(A's voice)

radio pod
bed
BIG TEE
(E's voice)

DOUGHNUT

TEA POT
BIG TEE
(C's voice)

small chair

CROSS
(B's voice)

light pod

ball

suitcase
with line pod
COLONNADE
(D's voice)
hat, arms
caterpillar

bed

cake

Plan

supported by a suitcase and a ball made from parts of smaller grey plastic waste pipe, and leads off into the park. It negotiates the contours of the ground, and in one place rises to go over a bed made from the same plastic pipe. The end of the pipeline is connected via a spur to a giant table and chair made from the same steel pipe. Inside the pipeline are located six sound sources (some mobile, some controlled from the desk), lights, a smoke machine and a fan.

The suitcase and bed are linked by a subsidary network of plastic pipes, which also includes a chair and sections of a ladder. At various points this network small horns or trumpets sprout upwards. One end of this network is plumbed into the Line Pod inside the suitcase, the other into the Radio Pod, which is standing near the bed.

The Pre-set

The steel pipeline is full of white noise. This originates from a VCS3 noise generator placed in the main area, which is operated by the performers. The end of the pipeline is open, there is also an opening by the bed; otherwise the orifices are closed. The pipeline is also full of smoke, which slowly drifts out from the end. With the ear close, music can be heard coming from the plastic trumpets. It is Victor Sylvester.

The Telephone

Performer C places a cap on the end of the pipeline, reducing the sound. The sound is cut. Performers A and B enter. They speak to each other through a tube at each end of which is a headset made of plastic pipe.

Each performer attempts to describe what they do, and attempts to do what they hear the other describe. If they do not hear the other's voice they are free to instigate action, which they describe as they do it. However, there is an assumed need to be in touch. If they think they are not being heard, or that they cannot hear the other, they make clicking sounds with their tongues, until they can hear the other again.

Back to back, initially they walk from each other. The speaking tube unfolds like a concertina. However, as they move the pipe is likely to come apart. Performer C, the plumber, reconnects any breaks in the pipe, adding in new parts as necessary. The telephonists get further and further apart. They also assume different positions despite their communication, which serves only to make their predicament more difficult to resolve. (A performer who falls over may describe this event as a turn about a horizontal axis of 90 degrees, which may not be interpreted as falling over by the other. Once in different positions the other's description may be impossible to follow, leading to a failed version of that description's enaction being transmitted back.)

The language used is neutral description, without redeeming poetic qualities. It is private; not intentionally heard by the audience. It is not rehearsed, but functional. The beginning actions may be agreed though rarely accomplished. The task is to express the nature of this system by articulating the successes and especially the failures in the mind of the audience.

Into sight staggers performer D, carrying performer E on a plastic pipe chair. D shouts down a mouthpiece leading into this chair, asking for guidance. His voice

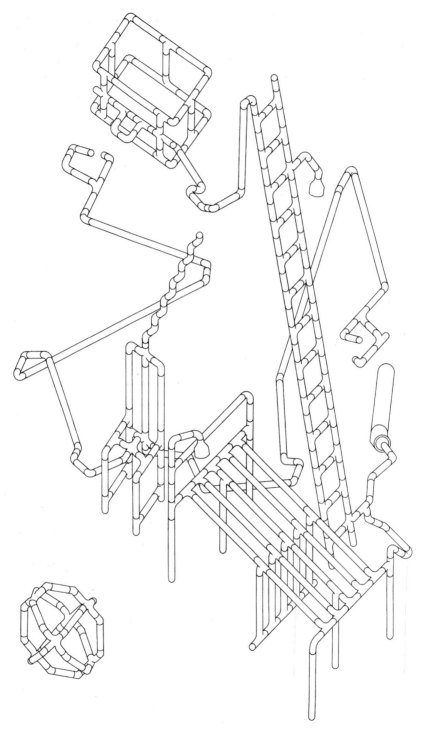

The Plastic Pipe

emerges from a trumpet on the the top of the chair. E points – as though D can see him pointing. D puts E down on his chair between A and B. C plumbs the chair into the pipe between them. E has an ear piece which allows him to evesdrop on their conversation, and a mouthpiece which is connected to a radio transmitter. D picks up the radio pod which emits E's voice, and walks near the audience, which now hears E's version of the mixture of A and B's voices that he hears, describing their actions. Even to E they are often indistinct, confused and contradictory.

The Ladder

The telephone ends when B achieves her end position at the chosen location, holding the handset of the speaking tube vertically in front of her. She is disconnected. D fetches a section of a pipe ladder containing three rungs, and fits it under B's handset. C plumbs the radio pod into the bottom of the ladder. D returns with the top section of the ladder, containing nine more rungs and a trumpet, and fits it onto the top of the handset.

D holds the complete ladder for B to climb. From the ladder comes a scratchy recording of Caruso singing the aria from Act 2 of *Die Koningen von Saba* by K. Goldmark. E pulls his chair and associated plumbing away from the area. B climbs. The ladder creaks and bends backward. She climbs until she is standing above D, who staggers under the weight, and his head goes through the ladder. D slowly collapses onto the ground, with the ladder and B on top of him. The sound of Caruso swells as it is diverted to the 18″ speaker. C removes the lid on the end of the pipeline, swelling it further. Smoke and light emerge from the hole. A stands and walks to the tee-junction by the 18″ speaker and removes its lid. Light and smoke emerge as the music swells to its loudest.

The Rail

The song comes to its end. C and E have prepared pipe trumpets, with which to speak to B and D. E is sitting on his chair. They give instructions whose aim is to cause B and D to stand, pick up the ladder, and hold it horizontally between them. The instructions are limited to movements of single joints or limbs. This language is heard directly by the audience.

A walks to the 12″ speaker at the end of the pipeline. It begins to play D's tape. He goes to the mobile horn unit, and turns on B's tape. He goes to the open tee by the 18″ speaker and climbs in it, sliding the lid back on from inside. The 18″ speaker begins to play C's tape. A crawls through the pipeline, pushing sections of the legs of the rail before him. As he passes through the doughnut, the horn speaker there begins to play the Fly tape. At the tee-junction on the bed he turns on the tape-recorder. playing E's tape. In the rhino horn, he turns on the tape-recorder playing his own tape. He continues down the pipeline, pushes the legs of the rail out of the end of the pipeline and emerges from the smoke.

TEXT: she was kneeling on the floor/driving along in the middle of nowhere/**somebody called out to her**/because/two of them/there was nothing to worry about/SO, SO we went back/**and she turned**/because they couldn't decide how/and licked it up/so they, they both looked up/driving along in the middle of nowhere/**she was walking down**/because/ignoring each other completely, and then/there was nothing to

The Rail

The Dismantling

Photos: Bob van Dantzig

worry about/Jesus on the Cross/**somebody called out to her**/the house never got built/ignoring each other completely, and then/she was kneeling on the floor/SO, SO we went back/**she was walking down**/because they couldn't decide how/two of them/so, so they both looked up/Jesus on the Cross/**somebody called out to her**/the house never got built/and licked it up. . .

B and D are now carrying the ladder. A assembles a rail leg and approaches the end of the ladder furthest from the pipeline, occupied by D. He knocks down some of the lower side of the ladder, and inserts the leg into the socket of the end rung. He fetches another leg, and knocking down more of the ladder's lower side, inserts the leg into the socket of the fourth rung. E keeps D moving forward just ahead of A. A repeats this at the 7th, 10th and 13th rungs. The entire lower part of the ladder now lies on the ground, and D and B stand at the end of the rail.

Lies

D walks past B to the pipeline, describing himself doing something that he is not. E describes what he is doing. B walks to the end section of the pipeline, unclips it and drags it away, and as she does so describes herself doing something that she is not. C describes what she is doing. D walks to the next piece of pipeline, unclips it and drags it away, and as he does so describes himself doing something that he is not. C describes what he is doing. And so on.

The Dismantling

The tapes begin to play longer extracts:

because they
couldn't decide
how the light
should get in

she was kneeling

on the floor with
 I, I thought
her head in the oven
 I saw a dead
so she took her head
 body lying by the
out of the oven
 side of the road

somebody
 towards me
called out to her

because they
couldn't decide
how the light
 she was kneeling
should get in
 on the floor with

 her head in the oven

 so she took her head

 out of the oven
I, I though

I saw a dead
 towards me
body lying by the
 and peed, and formed
side of the road
 this great lake of piss
somebody

The Pause

The Pause

Photos: Bob van Dantzig

and peed, and formed
and she turned
this great lake of piss
and she waved
in the paddock

in the paddock
called out to her

and she turned

and she waved

.

.

When B and unclip the rhino horn they pause for a moment, listening to the sounds which come from it. Together they roll the rhino horn away, while C and E put down their trumpets. C helps B and D dismantle the rest of the pipeline, down to the colonnade, illuminated by the light pod held by A, and by the lights inside the pipeline. Smoke escapes as each of the freed sections are rolled away from the area. At the doughnut, the two ends are folded over so that the pipe forms a sealed ring, while the Fly within buzzes continuously. It is heard trapped within the doughnut for the rest of the performance. Meanwhile, E slowly moves his chair backwards towards the colonnade, keeping the plastic network connected in the wake of the destruction of the steel pipeline. Sounds from the VSC3 begin to emerge from the restored network (*Bleeps*), followed by sounds which are panned between the main speakers (*Twittering*). The dismantling continues until the whole pipeline, save for the colonnade, is in pieces, dispersed around the area.
Bleeps and *Twittering* stop.

The Pause

The tapes have now begun to give the full stories:

I, I was watching two of them and they were ignoring each other completely, and then the male walked over towards me and peed, and formed this great lake of piss in the padock, and then, the female rhinoceros walked right over and licked it up.

We were driving along in the middle of nowhere, and I, I thought I saw a dead body lying by the side of the road, so, so we went back to have a look at it, but it was just a smashed up Jesus on the Cross.

She was walking down the street and somebody called out to her, and she turned and she waved.

There was this tremendous sound of thunder, so they, they both looked up and saw a packing case that was on fire suspended in the sky, so, they both ran into the kitchen to tell their aunt, but when, they got there she was kneeling on the floor with her head in the oven, so she took her head out of the oven and explained to them that there was nothing to worry about, because it was just Peter Pan rolling his piano across the sky.

The house never got built because they couldn't decide how the light should get in.

Each performer goes to listen to the section of pipe that contains their own voice, and assumes a position suitable to the shape of the pipe and the text. D puts his head into the colonade. B lies beside her cross. C crawls inside her tee-junction and waves. E lies underneath his. A holds up the rhino horn and slowly rotates it.

The Ballroom

The Bed

Photos: Bob van Dantzig

The Colonnade

After two minutes smoke forces D's head out of the colonnade. The sound of *Red* from the 12″ speaker drowns out D's words. This is followed by *Grumpy Animals* from the 18″ speaker. The language is now lost for ever from these speakers. On the others, the stories become further and further apart, lost in time as well as space. At the end, occasional stories and the sound of the Fly can still be heard in the darkness.

E, standing at the rail holding the Radio Pod, is wrapped in plastic pipe by A. It is built in a spiral around his body, leaving many openings for further plumbing.

The sound is building at the colonnade as it is dismantled by the others. D removes the steel arms and hat. B and C take apart the bridging sections. The sound becomes *Rip It Up*. D removes the 12″ speaker and clips it onto the Caterpillar, which he separates from its column. B and C turn the other two columns through 90 degrees and pull them apart, revealing D.

The Caterpillar

D manipulates the bends in the caterpillar's body to the sound of *Putney Freakout*. When the mouth is pointed towards the listener the sound swells. He makes love to the caterpillar. Bends come off it one by one and are flung away. When D is lying on the ground with the stump of the caterpillar, A removes the Line Pod from the suitcase, which is filled with the same sound. A 'hoovers' up the sound where D is lying (the 12″ speaker fades). A 'hoovers' D. He puts the pod on the ground some distance away. The sound is cut off. He walks off.

The Trendrils

The sound of Victor Sylvester's waltz *Love is My Reason* emerges from the pipes surrounding E. He walks slowly towards where the colonnade once stood. In the clear piece of ground in front of it, he slowly turns and collapses. The sound swells slightly as the pipe comes apart. C and D take longs sections of pipe from the network and plumb them into the pipe around E. They are given shorter sections with trumpets attached by B which they attach to the ends, pointing diagonally upwards. The sound is transported away from E's body, which lies on the ground with plastic pipes spread out around him, like a dissected animal. The sound is amplified by the trumpets. The song ends.

The Ballroom

The next song, a quickstep (*Gotta be This or That*), is distorted by a pitch-change of one semitone laid over the original. It bursts forth from all speakers as the lights come up on the building behind and the glass doors open, through which come clouds of smoke and A, carrying the cake. A does a cake dance. B holds the hat on her head as she opens up the side doors. D opens the other side doors. C uses the lid from the tee-junction as a mirror. B emerges from the centre doors and her hat explodes with a sheet of flame. D puts on his arms. C takes the top off the cake and wears it like a skirt. E gets into the Tea-pot and dances with A, who wears a

steel midi-skirt. The bottom part of this drops of so that it becomes a mini. They all dance in and out of the building. Encouraged by their example, the audience also enters the building, as smoke still billows out of it.

The next song, a slow foxtrot (*Deep Purple*), is distorted by the same pitch-change with added feed-back, which increases slowly throughout the song. C helps put the mirror-ball on D, who slowly rotates in the light from the pods held by B and C. E has disappeared into the darkness. A follows him. He returns carrying the bed, and enters the building as D leaves it. He puts the bed down inside the doorway. He collects the ball and puts it under the bed. He drops his miniskirt and lies on the bed, arms behind his head. D is walking slowly away from the building into the distance, as the music disintegrates. Still lit by C's light-pod, he walks under the trees. E appears briefly in his Tea-pot, running around him and away.

The Bed

B has collected some plumbing. When the music stops the light brings the focus onto the bed. She plumbs her mouthpiece into the bed. She describes every movement she sees A make. A enacts every description she gives. This feedback amplifies every movement, so that his body is transformed into a twitching and then thrashing mass of unconnected jerks. The bed is progressively shaken, twisted and kicked apart. A's body falls through the bed onto the ball. The bed and ball are both destroyed and A is left thrashing on the floor. The lights fade to blackout, reducing the flow of information to zero, and putting an end to the movement.

Contemporary Theatre Review, 1994, Vol. 2,2 pp. 73–83 © 1994 Harwood Academic Publishers GmbH
Reprints available directly from the publisher Printed in Malaysia
Photocopying permitted by license only

Please Please me: 'Empathy' and 'Sympathy' in Critical Metapraxis

Susan Melrose

Synopsis:
Can those of us who write about 'new performance' give something back – a discursive replica, for example, not of *performance itself, but of our experiences in/of 'it'? (Laughter, self-mocking.)* What can I say? Discourse – that veritable Mother of a code – has its own logics of practice, and its own modes of reproduction, to the extent that *ways of speaking theatre (performance)*, ratified at different moments of history, speak and rewrite themselves through us, almost independently of *what we see and feel* in the event. Do you see the problem, for 'new performance' practitioners? 'Radical theatre', 'popular theatre', 'political theatre' – the *'avant-garde'*? You can see what I'm getting at here, in twentieth century terms, just as you *know that I mean* when I say 'plot' and 'character' – and then 'subtext' (as though these were eternal truths of theatre's nature, transcending history). But is it appropriate that it is in these terms that we appraise LiveArt, here, in 1993? This does not mean that LiveArt is unspeakable; but rather that it is metapraxis: intervention through practice into practices; and that LiveArt's logics of practice, like its tactical play with these, *may not be of the order of discourse.*

KEY WORDS Live Art, Discursivity, Critical Metapraxis, Performance, Scriptural Economy, Logics of Practice.

There is something charming about the theatre's resistance to being on the cutting edge of the discourses that have affected the other arts and cultural practices such as film, photography, television . . . But theatre's inertia is actually rather incapacitating since it prevents it from expanding, revising, and revisioning the theatrical knowledge derived from those earlier interventions into the order of representation . . . that may have prepared both the radical energies of the 1960s and 1970s . . . as well as the exhaustion of the "order" *and* of the avant-garde in the 1980s. (Birringer, 1991: xi)

It is almost certainly impertinent to make a single term or two – e.g. Birringer's use of "postmodernism", in his *Theatre, Theory, Postmodernism*, coupled with his "radical energies" and "avant-garde" – serve as an index of the writer's *attitude* or *position*. Because what the game of indexicality demonstrates is this: a *symptom* only functions as such if we know in advance where to look, and what (in that scene) it might be said "to stand for". The "stood for", in this particular scene – of the scriptural economy (de Certeau, 1980) – is frequently taken to be already-discursive (the strategy then would entail *interdiscursivity*); but for some of us, in 'new performance', this capture and framing within the parameters and logics of the scriptural economy is at the very least troublesome. Where to turn, however, when it is still largely taken as fact – and I work within this "fact" myself, as I demonstrate – that *what* we do, and *why* we do it (in 'new performance') can be worded?

But are "attitude", or "position" *discursive, at source*; and concealed – whence they must be 'decoded'? I am certain of nothing, here, so much as this: the beginning (of 'new performance'), like its end, is not the Word, but practice. Practice, governed in all probability by something like (the possible ways of

ıbining) crypto-logics, is not 'structured like a language' (cf. Lacan, in Wilden, ó8) except inasmuch as language-in-use is structured not just by a cryptogrammar which we cannot observe without transforming and thereby losing it, but by the possible and less-possible ways in which that crypto-grammar can combine with other crypto-logics of practice. Practice, then, works through and develops complex logics of practice – which equally are not 'structured like languages' (such a structuring would otherwise authorise a neat, Saussurean 'performance semiology'), because they do not exist separately from practice; and in practice they are characterised by those intersections and blurs which we find in catalysis (or mutually-transforming up-building processes). Only one such practice, within the heterogeneous and variously-hierarchised array, can be called 'discursive' – although the neatness of that term is deceptive: 'discourse' is always a combination. Discursive practice is 'structured', then, through crypto-discursivity (cf. Halliday, 1987) and it is, itself, a 'material-real' complex performance practice (i.e. in time and space, for someone).

Now, Lyotard (1977) has already indicated that the displacement of practice into symptom of '*some [textual] thing else*' is a strategy or institution (de Certeau, *op. cit.*) of the hegemonic scriptural economy's capture and containment of performance modes (e.g. performing *attitude*, in *the space of writing*); but it partakes, furthermore, of a generative model of causality: this works always through a spatial metaphor of 'depth', *from* a 'surface', via an Idea, to a 'deep' given as originary, and back.

My impertinence persists, strong like a feeling, an attitude. How to word it? Doesn't Birringer's *production* of a conventional category of cultural practice, by the strapping on of the suffix '-ism', function as a *regularity*, as soon as we note that it is coupled in Birringer with the terms "radical" and "avant-garde"? As regularity, can we suppose that the cluster of elements it forms serves to open up for a specific user, a little field of opacity (Pêcheux, 1984)?

For Pêcheux, this opacity directs us into a complex, patterned interdiscursivity mediated by the user, and individually hierarchised; but in our case, in uses of performance, this little opacity reveals and refracts images, amongst which our own as spectator/observer/speculator is lightly etched. Does this authorise us, and through what institutions of knowledge, to use this complex of images as an 'opening', not just onto our own already-acquired knowledges, but, in Birringer, as a pointer to established *modernist* practices of discursively *staging culture* (cf. Clifford and Marcus, 1986)? Perhaps it depends on *where we look from, the ways we see – and then, how we speak it.*

What I can see is that I have bound myself in, here, to something of the same. Because if this symptom-hypothesis were valid, then my use of '-ist', above, serves – once we find other similar traces enacted *in here* – as another such index. So that the (modernist-discursive) attitude, it seems, might well be my own, its fissures and querulousness marking my own little epistemologico-emotive dramas of 'LiveArt, the Theorist, and me'.

Paranoia, anyone?

This might smack of petards and hoisting – or is it maypole dancing, or the flux and spread of Barthes' ripples (1986), or the turn of the tides? Are we ruled here, *in theory*, by the Sun or the Moon? Here's another example from the theory/ practice mainstream:

A common interest of these theatres . . . is in the Orient . . . The company consists of . . . [the] exiled . . . [so that] the strength of character . . . [is] to be found amongst actors from society's marginalized groups . . . Over the past twenty years the Cartoucherie has been a hotbed of radicalism . . . One's horizon of expectation is determined by this reputation . . . (Singleton, 1991: 83–4)

Absolutely pertinent, the writer's note about horizons of expectation, however difficult it may be to justify the notion, *in the event*, of twenty years of hotbed radicalism. But this reminds me of something: in the *Fort/da* principle (cf. Derrida on "Freud", in Blonsky, 1985), something is thrown out, (*pained, pleased in pain*), and something brought back (*Ahhh!*). The thread remains, and the hold on it (*I've lost it/got it . . .*). The moment of abandonment is *performed* – hence controlled – and then the empty cry; and the willed control over the little thing on the string (e.g. "radicalism", "the Orient"), and the feelings attached, is mastered in the face of feared/longed-for dispossession (the string is a tightrope, and the walker longs/fears to fall). Desire takes over and takes the little thing (e.g. '-ism') in, in place of something feared lost. Where is that little thing, "the avant-garde", "radicalism", *performed* today – or is it only performed, now, nostalgically, in discourse? 'It', in any event, seems now to be a feeling and not a thing; a desire ("twenty years of . . .") nurtured by perceived loss; a little site of struggle in the theorist *himself*, rather than a matter of '-ismic' categories, or of that other theatre story of discursive causality, conventionally called 'subtext'.

And now a third example, given under the heading *'Why the hell? Graeme Miller's theatrical hybrid is full of angst but little analysis'*, from that other scene of theatre's discourses:

how you react to this kind of theatrical hybrid – for which we lack a proper name – is very much a matter of taste: I found myself . . . emotionally unengaged. . . . the limitations of this kind of text-movement-and-music theatre are also exposed. . . . Miller presents as socially inevitable a situation that is politically remediable. . . . the problem with *The Desire Paths* is . . . [that] it powerfully evokes a sense of urban desolation without apportioning blame or arousing the moral indignation to make you try and change the situation. (Billington: 6)

A taste for nameable categories of recognisable knowledge marks in each instance an eternally-willed return; and it attempts to practise containment, within the scenarios which discursively restage (in that little stage of the clause, Carroll, 1989) 'new performance' practice. In Singleton, cited above, 'new performance' in the French scene is *about* – because it seems to him to enact – "the strength of character and wealth of experience . . . which really can only be gained by living in fear, under tyranny, hungry, or in the shadow of death". Miller's performers, on the contrary – but apparently to the end of a similar sort of appropriation – are "simply figures in Miller's overall pattern", denied "any strong individual character". They fail then to arouse *in Billington* that "moral indignation" he surely recalls from the heady days of 1970s moral and political certainties, and approved modes of action. There is a nostalgia for radicalism, in each of these writers. Understandable, perhaps, since in Bourdieu's terms (1977), we cannot shrug off *habitus* – acquisition in childhood of habits of judgement and taste, ethos and ways of acting in the world, which are acquired from the personal-domestic scene of the workings of major, national economics – but must eternally re-negotiate it in a changing present circumstance. Judgements of taste and value, informing these three discursive appropriations of 'new performance', and

emerging, arguably, out of a range of masculine experience we might resume under the heading of liberal humanism, effect in each their own performance, and in consequence bind 'the new' back in to the ethos of another age. Can any discursive appropriation avoid this effect? Assuredly not, and no current analyst or commentator of culture has the luxury of standing outside such systems, of shedding her own habitus and its effects; but what we can attempt to do, through an auto-reflexivity some call *postmodern*, is to cede discursive authority to the metadiscourse, even as we produce it. To this extent, the metadiscourse can attempt to parallel the autoreflexivity of the LiveArt we are concerned with here.

Performance we might call 'new', and which I am calling LiveArt, is always about (not as in 'subtext', but as in *'around and about'*) performance. At its best it cannot usefully be assessed in terms of "radicalism", since it performs a pedestrian poetics, the aesthetic of *making do* (de Certeau, 1980): it *walks about* (and within) the institutions of performance. This is most strikingly effected in *The Desire Paths*, walked with the voice and in stage space through parataxis (movements, the one equivalent to the other, strung loosely together), and ripening into hypotaxis (stage movements – of voice, body, light, colour, image – adopt complex hierarchical relations). Such 'new performance' is *metapraxis* (the pedestrian always acknowledges the buildings and blocks and walkways in the cityscape, even as she finds her – poetic – way around and between them) – but it is constituted far from the edges where one or another avant-garde was seen to teeter. LiveArt, today, is *in the scene*, not on its edges – witness the *New Stages*, funded by Barclays, and presented at London's Royal Court. Its concerns, and ours, no matter what else they might be, are ap*propri*ately (cf. *le propre*, de Certeau, 1980), *in the age of video* (cf. Ulmer, 1989), *interpraxiologi-cal*, rather than intertextual or interdiscursive (e.g. the *a priori* 'political discourse' as basis for action). And what Billington experiences as "loss of individual character", and his curious loss then of the pleasures of a sympathy and empathy projected onto believable fictions, results from one such meta-praxiological intervention. But to sidestep the fairy-tale constituted through *character* and/as action, does not mean for a moment that performance fails to figure the scenes and events of a plausible reality – what for Billington is *only* "a state of mind" – or that it thereby alienates those spectators whose contemporary subjectivity is precisely such, that the space between the possibility/impossibility of binding-in to a fairytale is what Miller's piece is in part *about* – because this is what *it shows*. If 'walking in the city', listening to the jabber of social life (de Certeau, in Blonsky, 1985) dispossesses and displeases the nostalgic radical, then we might want to ask (as Billington does not), just what have been the enabling conditions to the founding of contem-porary subjectivities. The seventies ghetto ("radicalism", the "hotbed") walled-about by its own self-approval, self-mutilation or misanthropy, its own elitism, its own marginalization, willed its own fixing, its own historical *placing*. Its survivors are now comfortable, well-placed, well-heeled – and still they advocate for LiveArt a 1970s "political analysis", and the pursuit of coherent "political remedies".

Remaining in the field of space and place, and not overlooking history, let me suggest that performance is not just *about performance*, but – given the interest in the past fifteen years in "theorter" (Ulmer, 1985), or theatre-in-theory-in-theatre and in 'performance in everyday life' (de Certeau, 1980) – it is now always within.

Performance is always *within* performance as complex system; and within 'the performance relation', which means that the spectator, by (the performer's) definition, is in it. What characterises LiveArt and its work for and on the spectator – I include here the work of Miller and recent work from the *Desperate Optimists* – is the performance of a *feeling* of *dispossession,* staged within the property of theatre. For Billington this dispossession is a problematic loss, but for some of us the liberation from those discursive strategies commonly called 'subtext', or 'the company's philosophy' (Singleton), is positively pleasurable. (I am dispossessed, but responsible: Pecheux, 1984.) What, then, are Billington and Singleton up to; what are they asking of theatre's experience, when they seek either to find a 'political remedy' *in* performance work, or to use new performance work as "a window on philosophy"? The window – like the remedy – is no window at all, but a strategy of displacement of performance-specifics into the terms, constructs and register of a pre-established discourse, given, thereafter, as *the order of* (stage) *things.* Singleton's gaze does not cross neatly between zones at performance's bidding (from the pre-stage, to the stage, to the philosophy), but – blocked, at points not specified – shifts sideways, and finds what its user has placed there as insurance policy against what performance will produce. What is placed are the bases for a *talking cure* for troubling practice. Troubled, Billington goes back to the firm ground (of thought) he brings. Something in performance accesses it, and Billington is right, at least, to suggest that what he then writes derives from personal taste (never separate, however, from history). The problem arises when that emission of taste is contextualised within *The Guardian,* at which point it functions not as anecdote but as *expert discourse* (Ulmer, 1989). Let's relativize that 'expertise', to diminish its self-proclaiming authority: 'new performance' or critical metapraxis (interrogations through practice of practice) is *about* performance. It is not *already within* discourse, and then translated and retranslated, although to see it so (e.g. Pavis, 1992) may well be *within desire.* For Lyotard (in Benamou and Caramello, 1977):

translation consists, at least in principle, in transcribing linguistic signifers into other linguistic signifiers . . . [But] when we say that desire "speaks", are we using metaphor to say that desire is not nonsense? . . . [Now], the operations that permit one to deduce the primary message from its performance do not seem to be rule-governed . . . [but emerge from] irregular, unexpected devices. (89)

There are many regularities, in Miller's work and at the *Epée de Bois,* but those which lead to Singleton's discourse production (like Billington's), are under the control of these two writers' desire – which is not to say that the writers control them. Not knowing what they do, they do more than they know (Bourdieu, *ibid.*), through their experience of a flickering and fluttering of little opacities, not regular for the same user, and not regularly the same for different users. No coherent philosophy emerges *from* performance (this would make 'philosophy' *agent*), except where this is already installed as desire in the user ("horizon of expectations"; "a situation that is politically remediable"). In both Singleton and Billington, re-writing LiveArt as the teleological stage is an attempt at capture by the spectator troubled by change.

The 'ground of thought' revealed in my sideways glance at the regularities I find across these critics' texts, tends conventionally to authorise (and naturalise) the use of bodywork in performance as *symptom:* of social conflict or of conflictual moral interiority, attributed to the fiction and/or the social context of writing or staging.

But this assumption can now be seen to be relative to dominant scenes of everyday interpretations (cf. Hunter, 1983). As dominant, institutionalised strategy, it conventionally works to excite sympathy for or empathy with a fiction (character), for the right-thinking (conflicted) spectator. It is relatively ancient, but it is kept well-oiled, for the safe pleasures it ensures. The problem lies in the assumption that this strategy is part of theatre's *nature*, and not one of its histories – which is naturalised and forgotten as such. Performers sidestepping or relativising that strategy dispossess the conventional critic, who likes to *know what he knows*.

Sidestepping but not erasing indexicality (what we see points to what we don't, but are authorised to bring), LiveArt (see, for example, *Desperate Optimists, Théâtre de Complicité, Man Act*) combines it with other strategies and tactics. Billington gulps one such down *('Ahhhh!')*: *"a striking girl in a green dress very good at indicating mental crack–up"*. But surely the effect of this usage – its performance as one convention among many – is to cause us to investigate it as such, even as it binds us (unprotestingly) *in* to what it does. Such instances explicitly function as performance in terms the market can recognise, and as critical enquiry into the re-presentations of 'performance' itself (i.e. metapraxis). Theatre performance *about* and *within* live performance, and live performance within *'the theatre relation'* is curiously able to be both critical metapraxis, *and* – in Birringer's terms – "inert". That is, its modes of experimentation tend to remain within its own systems and properties – although we very much need to re-examine, in terms no longer dominated by Newtonian epistemology (cf. Elam, 1980 and Pavis, 1982), just what is meant by 'theatre's systems'. For the moment, let me say that in 1990s LiveArt terms, *there is no outside to performance* (it is everywhere and everyday, and lived), from where an observer might lead an "expanding" and "revisioning" theory of performance/performance of theory. Such a development is largely based, besides, in many of the other fields invoked by Birringer, on a rapid technological change within them, from which 'theatre' is content to borrow, but which, in terms of its own systems, it largely does not need. Indeed in the 1990s in late-industrialised, recession-struck Europe, it is not my impression that the systems of 'new performance' are liable to be technologically-transformed, *nor* that they are 'radical', since their drive is largely to revisit and re-appraise the already-existing modalities of performances. This interrogation consistently takes up certain of the synoptic, "in place" (or institutionalised) qualities of performance, precisely in order to dynamise them ("in flux": Halliday, 1987). That is, LiveArt works tactically within the zones of a strategic order it explicitly, and always, re-presents (de Certeau, 1980).

What *comes back* (the eternal return), between my experiences of LiveArt (take, for example, Desperate Optimists' *Anatomy of Two Exiles*; Man Act's *Call Blue Jane*; Forced Entertainment's *Emanuelle Enchanted*; Graeme Miller's *The Desire Paths*), as stability or regularity, as zone of opacity produced *between* events, is not "radicalism" nor "avant-gardism", not the "strength of character and wealth of experience" (Singleton, *ibid*) of the necessarily-alienated, but that curiously *vital* fact of each live performance, which is the performance relation. This hyper-charged quality can be approached as spatial, temporal, a doubleness, internal division; social, psychological, ethical; oriented to actional modes, to showing, sight and hearing but also to heat and smell (Pradier, 1990); always to be negotiated anew; and at the same time marketable, a provision of goods and services of symbolic capital (Bourdieu, *ibid.*). What *comes back*, whatever the

stereotypical wording of event-category ("in place"), is desire, need, a potential for pleasure, for binding-in, for *something rather like* those ancient categories of performance-experience, "sympathy and empathy" – but then again (if we sidestep the cultural contingency of 'dramatic character', and look anew at all participants in the LiveArt processes), not functionally 'like' them at all. In the case Singleton notes, he draws into the experience of performance a sympathy for the self-*mythologised person* of the actor, acquired prior to performance, largely through the interactive scenes of anecdote; and then he 'sees' (or "deduces"), through performance not so much these actors-in-the-world, but rather his own ("unexpected, irregular") transformations of them into biographical discourse.

This leaves me – before this show – quite at a loss . . . until the performance,in which that historical contingency, character, is itself side-stepped. We can see this move made inversely in Singleton, as he shifts in mid-discourse from the name of the actor as agent, to the name of the character as agent. At that performance moment, empathy with/sympathy for one or another *performer–at–work* takes (me) over. Binds me in and takes me over – but not uniformly and, in some instances, *not at all*. So that what Singletn cites as shared criteria for performers' *place* here, is not *in the event* a shared performance quality *for this spectator*. A background of pain and dispossession *simply does not show through*, within my individualised hierarchy of values-at-work, as a performance code. I perceive it, instead, as gossip from which I am excluded. Now, the pre- or post-performance anecdotal, Ulmer (1989) has demonstrated, can exist alongside the expert discourse, and the latter can be disseminated through the former in order to make it accessible. But in the given example, extra-performance anecdote binds Singleton in, in advance of the show; and bound-in, he makes anecdote have some-*thing* 'to do with' (i.e. to transform) the show. But in his writing, he can no longer recognise anecdote as such; so that from that moment when he changes frames, taking on the expert discourse of performance analysis, and of "philoso-phy", he erases the real heterogeneity of empathic productions in that scene, and intrudes the interpersonal-interactive and anecdotal into that formal register.

Is it a potential for a subject-specific sympathy and empathy *in the event* (and not before it), and *for* the working performer, which most clearly sets 'new perfor-mance' off from the other modes of cultural practice cited above by Birringer? It does seem, at the very least, that the performance relation in the live event entails a specific ethics of practice which is not thus engaged in our relation to and in other media. Are these the qualities, because of the endless return *in the event* to real time and the really-divided space and to complex logics of practice, which seem to render theatre (theory) "inert", relatively conservative and even "inca-pacitated" to his critical gaze? If theorists of television desperately seek its audience (Eng, 1990) and do not find 'it'; if theorists of cinema have the audience in [the mind's] sight but not in fact; and if literature's *archi–lecteur* works in the scenes of 'its' *typical* imagination, what we might note about practices in each of these modes is that they are established and fixed *before* and quasi-independently of a foreseen user's real participation; and they have a material-object status which fits readily as marketable, within the propertied world. But the 'new performance' spectator is *effectively* there *in the event,* and *in the frame*, where she functions as one component in a process of catalysis)building-up, catalysing and mutually-modifying). We can't take her away from it/she can't take it away – hence the legendary delicacies of substituting recorded discourse, after the event, for

performance's experience. So that performance *real*-ly always exceeds – through its work in/of the other – the sum of the objectively-observable material components and stimuli which enable, but do not assure, its effective function. In de Certeau's terms, LiveArt is poaching/nomadic/leasing, but not ownership. It moves on.

What is the nature of that stability that is the live performance relation? In Blau (1990) the drive to see/be seen *in the event* which criss-crosses the spaces is sado-masochistic, turned on and responding to something that the presenting performers and spectators figure together, without necessary intention in its im-press: they bear "what should not be looked at . . . it's as if what we're looking at arises from a kind of frozen or static memory as the hysterical symptom of what, in the collective amnesia, is still disturbingly there . . . And it's still a sight that hurts the eye" (181). Now, the "inscription on the bod[ies]", in this case, pre-dates or rather transcends historical conditions such as "marginalization" or the "shadow of death", or 1970s political remedies. Given as ancient but as eternally emerging (provided we know where and how to look, and what connections might be made), so that the shared and interactive bodywork of the theatre relation bears in varying modes its traces (i.e. not 'on the body', but rather 'in the relational bodywork' which includes as vital the spectators), it cannot be 'read off' these, unless we agree in advance that what we are dealing with is indeed 'readable'. What we might prefer to suggest, attempting to sidestep the logocentricist and scriptural economies and their metaphorics, is that the displacement or disfigure-ment of the bearable-unbearable *within the performance relation* is wrought there, *not in words, and not in script,* precisely because it is a condition of live performance that it makes its site available for figuring or imaging, within and across spatial divisions, what might remain unspoken: it works *the space between.* No 'reading' then is possible, because the graphies, for all that they are in some manner or form present, are not 'over there', presented to one or another gaze. Together in performance, we do more than we know we do, and this 'knowing' is felt.

What then can I say? Can we sidestep the logocentricist epistemology, and its comforts, and acknowledge LiveArt's own rigour, exigencies and autoreflexivity (which is not narcissistic but rather critical metapraxis)? *In* this scene, I want no closing 'sub*text*', nor framed "philosophy", to capture, after the event, the complex work as I experience it; but rather a multi-semiotics – of our performance workings – which examines, in its processes, its own strategies and inadequacies. That is, a semiotics merging in, within its own frames, to a metasemiotics. This attempts to avoid the comforting body of authoritative, third person assertions; to get back to discourse-production as a pedestrian wandering/wondering, ready always to change direction. That begins to sound a little like a (principled) live *art of making do* (de Certeau, *ibid*).

When it works (because it struggles against a little opacity), I *recognise* 'it' but cannot yet speak 'it' (because I am not divorced from it). It evokes *some 'thing' for/in me.* And it demands that we pause before granting it a place in "philosophy", asking instead *how to word our own account,* what enabling conditions seem to apply, how much, and in what. Our own metadiscursive autoreflexivity needs to work to take it in, without too much damage. At the very least, the *propriety* of ap*propri*ations of LiveArt demands that I multiple the *propos* of metadiscourse.

From this viewing point, I recognise in LiveArt at least three sets of "regulated improvisations" (Bourdieu, *ibid.*). My *never having seen the work before*, but my re-cognition of 'it' (in it), seems to me to suggest that this new work graphically figures, presents, and re-presents, visual and spatialised interrogations around and about, and within, the regulated or strategic *institutions* of performance practice. Critical metapraxis interrogates as it re-presents, and it invites the not-yet-figured tactical interrogation within its frame. There is a complexity to critical metapraxis here (recognisable in part; reiterable in part; regulated improvisational, in part – where these parts are not unitary nor stable), which can only be effectively appraised, *in discourse*, by our responding through a similar density of interrogations into the institutions of wording (the scriptural economy and its production values) even as we practise them. One necessity, here, is that we acknowledge what Pêcheux (1984), in terms of interdiscursivity, calls the complex range of the effective *non–dit* which discourse carries *for someone*. Modifying this here, we need to acknowledge *involuntary agencies* and *effects/affects*, in or around (and about) performance practice. In the case of less-than-willed mediations in practice, the terms "philosophy", "motivation", "objective", or "intent", suddenly show themselves to be too straightforward by half. Blau's assertion, for example, that another, history and culture-transcending im-press works within the theatre relation (it is neither *here*, nor *there*, but *in between* – cf. Melrose, 1993), is itself lodged within that particular episteme which authorises us to suppose that there is always more in LiveArt than meets the eye/I. If we accept this hypothesis, we need absolutely to be aware of what it carries with it: i.e. that it is precisely the unspeakable which elicits the most words (a perfect example frames us here); and that it is the perceived dis-order of the felt which arouses in the logocentricist his strongest resistance through one or another Master Discourse. The recourse to expert discourses which attempt to contain and constrain effective/affective embodied practice, might seem to demonstrate (as I do here), a habitual *Fort/da* process. If this is indeed what secondary appropriations are doing – and we can suggest that at the very least, in some cases, *it might be* – then we need to take LiveArt back to its performance scene; to relocate ourselves and our anxieties firmly *in the picture*; and to attempt to see, then, what is going on, and what is coming off. What is *felt* as unexpected or dangerous ("Suddenly I couldn't take my eyes off it!"), and what, exactly, is recognised; and then, what we might want to do with it, and the reasons for and consequences of those actions.

Certain observations emerge immediately from this reframing of practice, which draws into its webs not just the strategic – *dispositifs* (cryptologics), recognised experience, and the orders of wording after experience – but also the potential for tactics which each of these makes available. The first is relatively simple, at first appraisal: despite Billington's wholly conservative desire, and Singleton's slippage between actorly person, persona, and character, the latter is not a necessity but rather an historical contingency of dramatic theatre. In 'new performance' or LiveArt in the 1990s, that contingency, like others, can be revisited and reappraised, without doing it a terminal damage. As a performance device, and not its 'truth', its 'humanity' (or historically-relative "whole human semiotic": Halliday, 1978) is not already there *in* performance's text or intent or company philosophy. Not already there onstage (although the performer is – but what does that mean?), what we call *character* is a figment of the user's desire, and that desire cannot be abstracted from 'it' after its event. If for Billington's habitual desire

'character', *as event of his subjectivity*, seems to mean 'written in depth' in his own (generational and class) terms, and able then to activate the full panoply of 20thC discourses on moral interiorities and psychological and social determinism, for some of us these myths are now wholly relative. Supposing, instead, that discourse is not the source, nor psychosocial master discourse the rationale for performance (although it can in some cases transmit their plausible co-ordinates); that *in effect/affect* performance 'reiterates' – or, rather, re-stages – performance and not discourse, then from this viewpoint performance's scenes can only be 'translated' into discourse at a cost. The 'translator', in the scene, can lose – precisely through the desire for sympathy and empathy – an element of ethical responsibility to the practitioner and her practice. Now, one of the enquiries of critical ethnography (Clifford and Marcus, 1986) which might be useful to us here is focused precisely on the status, agency, and effect on its 'object of analysis', as well as on its eventual reader, of the (wholly human) expert witness (the theatre critic, the performance analyst and reporter) and his reports. If we accept from the outset that LiveArt's expert witness loses that status *outside* LiveArt, acquiring another, then we can see that the witness is interested, a carrier; who converts, in that transfer, 'what he has seen', in terms of what he habitually *can see*.

The second observation responds to Blau's conundrum of the embodiment of pain and the actor. Pleasure seems to emerge, in Blau's theory, precisely in that space of doubt and desire which the spectator's attentive body lives out because of the play, in live performance, between the material (live) body and the symbolic (art's body). Fixing our quivering between pleasure, doubt and desire, may well lead us to Birringer's (and Lacan's own) "inertia": I catch my breath at that precise moment at which the *work* of the performer, *struggling against intolerable burdens* (Melrose, 1993), reaches – in a way I experience as willed by that agent – beyond the imprecise limits of what I can *reasonably expect*. In theatre's economy, then, *when it works for me*, I *get more than I bargained for*; and in the midst of my use of goods and services I have purchased, I feel for an instant or two a troubling, old-fashioned *wonder*. Sympathy for and empathy with the performer herself flickers here (fnding no other site), but solely on condition of that other production: my perverse pleasures in her perverse pain, which perversely pleases her.

My third observation takes up once more Birringer's "inertia"-in-theory, in order to note this: Lacan's own "inertia" erupts to trouble the onward-flow of the discursive symbolic, and to fix it while the Imaginary takes over. Is this a problem for theatre's theory; and if not, should we not acknowledge that LiveArt's autoreflexivity is precisely what its technologies permit? This is not the place to set out again the complex *dispositifs* organising and enabling performance's scenes and relations. But what Ubersfeld showed us (1982), in appraising theatre's semiotics, is that performance is neither here nor there, but in the space between; held there, precisely enabling it to investigate its own codes and conventions (which are ours), and what can be done with them (and us).

In the attempt to draw together the quite different logics of practice of critical metadiscourse and LiveArt's own metapraxis, so that the one might be given as partly analogous with the other, a space opens up and a place-taker steps into that space. That place-taker is propertied from the outset, a carrier, and thus a third performance – with its own ways of seeing and saying and owning – is intruded into the performance-practice *dispositifs*. The impress which results frames and colours, and lightly obscures what we thought we were seeing; and the process

cannot be other, precisely because we are not 'translating' but restaging, and the effects of this are beyond our conscious knowing. Nonetheless this third agency must be acknowledged as active within a space from which we knowingly and unknowingly act upon *the other/s*. In this complex set of heterogeneous strategies and as yet unforseen tactics, critical metapraxis of one mode or another is held, and held to wander within a maze of its own imaginings; and it is "incapacitated", and it likes it.

My own words – when I look at 'new performance' *which works* – are stained with something I am trying to see, encrusted with it and thick. Which means that I can see *as Singleton and Birringer see*, and – at the very least – *what Billington is looking at*; but my perceived and borne responsibility in the playing out, through theatre, of my own desires and cruelties, is rather different. In terms of Birringer's complaint, then, I conclude with this caveat: the technologies are different, and while it so remains, we are caught, like Blau, and willingly, *between dream and event*.

Play on.

Contemporary Theatre Review, 1994, Vol. 2,2 pp. 85–93 © 1994 Harwood Academic Publishers GmbH
Reprints available directly from the publisher Printed in Malaysia
Photocopying permitted by license only

How to Shop: The Lecture – An Interview with Bobby Baker

Alison Oddey

This paper introduces the reader to Bobby Baker's latest piece of live art *How to Shop: The Lecture*, which was commissioned by the London International Festival of Theatre in 1993. *How to Shop* is the second show in a series of five entitled *Daily Life*. Following a brief description of the work, is an edited interview between Bobby Baker, Polonca Baloh-Brown and Alison Oddey. This interview explores the collaborative process of making *How to Shop*, indentifying initial ideas for content and form, the progression and development of Baker's work from solo artist to group collaboration, the role of co-director, and use of technology in performance.

KEY WORDS Bobby Baker, *How to Shop: The Lecture*, Interview, Process of making live art.

An edited interview about the process of making *How to Shop* between Bobby Baker, Polonca-Baloh-Brown and Alison Oddey in 1993. The interviewer and writer of the article is Alison Oddey, Lecturer in Drama and Theatre Studies at the University of Kent.

Introduction

Seeing *Kitchen Show* in Bobby Baker's London kitchen during July 1991 was an overwhelming and exciting experience. It was inspirational for many reasons, not least because it introduced me to this extraordinary woman's performance art. Bobby Baker is a live artist who initially trained as a painter. Watching *Drawing on a Mother's Experience*[1] in 1992 (originally conceived in 1988), confirmed my belief that beyond the visual splendour, humour and pathos of the work, was a performer preoccupied by the conflict of being a woman, mother, and artist. Baker is currently touring *Drawing on a Mother's Experience*, *Cook Dems*, *Kitchen Show*, and *How to Shop* in Britain and abroad. *How to Shop*, commissioned by the London International Festival of Theatre (LIFT) for 1993, is the second show in a series of five entitled *Daily Life*.

"I am middle aged, mother of two, and a housewife." This is part of Bobby Baker's opening preamble to her latest show *How to Shop*, performed in the

[1] For further description and discussion of *Drawing on a Mother's Experience* and *Kitchen Show*, see:
Baker, B., *Kitchen Show: One Dozen Kitchen Actions Made Public*. A booklet available from Artsadmin, 295 Kentish Town Road, London, NW5 2TJ.
Edling Shank, E., Bobby Baker Master Chef of Performance Art, *Theatre Forum*, spring 1992, pp. 43–48.
Pollock, G., Bobby Baker: Drawing on a Mother's Experience, *Performance*, No. 62, November 1990, pp. 78–79.

magnificent, majestic setting of the large lecture-hall – Tuke Hall – at Regent's College, London. Baker has chosen to lecture on shopping, with the aim of throwing ". . .new light on this domestic duty". She informs us that there is an extensive reading list, quoting from various sociological terminology and concludes, "I've decided to approach the lowest common denominator".

The focus is on the supermarket and on food. Baker wants to take us on a shopping trip, deconstructing the shopping experience with the use of various visual aids. We witness the first slide of Baker in a Croydon supermarket. The thrill and excitement of the 'trip' emanates forth ("I lose a sense of my edges"), as she takes us through multifarious techniques of shopping, such as, how to cope with the trolley with a damaged wheel, a "hip thrust" movement for going round the aisles, and advice on dealing with inter-personal relationships with other shoppers.

Back at the lectern, Baker returns to the central preoccupation of the piece – what are we shopping for? Evidently, not just a search for groceries, but ". . . a search for enlightenment, a spiritual adventure, a quest". Baker read Bunyan's *Pilgrim's Progress* as a child, and recounts that it always worried her that there was little mention of Christian's wife or children. The shopping list – the essential list for life – is our guide to enlightenment, which includes seven virtues to be obtained. Baker says a prayer in preparation at the entrance to the supermarket, "Lord, here I am. Send me!"

By following her inner voice, Baker finds the appropriate food or drink relevant to the virtues of humility, obedience, patience, joy, courage, compassion, and love. Baker moves to her demonstration table to show us how to make a posy of parsley (tied up with crisp, white ribbon), which is relayed by the use of closed-circuit video camera onto a large white screen on the back wall. Once she is holding the posy, she is now transformed. The virtue of humility is then demonstrated further as a large, burly man from the audience (actor Stan Nelson) catches the posy from Baker, and is immediately transformed.

Baker tells us that obedience is not a modern virture at all. An anecdote follows about a couple swimming in Greek waters in the midst of a shoal of fish. Hence, obedience is to be found in the fish section. We then watch a hilarious film of Baker placing a tin of anchovies in her mouth, followed by a continuing live sequence between Baker and a shopper (played by actress Patricia Varley). This section ends with Baker dancing (with tin of anchovies still in mouth) to Varley singing "Dance to your Daddy" at the piano.

Patience is to be found in the men's toiletries section – shaving soap – ". . . the smell is so manly". Baker patiently builds up a lather of shaving foam on a foil platter, which she then smears on her stomach. The same male spectator/actor now helps the pretend pregnant Baker along the stage, suddenly smashing the foam to bits. Much is made of him wiping up the mess with a towel. Each section is always punctuated by the showing of an icon slide, which in this example is a shaving brush and small bowl of shaving soap.[2]

Baker's choice for joy is an apple. Out of her demonstration on how to make a toffee apple, we wonder at the sexually orientated movement/singing sequence

[2] A set of cards has been produced using Andrew Whittuck's icon photographs with a text by Antonia Payne. Cards can be purchased from Artsadmin, 295 Kentish Town Road, London, NW5 2TJ.

under bright, changing lights to Dusty Springfield's "I close my eyes and count to ten". Baker has removed her white overall to reveal a tightly fitting dress, which allows her to gyrate and moan into the sticky toffee apple microphonephallus.

"I need an enormous amount of courage to get me through my life", Baker shares with us, as she goes on to explain the reasons for courage being represented by a vinaigrette jar of oil. She then stands perfectly still in the middle of the platform and pours oil on her head. Compassion is a bottle of red wine – "I know it's good because my husband chose it". We then witness a fabulous film sequence of Baker as a corkscrew opening the bottle and swimming naked in a glass of wine.

The last virtue, love, is the most difficult to find. Baker likens it to the Bread section in the supermarket, which is always the furthest away and encourages us to pick up things we don't need on the way. Back at the demonstration table (monitored by live video), Baker shows us how to make garlic croutons. She then distributes them to the audience whilst we listen to The Ray Conniff Singers sing 'Somebody loves me' and watch film of people taking communion.

We now have everything we need to find enlightenment. Wearing a halo type headdress (a last free gift from the shop), Baker climbs into a large plastic shopping bag with all her virtues, and is winched upwards. Celestial music plays as she flies above us against a background of clouds and tones of 'Hallellujah'.

The Interview

AO: When did you first think about *How to Shop* as a show?

BB: I had the initial idea when I was finishing off *Kitchen Show*, which was two years ago, and it developed out of those ideas. I do find that the longer spell I have to think about something, the more chance I have to really take it as far as it can go. Whilst working on *Kitchen Show*, it slowly occurred to me that I could do a series of shows and that it would have more impact to describe it as a series. So the title of the series is *Daily Life*. The first being *Kitchen Show*, and the second *How to Shop*.

AO: So this idea developed for doing a show about shopping?

BB: The first idea was to do a show about a shopping trip, which was actually a spiritual journey. That became clear very quickly. I tend to have an idea (which I find exciting and can think of all the aspects of it) followed by this terrific feeling of freedom to just have it there, as well as come back in and out of it. When we were having financial and practical problems last autumn with *How to Shop*, that's when I started actively thinking about the next show, which is about women's health in a health centre.

AO: Why did you decide on the form of a lecture on shopping?

BB: Originally, I'd thought of taking small groups of people round a supermarket but this was problematic, so I decided to create a lecture. I loved the idea of bringing together the shop, the spiritual journey, and the lecture. One of the main points of the lecture was to play with the idea of giving more status to what I was talking about.

AO: Was that because in *Kitchen Show* people could patronise and dismiss issues that you were dealing with, because they were about domestic life?

BB: Yes. I felt that a proportion of the people who came into the kitchen only picked up on one or two aspects of it, or just saw the funny side. It was essential that it was accessible, but I really wanted to have more control and to be able to get across points more directly. I got involved with the idea of producing a lecture which had sections of film and photographs in it, so I started talking to Carole Lamond who had made a video of *Kitchen Show*. At this stage we discussed the form, structure or context, and whether LIFT was interested. I had the idea for this spiritual journey and I'd got that mapped out to a degree. I'd worked out the ending, which was getting into a giant carrier bag and being lifted up to heaven by the hand of God. The journey would involve searching out seven virtues in the supermarket and ultimately achieving perfection. The only thing I'd actually put down on paper or indicated to anyone about the content of the show was that one part of the trip would be to do with a posy of parsley. While I was touring *Kitchen Show* in Australia, I realised that each virtue would involve a small story or scene; for instance, the posy of parsley would signify humility. I would demonstrate this by tossing a posy of parsley to a burly, thuggish man who would be immediately transformed to be humble the moment he caught it. I hadn't finalized the exact list of virtues that I wanted to use. I had decided on the first five from using my own thoughts over the last few years. The last two virtues took longer to decide on. I talked to a couple of Christian friends at great length about the whole concept.

AO: Could you say more about this?

BB: I'm a Christian, although I don't belong to any church. I have my own faith and a way of thinking things. So this set of words or virtues had occurred to me over a period of time. Once I'd established the form, I could develop the ideas over the next few months or so. That is always a very wonderful phase of feeling free to ramble around.

AO: What exactly is it about that phase which makes it so delightful?

BB: It's a complete freedom. I'm not committed to doing anything. If I don't feel like pursuing it, I leave it for a while. I've got all these ideas and I can just wander around with them in my mind. I don't have to bother to talk to anyone about it. It is like being a child in a huge hall or a wonderful space, a sort of palace with a garden. You can wander around, picking things up, putting them together, adjusting things in your own way, and creating whatever you want. The possibilities are endless. It always seems very tempting to leave it at that stage.

AO: So the reality is putting the show together. How did this work in terms of collaborating with Polonca Baloh-Brown as your co-director, and Carole Lamond as film director?

BB: Trying to communicate ideas was the problem. Collaborating with both Pol and Carole was quite a confusing process. Both of them were trying to get me to make decisions about what I wanted the content to be. There was definitely a different way of working with both of them. Carole and Pol were both incredibly generous in terms of time and their way of listening. It was a clearer process with Carole in that once she understood, she then interpreted and put together what I had explained. It was meant to be a filmic version of what I was talking about, and I'm immensely pleased with what she's done. Pol concentrated on the live work, trying to keep a balance on the development of both film and live performance. I found it very stimulating to work like that, rather than just wandering around thinking things, which is how I've always worked. I've never before written anything down particularly, except for applications, it's just gone on in my mind. I was forced to do it because of the restrictions of time, and having to communicate to them. It was Carole's suggestion to draw my ideas, which was very liberating.

AO: Can you elaborate further on how this collaboration has specifically encouraged the development of your work as a live artist?

BB: Both would come up with ideas or suggestions that we might develop. For instance, when working on the virtue patience, I was talking about the notion of making something over a long period of time. I talked about soap. Out of this discussion Carole had the idea of a huge figure walking along covered in foam. I then had the idea of making something out of foam which would take ages to construct and would then get destroyed. Pol and I played around with all sorts of ideas until suddenly I realised that I could make myself pregnant by smearing the foam on my stomach. Then it would be destroyed somehow. It was a wonderful two or three weeks of experimentation, developing and pushing ideas as far as they could go.

AO: How did you eventually arrive at the image of the man (actor Stan Nelson) helping you along and then destroying the foam/pregnancy?

BB: I initially had the image that it would be a wind machine that would destroy it. I discussed this with Pol and my production manager, Steve Wald. We thought it would be too clumsy, technically.

PB-B: The destruction had to be something unexpected. We were in my garden trying out the possibilities of using Stan to destroy the image. We experimented with various ways of doing this.

BB: It was very much a feeling of the extraordinary patience that goes into bearing children and bringing them up. The transformation of your whole body and person changing. It was also trying to play with ideas of slapstick, fun and the custard pie. The images became linked in my mind to what we were reading in the newspapers about what was happening in Bosnia. Indescribable, unbelievable violence against women on such a scale.

AO: Pol – what was your understanding of the role of co-director, and of your part in the creative process of making *How to Shop*?

PB-B: Bobby is the instigator of an idea, and my role is to enter into dialogue with her. What I have to do is to stand back for quite a long time in the initial part of the process, and only when there is a structure or definition can I enter without jeopardising Bobby's ideas. I can help Bobby tie things up into a coherent form. Our way of working together is particular to us. It's to do with friendship and trust. We started working together like this with *Kitchen Show*. This process doesn't separate the artist from the artwork. It's a subtle process, a dialogue, an intuitive way of working very collaboratively as two women. When Bobby brought the drawings, I couldn't enter into them. They were still images in her mind, personal to her. It took several months of talking before I could engage with the work. Later in the process, as an 'outside eye', I could challenge and help develop the various aspects of the performance itself.

BB: It's a process of examining what's happening with every aspect of the performance, and it's wonderful to have that sort of 'outside eye'. With Pol, it's a subtle process of batting things backwards and forwards. For instance, the ending of the show involved a month of discussion, and then I completely changed the whole structure of what we'd set up.

PB-B: Our roles are constantly shifting; they're not definitive roles. Over the last year it's been a process of talking, getting up, and doing. The structure came quickly, but working on sections of the journey was complex. Improvisation really.

BB: Pol and I worked two or three times a week together. Over a period of about six months Pol developed a 'script', which has been an essential part of the show. This involved noting down words and images of interest, which I've then re-written. It's been a process of adjusting, cutting out, and changing initial ideas. The introduction's far more concisely controlled than any introduction I've done before, and difficult to pull off.

PB-B: The idea of the introduction, and what makes it difficult, is to lead the audience almost to boredom before the break into the unexpected, and thus timing and the words are crucial. I started with what Bobby said in rehearsal. It got put down on paper.

BB: In fact, I've changed the introduction in performance quite a lot. We've cut out quite a few bits, and are altering it as it goes along. I find it a very interesting way of working.

AO: What are the issues in this show?

BB: Well, God and Sex. It's a strong desire I've had to explain my experience with spirituality, my feelings as a woman, and to be acknowledged as a complete person. This particular piece was about an awareness that my daily banal life was not given enough importance, attention, or validity, and how a focus on spiritual and moral concerns is intertwined with minute details of this 'daily life'. It's about how I feel ultimately excluded from the whole structure of the image of God, and the way the church is established. I'm trying to reclaim my experience, my sexuality and my femininity. Don Cupitt has written about the conflict between women who have been regarded as impure, fickle, leaky and unstable in relation to God, masculinity, form and the rational soul. In this show I go on a spiritual journey, which is seriously about various issues and virtues that are important to me. However, it's a very complex approach to them. It's critical and accepting at the same time. It's not having any answers, it's posing questions, setting up images and situations. I feel very mixed about it all; I love that complexity and confusion. My experience as a woman is that things are extraordinarily complex and subtle. In the end, it becomes a celebration in that I swim in the communion wine, and I take bread (made into croutons with garlic in them) to hand out to the audience. One side is of a joyful experience, but with a rather wry, ridiculous comment on the whole image of saintliness, purity, and heavenly bliss at the end.

AO: I loved the film sequence of you becoming the corkscrew to open the bottle, and then swimming in the wine. In fact, the piece is dependent on the integration of live performance and technology. Did you enjoy the collaborative process of working technically on the show?

BB: I found it very interesting to work with Steve Wald, the production manager, and Stephen Rolfe, the lighting designer. We talked over a period of two or three months, clarifying what was wanted and the various situations to be interpreted. The excitement is in explaining ideas, giving them to someone who knows what they're doing, and seeing them realised. One initial difficulty for me with the lighting was that it didn't fit in with the form of a lecture to have lighting like that. I was very happy with what Stephen Rolfe designed because he changed the 'normality' of the introduction slowly into a more 'fantastic' theatrical end.

AO: What about use of live video?

BB: The video demonstrations were suggested by Carole Lamond quite late on. We had a limited time to experiment with the equipment, and I would like to develop it more. Working with the video was very problematic. It really struck me hearing the Wooster Group talk about how long they've worked with their technology, and how little time I've worked with this. We've just started. It's also about juggling with very limited resources to get the best out of it.

AO: Has the financial side of the project been problematic?

BB: Working with Artsadmin (with Judith Knight) has been a very crucial part of this whole process. The project wouldn't have happened without LIFT or Judith. However, it's been an immense struggle financially, and I've felt pressured to tour shows in order to raise money. For instance, I toured three different shows (*Kitchen Show, A Mother's Experience,* and *Cook Dems*) in Australia, performing ten shows within two weeks. The money earned from that was essential to keep *How to Shop* going. It was absolutely exhausting. The fund raising scheme took an enormous amount of time and energy to coordinate. It was a useful process, emotionally stressful and draining, but I learnt a lot from doing it.

AO: As well as being "middle aged, mother of two, and a housewife", as you state at the beginning of *How to Shop*.

BB: I've never worked so hard in my life, and yet there is a general attitude that artists should feel lucky to earn any money at all. The Arts Council is very keen and supportive of new innovative work. I got the research and development grant of £5,000 from New Collaborations for *How to Shop*, but a higher level of funding is very much needed so that work like this can gain parity with, for instance, contemporary dance and drama.

AO: What strikes me particularly about *How to Shop* is the move away from an intimate space or setting to the much more public and formal venue of a lecture theatre. You appear to have chosen the assertive role of lecturer to develop a different aspect of the Bobby Baker persona, sliding in and out of the vulnerable, apologetic performance artist we encounter in earlier work. Can you say something about this?

BB: I think it came very directly from the experience of doing *Kitchen Show* in such an intimate setting. I had to almost step away from that process in order to examine it. I wanted to make some statements in a different way, in a physically bigger way. The intimacy of *Kitchen Show* placed me in a vulnerable position. I felt that if I could remove myself to a position of authority and play with the idea of the authoritative lecturer teaching people things I knew, that it might have a different impact whilst dealing with the same development of material. It seemed both interesting and funny to lecture on the banal, mundane, or trivial, and to talk about these details from a stance of power. I couldn't just be myself. I had to have far more control and use various techniques, which I've learnt from performing *Cook Dems* and *Mother's Experience* in very big spaces with quite different types of audiences. I've brought the demonstrator into the lecturer, as well as chopping and changing to being vulnerable, and the audience can understand that.

AO: Seeing you standing behind the lectern in an imposing, majestic, academic space certainly created an image of status, power, and distance.

BB: That's what I wanted to experiment with, and then to break it. Bedford College, being the first women's college in Britain, I felt that the hall (which was constructed in 1927) was built with that in mind, to be as grand as possible. I wanted to move in and out of the space to the point where I was actually close to the audience again. We planned that 'the lecturer' would disappear almost totally by the end, and maybe come back for odd moments. It would mainly be in the introduction and then there would be the points of demonstration, which were different. What was important was that it allowed me a very clear structure and form to this set of ideas.

AO: So the public lecture form enables you to bring in various visual aids, whether they are actors playing caricatures, props, such as shaving foam and a supermarket trolley, or the use of film and photography.

BB: The thing I found the hardest and I still don't feel is quite resolved, are the joins between the two different processes of film and live performance. It's still developing and changing as the show goes on.

PB-B: The lecture is a vehicle to control all the different visual effects, which are all powerful mediums in their own right. It may be easier to integrate the moving image (ie, video) into performance, but the photographs, which were done by Andrew Whittuck, had to blend in more subtly, for example, where his seven beautiful icon slides are used to quietly convey and tie up the whole structure of the performance. What I was building on was Bobby's ability to be schoolmarmish and in control of herself. Previously, she played herself as a vulnerable person. In the lecture, she had to be careful about this. It's about tapping into another part of her personality. It's not acting, but bringing out another aspect of herself. The lecturer talks above people's heads, which is then broken through with moments of extraordinary fantasies, stories and images, which are all part of Bobby's persona.

AO: Daily life domestic issues of housewifery and shopping are not normally the subject of art, and yet there is clearly a strong audience awareness and following for domestic art. However, the female live artist, wife, and mother is still quite an alien concept for some. Have you enjoyed collaborating with others on this piece?

BB: Making *How to Shop* has been a big change in my way of working, but has been an extremely positive experience for me. I find it exciting to work with other people, to be part of a group. The wonder of being in a company is the solidarity, and strength you get, which I haven't experienced as a solo artist. There is the chance to develop relationships and the process of learning with others, which is the best thing about continuing work with the same people so that you can work from the same shared experience. That develops from the way I've worked on my own. I've learnt more from failure than from success, and it's an essential part of the process to adjust and move with the making of each show.

Contemporary Theatre Review, 1994, Vol. 2,2 pp. 95–106 © 1994 Harwood Academic Publishers GmbH
Reprints available directly from the publisher Printed in Malaysia
Photocopying permitted by license only

Self as Source, Part II

Mara de Wit

As and for the dancer and in dance, the bodily self, the physical experience of the self, is the primary source in the creation, process and output of performance. This experiential knowledge informs and shapes the 'Self As Source' articles. In these, I outline and simultaneously explore performance related features, concepts and concerns in an attempt to balance practice and theory, in and from the realm of 'live' art and 'real' life. This text momentarily focuses on compositional structures and the sensory, embodied self, the tool, trade and skill prolific and highly profiled in the world of dance and dancers. Converging aspects of individual developments in dance are re-counted in detail for their relevance to current performance practice. In the course of the narrative the borders of other disciplines – and related – fields of perpectives are touched upon and crossed. Active intersection of subject and object, present and past, self and others occurs in this written (sub-) version of 'live' performance, whilst the material bodily 'self', is both considered and physically engaged in the production, the process of reading and writing the text.

KEY WORDS 'Live' Art, The Dancer, Non-linear Structures, Composition, Performance, Preparation of the Body, Improvisation, 'Real' Life.

Live Art Forms, The Body and The Senses

The 'Live Art' of Performance, or 'Live' Performance can be perceived as a cultural form and contemporary specialist arts practice, as well as a shared essential feature of the various, established artistic disciplines of Dance, Theatre, Music and the Visual Arts. This text sets out to probe and investigate aspects of this form and its boundaries. In the process, the overlapping and intersecting nature of / and at the boundaries of 'live' art and 'real' life are explored, as part of the Performance Lecture series 'Self as Source'.

Drawn from the writings of Goldberg (1979), Kaylan (1989) and Nutall (1979), one temporary theoretical construct, or definition of 'Performance Arts', also known as 'Live Arts', sometimes called 'time-based' arts could be: the aesthetic form and practice that privileges the act of 'live' performance. The 'live enactment' being 'the primary and only text' (Kaylan: 1), where 'the performer is the artist' (Goldberg: 8), the creator/author of the text. This 'live enactment' often entails the crossing, extending, or breaking of traditional boundaries and conventions of the established arts disciplines and their sub-categories such as different genres and styles. Artists turning to performance 'as a way of breaking down categories and indicating new directions' is noted by Goldberg as one of the twentieth-century prerogatives of 'Live Arts', particularly 'within the history of the avant garde (1979: 7).

In common in the aesthetic practice of 'Live Art' (which aligns it closely with contemporary dance and theatre practice), is the employment, or use of the body, the body of the (perceived) performer, as well as the (perceiving) spectator. He or she can be sitting, standing, walking, watching, looking, listening as a breathing,

digesting, heartpumping, circulating, biological microcosm. During performance experience, the body and its senses, (including the sense of the bodily self), are engaged in a process of 'kinaesthetic transference' as suggested by dance practitioner Steve Paxton.' Paxton referred to Gibson's book *The Senses considered as Perceptual Systems* for further explanation of his point that:

the senses can be perceived as systems that interrelate. So that vision for instance is supported by the muscular system, to move the eyeball, to move the head, to move the whole body, if you want to see something, or go some place to see something, you got a whole body supporting the visual apparatus and the same thing happens for hearing. You cock your head, move your hand to your ear to hear. It wasn't your hearing that moved your hand. It was the interaction of the systems that caused actions to enhance the senses operation. (Int. 1991)

Thus, the body (of both the performer/writer and spectator/reader) is depicted and proposed here as a multiple 'perceptual system' receiving and transmitting information as to the state (conditions) and picture (images) of reality. These bodily processes can be observed in, and for one self, by simply re-considering the moment and action of for instance entering a lecture theatre and deciding where you are going to sit down.

This active process of perception, 'making sense' of a situation and location is particularly highlighted by the momentarily performing spectator 'embodying' the space in an empty, or bodyless installation, which one could come across, or encounter in contemporary art galleries or musea. On entrance the spatial texture and energy is 'read' by the perceiving body and at the same time he or she, the 'self' affects the reading and the 'text' and so becomes the artist/author in the creation of its meaning.

The literary metaphor 'reading the text' articulates more about the dynamic relations involved in the performance experience than for instance the word 'seeing' and indicates 'critical spectatorship' in and of dance (Sayers, 1992: 49), as well as in and of 'Live Art', Performance Art and other 'Hybrid' forms of aesthetic practice and cultural activities (Kaylan).

Self as Source

The central and underlying theme of the performance lectures 'Self as Source' is approached and presented from a practitioner's perspective and the spoken text accompanying (and voiced in) the performance lecture is informed by this. At times the text moves into the realm of language as metaphor and the body moves in the realm of textual language (the body as text). In its ideal form the performance lecture becomes the 'live enactment' as, and 'embodiment' of, the text in the presentation of the paper. To consider and explore with you (as the reader) aspects of 'Self as Source', I talk about and around the subject, being the object / source at the same time. In this process, I draw from personal history and research, combining practice and theory, not in binary opposition, contraries, or mutually excluding categories of either – or, but aiming to arrive at a balance, a comfortable leaning and hanging of component parts.

The material of this paper inevitably relates to – and is embedded in – (1) the time, or period lived, (2) certain geographical locations (my origin and places of abode, which include Holland, North-America and Great-Britain) and (3) experi-

ence as a white, western, female dance – theatre practitioner. I refer to my life and work (past and present) as a dance-artist, or a theatre practitioner working primarily in the field of dance. During the 1970s and 1980s I have embodied different roles, activities and functions of varying status in this field of work as choreographer, dancer (solo, duo, group), director, student, performer, teacher, researcher, video-editor, administrator, producer, company member, singer, actress and others.

This textual elaboration connects with, and overlaps at times with the Performance Lecture 'Self as Source' Part I, which was presented at the conference: 'Perspectives on Women in Twentieth Century Theatre – Creation, Process, Output', held at Warwick University in 1990 (De Wit, 1992; Goodman, 1993). Part I, traced 'Self as Source' in the work of twentieth century women artists, the 'autobiographical' aspect in Performance Arts, its relation to the late 1960s–1970s Women's Movement's (then coined and buttoned) slogan 'the personal is political' and its further resonances in developing gender perspectives. 'The personal as political' according to Mackinnon's reading:

is not a simile, not a metaphor and not an analogy . . . It means that women's distinctive experience as women occurs within that sphere that has been socially lived as the personal – private, emotional, interiorized, particular, individuated, intimate – so that what it is to know the politics of woman's situation is to know women's personal lives (1985: 534)

Against that backdrop and background as one contextual layer, I reviewed and continue to review aspects of private and individuated experience for their relationship to my present (ed) state of life and work as a twentieth century woman / artist. So far this exploration brings forward the lived experience of multiple identity as illustrated by the previously mentioned numerous embodied 'roles', 'functions' and 'activities' in the course of one's life and work. The main proposition of Part I to the audience/readers, is to consider the 'self' as a multiple – rather than a singular identity, a chorus of 'inner voices' (Humphrey, 1959: 21), a plural of selves, and to introduce the notion of multiplicity to one / our 'selves', as source.

Moving from female artists and their influence on post-war performance art forms and practice, Part II incorporates another set (and setting) of artists, specialists of dance, movement and the body. Discussions during the Summer of 1991 with a number of dance practitioners provided another layer (of background and information) to the development of 'Self as Source' and the multiple nature of this model in and for current dance – and performance practice and theoretical perspectives.[1]

From Multiple Self to The Non-Linear

In Part I, I touched briefly on compositional structures in relation to the conceptual notion of multiplicity, of 'selves' and its implied deviation from a linear, singular path 'this one self takes', the linear development of story line and its direction. A

[1] Semi-structured interviews with a number of dance practitioners undertaken by the writer in 1991 formed a major source of reference for this article. Direct quotations from the original oral data are attributed to the particular speaking practitioner and indicated as: (Int. 1991).

clear example of multiple selves in relation to non-linear narrative structure can be observed in Deren's film 'Meshes in the Afternoon' (1943). Maya Deren (1907–1961), film maker and theorist (with a background in dance) identified the 'vertical structure', which she described as: 'An investigation of a situation, in that it probes the ramifications of the moment, and is concerned with its qualities and its depth' (Michelson, 1974: 483). The vertical structure allows the experience of a moment, of probing and ramifying the moment itself, a process not dissimilar from 'live' performance itself.

Another non-linear approach to compositional structure for performance can be gleaned from dancer, choreographer Merce Cunningham (1919–present) who suggested that one can think of the structure as 'a space of time' (1992: 39). A space of time opens up the sense and possibility of a geographical landscape, or 'a field of reality', which we enter for a (and in the) moment, not unlike the reading of an article for twenty minutes. 'A field of reality' (Devons & Gluckman, 1982: 19) is a term borrowed from anthropology to describe the demarcation of fields of study. This takes us into the realm of cultural landscapes and so, we arrive here, in the converging fields of dance and performance, to explore concerns, issues and questions in the (re)search for possible methods to map and inscribe their multiple, parallel and often overlapping shared realities.

Life and Work

For a number of years (1981-1986) I made very detailed, carved dance theatre pieces, where each moment was completely set including at times the direction of the eyes of the performers, the position of the fingers, the heartbeat, the breath rhythms and so on. Gradually I became re-interested in improvisation and compositional structures. I began to re-consider the structural notions of improvisation and composition, in practical and conceptual terms, as a 'live' performance mode and in 'real' life, in the work and life of others and my own.

Whilst fascinated with structures, questioning the 'how things hang together' and 'what occurred within what and why and how' (1987-1990), I choreographed and devised a number of dance theatre pieces constructed within the notion of improvisation such as 'Bodyless' and 'The Gap'.[2] Both pieces were, what Parry identifies as 'dance pieces', in the sense that their structure 'evolved through movement, each scene springing from the physical language of the previous one', with 'a coherent choreographic logic' (1992: 23).

'Bodyless' was a compositional structure with recognizable body, space and movement based orientation points for the two performers engaged in the 'Live' performance (output). The structure was created on, for, by and with two actor-performers Joanna Scanlan and Julie Garton, which contributed to the presence of characterlike images, or personae and a vivid inter-change of verbal snippets, sounds and singing in the piece.

[2] 'Bodyless' made with the support of Rotherhithe Theatre Workshop and the Bubble Theatre in London, was performed at London venues including Chisenhale Dance Space and the Deptford Women's Centre. 'The Gap' was created for and performed at the Summer School 'Dance into Theatre' organised by The English Dance Theatre, directed by Jacky Lansley, held at Dance City, Newcastle.

The latter piece 'The Gap' was an almost mathematically set, timebased structure, which – if space allowed, enabled sixty dancers to improvise 'freely' and still sequentially coincide. The performances of this piece, in three, twenty minute sections, were further layered and informed by the 'live' soundscape (in- and output), created by improvising musicians Penny Callow and Juliet Whitworth.

I attempted to create structures like safety nets for the performers. Structures like pathways to accomodate journeys, initially set within the linear, but with room for loops, U-turns, bubbles, sub- and side stories. Removed from, yet not dissimilar to, the Stanislavskian acting- direction method of moving from unit to unit, within the objective and (within) the super-objective. However, with the super-objective not necessarily progressing in one line, to what is ahead – moving forward and through beginning, middle and end, nor progressing 'on and up', like a 'ladder' structure (Lauter, 1984: 204). So that effectively, in performance, an overall pattern could arrive like a web, or a mandala, layered with intersections, connections and repetitions.

The probing of improvisation and composition in performance practice was interrupted and henceforth affected by my father's death (1988). A year later I choreographed and devised from improvisation, but returned to a tightly set (on a group 'Clocktower' of four women actors) two part (ten minutes each), almost narratively descriptive series of images: '4 English Ladies' (1989).[3] Aspects of the self, were the source for the improvisations leading to the set piece. This was also the case for the following piece 'Why Dance Now' (1990), a solo, 'set' on myself, although accompanied by four 'improvisational' parts taken by fellow artists in performance. Four friends/colleagues were invited to: 'walk-on, sit down, read (for about five minutes) and walk off', taking agreed turns, but without preparation, or rehearsal as such.[4]

However, the practical explorations of improvisation and 'live' performance structures were taken over by the non-set, or unexpected and changing experience (private, intimate and emotional) of death and the process of recovery. This real life event set me on a particular course of activity over the following years (up to the present), which included (interiorized) reflection and theoretical re-orientation in the academic field (the world of words). Different perspectives began to broaden my horizons. Equipped with research tools I re-entered the field of dance and performance with a fresh and exploratory sense. Although slightly estranged and dis-orientated on return (which I knew was not considered an unusual state whilst undertaking fieldwork of ethnographic nature) the time 'out', spent engaged in academic discipline and procedures, thus enabled me to view, approach and enter the world of dance and dancers anew and from different angles.

Further to the current questions such as 'What does dance represent, or express? I would like to insert Who dances and where? and What is recorded and why? For what purpose? How do we place what we learn from the existing recordings, the

[3] 'Clocktower' members were: Nikki Melluish, Joan Walker, Jenny Wilkinson and Julie Garton, who toured '4 English Ladies' with 'Le Cirque Mondial' Eudia Productions in France (1989–1990).

[4] 'Why Dance Now' walk on parts by: Denise Alonzo, Alison Moore, Liz Sutherland, Lisa Halse. First Performance at Chisenhale Dance Space, London (1990).

residue of dance activity, or the 'arte-facts' of dance in a broader context.[5] Or even just how do we extend this unique experiential 'body of knowledge' beyond the world of dance and dancers?

Self and Others

I guess I talk as myself – the dancer, the performer, the creator – , that there is no separation, that the person is all these levels and not to separate the mind, from the body, from the spirit; that if you're in your bones, you're in your mind, you're in your spirit. Maedee Dupres (Int. 1991)

As a choreographer, dancer and theatre practitioner the realm of my work is in the material, current self, the body in movement and stillness, the breath, the heartbeat. The sensory perception systems are alerted to hear and listen, feeling and sensing the in- and outside currents of energy, the pull of gravity and the momentum of the weight, the form falling, rolling, leaning, hanging, jumping, leaping, stepping, walking, running, standing, sitting.

For a dancer, the body (and/of the self) is an obvious starting point for exploration and the source for possible experiment. This can be so for any physical performer, actor, or 'live', performance artist, both in preparation for, and in performance itself. In the words of American dancer, choreographer Deborah Hay: 'the performer is the material', with access to the 'cellular intelligence' and the 'corporal reality', present in the body, at (and of) any given time, as starting point (1989: 73). Added to Goldberg's point 'the performer is the artist', we now have the acummulated sum of the performer = the artist = the material.

Placing personal practice and processes in the context of dance and dancers, I now add the real and personally lived aspect and influence of lineage, as in received dance teaching and training background. Steve Paxton, Mary Fulkerson, Rosemary Butcher, Mary Prestidge, Pauline de Groot and Maedee Dupres (who between them span a period of dance study and training from the 1950s to early 1970s), taught me (and many other dancers) during the late 1970s and early 1980s. As performing dance artists they all employ and have at times presented 'live' compositional structures, or 'improvised' dance pieces as a direct, immediate performance mode, or 'Live Art' form. Their teaching, performing, choreographic practice, ideas and past experience are now tapped to shed further light on this present probing, at and of the boundaries of dance and performance.

Present and Past

These contemporary dance practitioners and 'live' artists originated from the USA, UK and the European continent, Holland and Switzerland, where they continue(d) to work, move and live. They all performed, taught, choreographed and produced original work in Britain during the 1970s and 1980s. In retrospect their often informal, interrelated networking of practice and ideas across countries and continents can be perceived as seminal to the international New Dance development (See Adair, 1992; Banes, 1980; Dempster, 1988; Jordan, 1992; Mackrell,

[5] Another anthropological term, used this time by Paxton for a video recording of 'live' performance (Tee, 1993: 22).

1992; Merkx, 1985). A recent post-war development firmly located in western modern dance culture, intersecting and overlapping with other arts-, related practices, and social movements at (and of) the time.

From the 1950s-1960s onwards, unconventional, or non-traditional activities, compositional modes, structures and approaches in and of performance were introduced in the field of dance as well as the other arts practices and disciplines. The perception, reception and location of dance, movement and the body in Anglo-American and western European (continental) societies began to change and broaden accordingly. Developing cultural perspectives were informative to this, as illustrated by the title and article 'An Anthropologist Looks at Ballet as a form of Ethnic Dance' (Kealiinohomoku, 1970). This post-war international shifting at and of the boundaries of convention in established western modern art forms resulted to a change in the defining central question, from 'is it art' to 'what is art'. The critical terms, criteria and discussions in and for dance moved also, from 'is it (or is it not) dance', to 'what is dance' (Copeland & Cohen, 1983) and for whom?

New dance practitioners notably contributed to 'radical innovations' (Kirby, 1975: 3) in performance during the 1960s-1970s (Goldberg: 138). Around the 1960s, this post-war, post-Cunningham 'new' generation of dance practitioners began explorations of and through the experienced, or embodied 'self'. They examined and actively employed the body, the self, as the 'inside' model, opening up the 'self' as source in the process. At the time, this overlapped with the stirring of similar ideas (and related practices) among women artists. The fact that many dancers were /are women undoubtedly brought/brings about a certain cross-assimilation of emerging issues concerning the experience of self/body in 'live' and real 'life' performance.

– Action: *Performer/Lecturer demonstrates lying down on lecture table, or desk if possible, otherwise on the floor and continues:*

Stillness

During the 1960s, spending time in 'Stillness', both aurally and physically, became a way and means incorporated in developing dance and movement techniques. This accommodated the 'listening' to the self, the practice of quiet observation as starting point for exploration. Mary Fulkerson began to explore (in) stillness, the connections between the thought processes, particularly the imagination, and the possibilities in terms of movement, dance and composition:

Joan Skinner had initiated this "Rest Position" work into an improvisatory context, which was very experiential, very interior and feeling – imagistic-. I remember that I craved some more freedom to explore what was there on the imaginative level and then I became fascinated with the stillness and wanted to continue just to explore what would happen if I were to rest in stillness and let that take me into movement, but I had no meditaton practice and I had never even heard of it as such. In the mid-west this was not a feature. It was the height of the Hippy era and in a campus of about 30.000 people [Illinois], we might have had 6 Hippies. This is the conservative middle America's huge University setting. I just didn't know any of these alternatives. Yet I was taken up, swept away by the first moment that I was asked to be still and listen, I remember it was a transcending moment. (Int. 1991)

Quiet observation, combined with 'lying flat on the floor' also provided a way into teaching his students how 'to perceive their body anew' for Steve Paxton:

People were lying flat on the floor in my classes from day one. Because somehow I have to provide a way for each individual student to perceive their own body anew. Generally when we lay down, we go to sleep. It is rare that people spend time, quietly just perceiving themselves. It is not a goal in our culture to have this experience. What it provides is a way of learning anatomy, of the body, or the feelings. (Int. 1991)

Pauline de Groot received the information about lying flat on the floor in the 'Rest Position', or 'Constructive Rest Position' as 'the Lulu Sweigard ideas' in the USA during the 1960s. Skinner and Sweigard developed their practice and ideas, which were in turn influenced by the research work of Mabel Elsworth Todd around the 1930s, as illustrated in her book "The Thinking Body" (1937).

In the Rest Position, indeed you (the body) lay on the back on a flat surface. The knees are bent (about 45 degrees) and roughly in parallel line with the hips and feet (soles flat on the floor). Spine rests on the floor, extending into the head. Breathe and think 'up the front, down the back' (Fulkerson) through the body and gradually allow the weight of the body to drop into the floor, or in a sense 'let gravity have you' (Paxton), through the contact areas of the back with the floor, the feet, pelvis and head. Time spent (for at least fifteen minutes) in the rest position on a regular basis reinforces the structural balance and anatomical alignment of the body.
– Action: *Performer/Lecturer ends demonstration rolls over to get up, returns to upright position and continues:*
The constructive rest position is also central in the Alexander Technique, a practice and 'principle', passed on 'person-to-person', which connects thinking and action in order to attain, or regain an 'effective body-use' (Barlow, 1973: 13) The Alexander technique was another relatively new (turn of the century) non-traditional body and movement practice which began to be applied among dancers, particularly from the 1970s onwards in Britain.

Meditation and non–western movement practices

Another influence in the development of these listening and observational approaches to dance, movement and the body were non-western movement and meditational practices. Maedee Dupres pointed to meditation as a preparation to enable the performer to enter the performance 'moment' fully and consciously:

Meditation really teaches one how to be aware . . as a performer, this is really what one needs to work on, is to be conscious, is to be hundred percent in the moment . . and full, total, given attention. From your heart into what you're giving, into what you're doing . . and to be very generous with that. (Int. 1991)

Meditation based on breathing as practiced in (Za-) Zen Bhuddism and its related philosophy of 'Being without doing' was for de Groot:

A source of great inspiration at that time, which continued for me. It's underlying my whole idea of being able to dance almost, the Zen idea . . . I was reading a lot of Buddhist literature about "being", so somehow that was feeding my sense of body . . . then T'ai Chi Chuan, I started to do T'ai Chi because it was one of the forms that dealt with the body, like almost the instincts of the body, but in an incredible economical way and Yoga had been teaching me about the breath. (Int. 1991)

Other Eastern meditational breath-based movement practices talked of as influencing the dancers at the time were T'ai Chi Chuan and Yoga. The Martial Arts of

T'ai Chi as well as Ki-Aikido and Judo, all employing breath, movement flow, energy, balance, momentum, sensing of weight (gravity), were studied by dancers, Paxton recalled that:

In 1964, in Tokyo (Japan) I started Aikido for the first time and got very involved in that. It's been a major influence on my work and methods ... why that was so striking ... I had never seen a movement discipline that wasn't based in aesthetics. It was based on Martial Arts, which is a very different kind of philosophy ... life and death struggle, implicit in T'ai Chi Chuan, Aikido and Judo. To see a discipline that was based on life and death, rather than a message or expression, or lack of that – as Cunningham's was. Anyway, it was very much an eye-opener to see the differences, useful movement as opposed to expressive movement. (Int. 1991)

In addition, the disciplines of gymnastics and acrobatics were explored. Mary Prestidge (a former Olympic gymnast) began to deconstruct aspects of these disciplines in her dance and movement practice, incorporating in her teaching the challenge of breaking down other people's physical barriers:

I wanted to learn some basic principles of movement, of where the weight was going. How you could use it to propel yourself, using momentum and things like that. In teaching acrobatics ... let's see what happens when you go for a handstand. It was a challenge to break down many barriers for other people ... like going upside down. It really helped me to work with other people's barriers to get through, that created something to break, something to challenge, some tension to work with. (Int. 1991)

Exploration of the self

Besides the breaking of boundaries mentioned by Prestidge in the purely physical realm through exploration of basic movement principles employing the perceptual sense systems, another consequence of the observation of the body and its processes, these 'listening to the self' techniques, was the related – what Dupres called 'dive into the self'. In Prestidge's words, looking back on this period of development: 'it was self exploration I suppose. It had to start from the body and the mind really'.

This exploration of the self among dance-artists, through the direct employment of the sensory/sensing body opened up personal history, imagination, dreams, thoughts, memories, images, experiences, actions etc. as sources of investigation in movement and dance. Choreographic material could be derived from these sources and also form the frame of reference for the self, the moving body, to enter a present performance moment and environment. Improvisation, the presentation of immediate compositional structures as a 'live' performance mode and art form became established practice among the experimental, or new dancers around the mid-1970s in Britain.

Stretching the boundaries in and of performance

Dupres, who nearly always incorporated a period of time for improvisation in her performance progammes remembered, that improvisation and personal history also influenced the 'stretching those boundaries' of 'what we could do'. So dancers were singing, acting, telling stories, playing musical intruments, often in collaboration and improvising with sometimes dancing musicians, sometimes with dancing non-dancers with every day, or 'lay' bodies, or other dancers doing every day movements, or artists from other disciplines, who did other things in

performance. These other things ranged from showing a film, reading poems, or just 'being there', to the developing of 'live' improvisational performance skills and modes, pushing and extending the borders of established art forms.[6]

Other boundaries of performance conventions were broken, crossed, moved, and stretched in parallel lines with the new dance approaches and practices. Alongside unconventional bodies, movements and activities incorporated in dance, elements such as location and timescale shifted also. Dance performances, or events took place over extended periods of time like a slow walk across Chelsea Bridge in London, organised by Prestidge (1977). Dancers preferred non-traditional places to perform in such as galleries and museums (mentioned by de Groot). There was an expressed concern with making dance work for 'alternative spaces' like piazzas, churches or railway stations (Rosemary Butcher) and the desire 'to perform outside of conventional venues, like dance studios, on roofs, court-yards, wasteland, gardens'. As Prestidge put it: 'clear, conventional spaces for some sort of performance, but not your theatrical set-up'.

A different aesthetic

By the mid- to late 1970s, Contact-Improvisation (C.I.) and Release technique, or Anatomical Imagery Work, as developed and formulated by Paxton and Fulkerson respectively, had been introduced to dancers in Britain and the European continent. These two techniques and approaches to dance and the body, as well as other – individually developed movement principles around concerns similar to C.I. and Release such as weight, counter-weight, balance, falling, momentum, hanging and leaning, technique without tension, use of images, became visible in the outward, experimental and experiential dance forms at the time. Alongside these shared movement elements was the influence of the Eastern and non-traditional physical practices and related philosophies taken on board and incorporated by a young, or 'new' generation of post-war dancers in America, Britain and Holland.

The different movement aesthetic, or comparative 'non-aesthetic' noted by Paxton in the Martial Arts forms, was possibly gradually transmitted to and through the body, in the 'doing' of these – breath and self – observational, meditational practices and related explorations. The daily 'doing' of these practices affecting shifts in the structure of attention paid to one's self in movement and stillness, the conscious experience of, and at the borders of inner and outer self, the connection between thought and doing, or image and action.

The Self in the 'Live Art' of Performance

Through the speaking dance practitioners, I have described aspects of the body, the self in terms of preparation for, and exploration of performance (output)

[6] Extending the borders of musicianship, ranging from the soundscape creating high-tech, yet low profile performance work of Philip Jeck, to the organic (and technically sound) performing musician's presence of Sylvia Hallett, in their collaborations with numerous dancers over the last few decades.

including the bodily senses, the sense of self and the observation of inner processes. Multiple sources in the self were highlighted and illustrated, this time set against the background pictures – a field of reality, of and from the world of dance and dancers.

And so, from there to here, from past to present, back to the self in 'live' performance, or the self in the 'Live Art' of performance, I return to voice the questions I hoped to address in this probing, sub-verted form of 'live' performance, – a paper producing media- , in the (s)low motion act of 'writing' the text in a space of time. – What occurs, or happens in improvisation, the 'live' act and immediate art form and mode of composition in performance through the body/self in dance and movement? – How does this relate to 'live' compositional structures? – Why does the audience not always know the piece is improvised (unless you tell them), or think it is improvised when it is not?

These improvisational – structure – related questions, in consultation with the dance practitioners, turned into more questions about 'perception' and what is perceived as 'set' or 'improvised' in the 'live' performance of any dance (set or not). Furthermore, the 'improvisational' nature of the dancing experience and its similarity to real, or 'normal' life moved into the foreground, Paxton asked:

What are we talking about, when talking about improvisation. I don't sense that anybody knows how to say what it is very well . . . I don't sense that people understand that it underlies normal life to the degree that it does. (Int. 1991)

Fulkerson compared improvisation in performance with real life experience and described its features as an analogy to real life actions and moments, she said:

Improvisation is like crossing the street, you come up to the streetlights and you have to wait and that's your preparation and then the moment comes where you're going to cross the street and if you cross the street you can notice – if you just take the time-that everything is different from the day before . . . how you feel, what the atmosphere is like, the humidity, the light, the other people, the texture of the ground. Everything can be different than the day before and yet you go off from one stop light across the street to the other stoplight and you know exactly where you are going, but it is total improvisation, if you like. It depends on what level of awareness you have and this is why I have trouble with the distinction between set and improvised material. (Int. 1991)

The fine line (if any boundary can be identified), which separates the 'live' act (as in and of the 'Live Art' of performance) from 'real' life, was pointed out and located, in the act (ion) and art form of improvisation itself, by Paxton as follows:

I've analysed things to the point, where most of the structure disappeared. Looking at tiny elements of dance. Almost obsessed with tiny little elements that were of interest to very few other people, I did ten years of walking, standing and sitting pieces, . . . but after ten years of walking you notice that improvisation is happening every minute, that you are always adapting . . . This can be in extreme improvisation, or you decide to go someplace, maybe you decide to go to a country you don't know. You fly there and after that, that can be pretty extreme. Or you go to the corner store, stepping over the dog on the sidewalk. Whether it is raining or not, whether there is traffic or not. All the adaptions you do. It's there, in every step, in every fraction of a step. Every step is perfectly adaptable and keeps changing with the conditions. (Int. 1991)

In and at the last moment of this paper, although deviating here from academic convention and norm, or the path of linear logic, I am (still) in the process of connecting the recognizable points and lines (to keep within the metaphor of text and writing). In exploration and experiment I shall follow the analogical

proposition of the text, ending with sequentially coinciding discourses in and of dance and performance, an imaginary duet on paper, or a created dialogue breathed through the air.

Before I take my leave and 'improvise' my way out, off the page and out of the lecture space, I quote the words of the phenomenologist / dancer Maxine Sheets to close this probing of and at the borders of dance, set and non-set structures, 'live' performance and lived experience.

To create a dance is to create a uniquely dynamic form. There is nothing in any one dance which exists prior to its unique creation; whatever may constitute the nature of, and structures inherent in dance, both are created and created anew with each dance. (1966: 5)

Post–script for 'live' performance lecture

Image–Subject (ive): Breathe and imagine vertical line through the centre of the body, moving up the front, down the back with the in – and out breath whilst sitting, standing, gathering, packing, turning, stepping and walking.

Action–Object (ive): Get up and put tape on with sound. Calmly gather pages (ideally) in numbered sequence, place the paper / article in grey suitcase, take case and leave the lecture space empty, except for the sound.[7]

[7] 'Trumpets' composition by P. Callow, Newcastle, 1988.

Contemporary Theatre Review, 1994, Vol. 2,2 pp. 107–114 © 1994 Harwood Academic Publishers GmbH
Reprints available directly from the publisher Printed in Malaysia
Photocopying permitted by license only

The Screen: Looking through it, Walking through it

Tim White

Robin Blackledge's "Epitaph" and Forkbeard Fantasy's "The Brittonioni Brothers in 'An Experiment in Contraprojection'" are discussed as examples of British Performance Art that calls attention to the wholly visual way in which film and television is perceived. The former work suggests that the live performer can be compressed into the visual space of the screen, whilst the latter creates the illusion of a visual space on film that is circumjacent to that in which the performance takes place.

KEY WORDS British Performance Art, Blackledge, Robin, Forkbeard Fantasy, Film and Performance, Multi-Media Performance.

Two recent works that address the separation between the presence of the performer and the constructed image are Robin Blackledge's *Epitaph* and Forkbeard Fantasy's *The Brittonioni Brothers in "An Experiment in Contraprojection"*. British Live Art frequently employs film and video as a contrapuntal, malevolent presence. By setting up an opposition between the live performer and the pre-recorded image, the internal relationship between the differing media frequently offers itself as the content of the work. Alternatively, by conflating the distinction between the live and the pre-recorded, differences are found not so much within the work but in the varying ways in which it is regarded. Using dissimilar means, both of these artists attempt to privilege the present by manipulating the distance between the immediate and the mediated.

Robin Blackledge considers himself first and foremost a sculptor. After completing a Fine Art degree in Liverpool, he was concerned to amalgamate an interest in performance and dance with object work. Gaining a scholarship from the Bluecoat Gallery, Liverpool, enabled him to travel throughout Western and Eastern Europe, appearing at various festivals with his live sculptures. Concerned with the implications of presence, he would situate himself in an installation for five or more hours, taking the gestures of the audience and throwing them back at them. The alternating passivity and reaction created an uneasy tension between the fixed object and the mutable performer. The work draws on that of Stephen Taylor Woodrow, whose three figure piece, *The Living Paintings*, was shown in 1986, and Butoh dance. *Epitaph* marks a move away from presenting himself to an audience to offering a performance of his own devising. Funded by a North West Arts Board grant and Research and Development money from the Arts Council's New Collaborations scheme, the work has a depth that belies its modest five thousand pound budget.

The audience enter the space and are directed to a smaller, masked-off area. Within this are two metal screens, in front and behind the audience. The front screen consists of three panels shaped in the manner of a triptych seen from behind, and mirroring the arc of the rear screen. Set in each of the three panels is

a transparent window approximately three feet wide by two feet high. Behind this, the performing area comprises a seven metre cone formed from a flexible membrane-like material, three metres high at its opening and dwindling to a one metre aperture at its far end. The way in which the viewing area is prescribed by the fanning out of this cone invites recognition of the shared space of performer and audience, though this possibility of mutual habitation is tempered by the imposition of the viewing screens. The audience stand behind a line approximately three feet from these screens.

When near-darkness has been achieved, a faint ripple of noise runs across the outer screen, reinforcing the sense that the audience as much as the performers are confined. Suddenly, faces spring up from below the windows, four performers in pin-striped tops, only head and shoulders visible. It is the first of a series of tightly conceived disembodiments; openings in the fabric of the cone allow limbs and heads to emerge at all angles, whilst at the conclusion of the piece a bare back, arched like a conch, rises into the opening of the middle window. The body is fetishised in a way that is usually the preserve of the camera. It is one of many tensions the work sets up between the perspectival space, exaggerated by the conical structure, that draws things to its centre, and the imposition of the screen as a window on a larger world beyond it. André Bazin suggests that the picture frame and the screen are informed by opposing forces:

> The picture frame polarizes space inwards. On the contrary, what the screen shows us seems to be part of something prolonged indefinitely into the universe. A frame is centripetal, the screen centrifugal. (Bazin 1967: 166)

Blackledge's universe is finite, bounded by contraction of the space at one end, and the audience at the other. Centripetal movement is inhibited by the requirement that it is attended to; the audience, by their placement, physically limit the world they are regarding, and the physical separation of audience and performer reinforces the belief that the world will be seen rather than experienced. Choices as to what to attend to are largely removed; unlike a rectangular stage which permits events to occur simultaneously at the front and back of the space, here a performer close to the viewing window effectively obscures the rest of the space. In fixing the window on the world, any variation in that world must arise from the actions of the performers, who simulate close-ups, long shots and panning movements themselves.

The roving eye of the camera is replicated by the movement of performers between the front and back of the space. Blackledge feels that the movement furthest away from the audience has an abstract quality whereas that close to the viewing windows is typically more human. This is reinforced by the possibility of differing views of the performers close-up as they are seen from the side as well as straight on by looking through alternate windows, which gives them a three-dimensionality denied them when they are further away. By placing the construction of the view within the remit of the performers, the audience's sense of them performing is enhanced; every movement reframes the action. In this way, both performer and audience are driven to play out their respective roles by the placement of the viewing screen, the former composing shots, the latter attending to them.

Attention is drawn to the symbiotic nature of this relationship in a segment mid-way through the work. The performers advance to the front of the space in a manner projecting sexual desire. With only their heads and shoulders visible, the pouting of lips and widening of eyes, directed at the audience, are provocative as images, but curiously dispassionate as flirtation. The screen physically inhibits the development of more intimate contact with the audience and, by obscuring all but the top section of the performer's body, suggests that the gesture be acknowledged as the sign of desire rather than its presence. It invites comparison with the extreme close-ups of emotionally distraught victims, considered a vital component of television's narrativising of occurrences that become "tragic" in their recon-struction (Schechner, 1985). In both instances, the audience regard a person perhaps no further from them than the distance between people engaged in conversation: though they invite a response, whether compassion or reciprocal flirtation, none is possible. That the appropriate response is so clearly signalled, however, draws an audience in, not through identification with some fictitious character on the stage, but as the absent comforter or seducer, whose role is fulfilled by watching.

In attempting to seduce the audience, Blackledge's performers call upon a generally understood lexicon of signs that the audience are invited to respond to as if the subject of flirtation. The presence of the performers seems in excess of the visual shorthand they employ; excluding all but the expressive part of the body from sight and carrying out gestures that might emanate from any individual rather than one in particular. In *The Ecstasy of Communication*, Jean Baudrillard posits the stage and its inhabitants as remnants of an era of interpersonal communication that are made extraneous by the imposition of the screen:

We know that the simple presence of television transforms our habit into a kind of archaic, closed-off cell, into a vestige of human relations, whose survival is highly questionable. From the moment that the actors and their phantasies have ceased to haunt this stage, as soon as behaviour is focused on certain operational screens or terminals, the rest appears as some vast useless body, which has been abandoned and condemned. The real itself appears as a large, futile body. (Baudrillard 1988: 17-18)

In the project notes for the work, Blackledge makes clear his concern to map out an interior of the body, "to create a world within the performance which is a curious amalgamation of technology and 'inner body' imagery." The physical shape of the space is informed by this thinking; the performing area fans out in the manner of the image from an ultrasound scan, whilst the cone suggests the view from a fibrescopic video camera, exploring the serpentine innards of the human body, the membrane-like quality of the walls contributing to this impression. The sound is derived from heartbeats and biorhythm patterns, varying in intensity in parallel with the actions of the performers. These allusions to the body are mediated by technologies that privilege the visual and the (reconstructed) aural over the doctor/patient relationship and perhaps accelerate the loss of interior space, the obscenity which begins "when every-thing becomes immediately transparent, visible, exposed in the raw and inexorable light of information and communication" (Baudrillard 1988: 21-22). The viscereal body is only able to re-enter the space after it has been transposed into information, after it has been processed and extraneous phenomena dis-carded. As Susan Sontag observes, commenting on the difference between

seeing an actual medical operation and its depiction in Antonioni's film, *Chung Kuo:*

One is vulnerable to disturbing events in the form of photographic images in a way that one is not to the real thing [. . .] For the real operation I had to get scrubbed, don a surgical gown, then stand alongside the busy surgeons and nurses with my roles to play: inhibited adult, well-mannered guest, respectful witness. The movie operation precludes not only this modest participation but whatever is active in spectatorship. In the operating room, I am the one who changes focus, who makes the close-ups and the medium shots. In the theatre, Antonioni has already chosen what parts of the operation I can watch; the camera looks for me – and obliges me to look. Further, the movie condenses something that takes hours to a few minutes, leaving only interesting parts presented in an interesting way, that is, with the intent to stir or shock. (Sontag 1973: 168-9)

It is a further irony that in looking for the "liveness" of the work, the viewer is given signs of life that may have already passed. The references to monitoring equipment reinforce the notion that the more fully the body is known in these terms, the less one is able to interact with it, to bring one's own corporeality into contact with that of another.

In Blackledge's work the screen facilitates the transmission and assimilation of images, and it is on this that the relationship between performer and audience is predicated – the performers cannot simply move and be seen, but must direct their actions toward the opening whilst the audience must likewise direct their gaze or else see nothing. Rather than allow a dialogue between live and transmitted material, which enables the audience to actively choose what to attend to, the work denies the viewer any element of choice. The screen is interposed between performer and audience in such a way that the lure of its transparency conditions both action and response. Moments of opacity are rare, arising as much from the circumstances in which the work is performed as the fact that it is performed rather than broadcast. One brief moment in the seduction section looks toward the unmediated that is almost otherwise excluded; when one of the performers exhales too close to the screen, a momentary circle of steam appears on its surface, marking their presence, but obscuring the view.

Where Blackledge's performers remain behind their screen, the two performers in Forkbeard Fantasy move in and out of the screen with the same frequency other actors might negotiate French windows. Forkbeard have been presenting work, whether installations, street theatre, photography, film or touring shows since 1974. Though their activities are diverse, they share an enthusiasm for the absurd, frequently overcoming the soporific effect of high technology upon life with the ingenuity of their low-tech interventions. The early work consisted largely of outdoor pieces in which the two performers, brothers Tim and Chris Britton, silently interacted with their bizarre contraptions, drawing on a fascination with insect behaviour. *The Cranium Show* (1976) is described in their retrospective comic as a "Wildlife Documentary concerning a day in Life of half-arachnid *Cranius Kitchenetus*, male, female and zoo-keeper." The pieces evolved a narrative structure as the sometimes inexplicable actions were given a more overt comic edge. During the late seventies the brothers collaborated with a number of artists engaged in performance, including Ian Hinchliffe and Roland Miller. As with their other work, *The Brittonioni Brothers* calls on the various skills of its originators; Chris' understanding of experimental theatre and staging is complimented by Tim's cartoon-influenced visual sense. The film work is undertaken by their father,

Jim, whilst Penny Saunders, the director, realises the improbable props that populate the performances.

In the guise of their alter-egos, Timmy and Chrissy Brittonioni, the performers greet the audience resplendent in mirror shades and ill-fitting clothes from the wardrobe of the sartorially disenfranchised. The piece begins as a retrospective of the auteurs' oeuvre, parodying the pretensions and nepotism of the film world. From the outset, their irreverence extends to the film itself; Timmy sits in the audience with a Super-8 projector on his shoulder, playing a film of Chrissy moving on the spot ("Rollerblind"). At the same time, Chrissy is rotating the backdrop on which it appears, revealing obstacles and impediments to the image's progress which are overcome by jumping over and crouching under them by moving the projector. As with the subsequent films, its integrity is undermined by the realisation that it is incomplete without the interaction of the performers. This dependence is itself later the subject of parody in Chrissy's foray into multimedia, "Bidet". First shown at the 1967 Zurich International Festival of the Avant-garde, this "unique collaboration with Hilary Liverwort the indeterminist opera singer, Maria Grotowski the cubist choreographer and Penny Margaret Saunders the kinetic sculptress" synchronises revolving plastic buttocks with an animated skeletal torso projected onto Chrissy, now attired in a fetching white polo neck. It is the first of several costume changes that the audience are given to understand arises form the character's desire to appear dressed à la mode, though subsequent improbable lurches in the narrative raise such details to a much greater degree of significance.

Having established a fairly plausible comic situation, which entails the showing of a selection of films from the Brittonioni's career, the work switches direction when, during the projection of "Who Shot the Cameraman?", an unknown anorak-clad figure makes an appearance in the film. The brothers determine that the figure is not "a hair in the gate" (of the projector) but an intruder who somehow has infiltrated the celluloid since it was shot. To remove the trespasser who is gleefully running around on the film, Chrissy leans behind the screen on which the film is projected. As he does so his head appears on the film, even as the audience can see the rest of his body on the stage, crossing "the celluloid divide". Once this has been breached, all manner of transactions occur across the space. A priceless camera seen on film is retrieved by Chrissy stepping out of the film into the auditorium, whilst Timmy (on stage) appears to hold a telephone conversation with his brother (on film). Here, the basis on which the piece is viewed is undermined as the interaction between live performance and film, hinted at in "Rollerblind", is taken to the point where the film is solely concerned with the present. The precision with which the performers appear to walk in and out of the screen challenges the belief that it presents an inviolate here and now distinct from the one in which the audience find themselves. Bazin's conception of the film frame as a window on a space that stretches indefinitely into the universe posits a real world of which the image on the screen is a part, though the placement of the audience in relation to this world is unspecified. It perpetuates belief in a holistic world view without having to place oneself within it. The conviction that something on screen *has* happened and that this something is of importance because it was filmed contrasts with the less specific moment of watching. In "Who Shot the Cameraman?", the past is incomplete, seemingly

requiring the intervention of the present; without the interaction of the live performers the projected film has no narrative.

Though the spatial contiguity of film image and live performer affords much of the humour, the temporal convergence is more disorientating. Undermining the integrity of the past questions the distinctness of the present. Events that unfold on stage cannot be regarded as unequivocally present because they are dependent on what has already passed, whereas this prior moment looks forward to the present for validation. Particularities of costume and character that the audience discern in the present have already been fixed on film and events on film behave according to the circumstances of the present. Calling attention to the uncertainty of positing a holistic past looks toward the possibility of a present no longer impelled to re-present it. The present moment then becomes something in excess of a moment in which the past may be played out:

In the absence of any true origin, nothing is original, which is not to imply that the origin is merely nothing. When nothing is original, *(le) tout* is secondary. If, however, all is secondary, something is always missing and everything is always lacking. [. . .] That which is always already missing is a past that is "infinitely past" because it was never present in the first place. What has not been present cannot be re-presented. (Taylor 1988: 15)

The validity of the narrative structure is questioned, as the apparent framework – the Brittonioni's showing of their work – is usurped by one that emerges subsequently – the interaction with the film – but reaches back prior to the performance. This too, however, is incorporated within the narrative at the beginning of the second half as the Brittonionis present their "Experiment in Contraprojection". Using back projection and the revered Eisenstein projector, the space on the film replicates the real space behind it, culminating in the brothers (on film) cutting the paper screen in half and crumpling their image as the real characters appear behind the screen with the crumpled screen in their hands. This flaunting of continuity – incorporating crossing the celluloid divide in the film shown in the second half of the performance when it has only been discovered by accident as "a cinematic first" some forty minutes earlier in the first half – is consistent with the work's tenuous grasp of credibility. Though the piece is tightly structured, it either appears at the mercy of the filmed past or dependent on unexpected and highly improbable occurrences in the present (that in turn are usually dependent on film shot in the past). The only part of the narrative that seems to be linear occurs with the intermittent return to the presentation of the Brittonioni films.

The most improbable development occupies the last section of the show, which is taken up with the consequences of Chrissy's mirror shades falling into the workings of the Eisenstein projector, causing an infinite number of progressively smaller Timmys and Chrissys to replicate beyond the screen. Bazin's idea of pictorial space is here applicable to the film image as it vanishes into the centre. Instead of having to choose what will be seen in the window onto the filmed world, the Brittonioni Brothers themselves populate it; it is not a universe of which they allow the audience a glimpse but one they construct and literally inhabit. Chrissy enters the screen to terminate the replication of countless hordes of Brittonionis that threaten to overpopulate the planet and subsequently emerges dishevelled but triumphant. Inspecting the tattered remnants of his once pristine clothes he finds a thin sliver of film on which he can just make out the words

"...TH. .THE. . .E. . . .EN. . .END", which brings to a conclusion the ostensible story (the screening), the film from which they had escaped and, paradoxically, suggests that the tyranny of the celluloid which they had overcome might itself be viewed within the conventions of film.

In Blackledge's *Epitaph*, the viewer might be regarded as positioned at the far point of infinity, unable to do anything other than view eveything that fans out before them, the screen determining what and how much of this they might see. Forkbeard Fantasy reverse this situation, siting the vanishing point in the screen, so that what appears on it is subject to those things going on in front of its flat surface. Though the works are informed by widely differing sensibilities, they share a concern with the dual function of the screen as window and barrier. Blackledge taunts the viewer with the transparency of the screen that privileges the visual to the extent that it becomes a substitute for the experience itself. Forkbeard start with the premise that film is a tool like any other that they can manipulate for their own ends. The films hijack the Brittonioni Brothers' presentation though they in turn are tamed by the Forkbeard performance. The absurd and the implausible confront the 'normality' of the screen image, dragging it into a present seemingly without a narrative structure and populated instead by happenstance.

In contrast to Forkbeard Fantasy, where Blackledge allows the performers a space that seems to have considerable depth, the intervention of the screen flattens this out to the point where

[. . .] space has no social existence independently of an intense, aggressive and repressive visualisation. It is thus – not symbolically but in fact – a purely visual space. The rise of the visual realm entails a series of substitutions and displacements by means of which it overwhelms the whole body and usurps its role. (Lefebvre 1991: 286)

Here, it is the consciousness that they are indeed witnessing a live performance that invites the audience to recognise the substitutions and displacements that lead to the negation of all but a small region of their body – the eye. In contrast, Forkbeard draw the audience towad a purely visual space only to apparently fill it with live performers or else have them climb out of it into their own environment. Both strategies could be regarded as multi-media performance, though unlike other works that employ a thematic contrast between live and pre-recorded material, Blackledge and Forkbeard have produced pieces that blur the distinction between media.

Despite their obvious differences these two productions collapse the distance between that which is played out and that which is played back, altering the manner in which the live and the pre-recorded are regarded. Both Blackledge's use of a simple glass viewing window, and Forkbeard's low-tech "home movies" undercut the notion of the screen as a high-technology medium. In contrast, the performers' presence and behaviour could be regarded as unnatural both in what the audience see of them (dismembered body parts and false perspective in *Epitaph*) and in their actions (climbing in and out of the screen and talking across the celluloid divide in the case of *The Brittonioni Brothers*). In these ways, the live and the pre-recorded both admit a degree of opacity, questioning the status of the former as a world in a window (centrifugal) and the latter, as a window on a world (centripetal). Once this opacity can be admitted into the work, the primary dynamic might then shift from that between live and pre-recorded to

that between the world and the (previously transparent) window through which it is seen.

 The screen is thus used, not as a contrapuntal device, but as a template on which both live and pre-recorded actions are played out. Much work that is assigned the term 'multi-media' accentuates the distinction between the image on the screen and the performers. Often, the image is multiple, contemporaneous with the performers' actions but depicting another time or place. The British company, Forced Entertainment, frequently utilise contrasting live performance and pre-recorded material. The monitors hovering above the self-destructive frenzy in the group's *200% and Bloody Thirsty* project a conversation between two heavenly observers whose placidity is matched by the violent actions of the onstage performers. A recent piece by Mark Gaynor, *In a Network of Lines*, part of a season of work combining performance and projected images at the I.C.A. in London, also uses film and live presence in a contrapuntal manner. As the lights come up on the work, Gaynor stands naked, with his back to the audience, vulnerable and alone, whilst monitors replay footage of the Gulf War precision bombing. The performance is provocative, subsequent events challenging the assumption that the performer's presence contrasts with the absence of the screen image by reversing their respective roles. In a different manner, Solid State Opera's production, *The Last Broadcast* enhances differences between the live and prerecorded. Staged in a geodesic dome as part of Liverpool's "Videopositive" season of work, the singers and dancers performed on and around a set that projected into the viewing area, foregrounding their physical presence. Above them, on rotating spars, miniature television screens were arranged in an inverted triangle, projected two eyes and a mouth, disembodying the performer to reconstruct them as a pure communication device. The two pieces discussed here, however, disrupt, and so withdraw the means by which one might make such a distinction. As a consequence, the beholder is then invited to ascertain what terms operate within this unified whole that would disregard the parameters by which one might separate one form from another. By inviting consideration of what is before them as alternately live and mediated, this work would empower the viewer, inviting her to choose how to regard the work.

References

Baudrillard, Jean (1988) *The Ecstasy of Communication* [originally published as *L'Autre par lui–même* Éditions Galileé Paris 1987] (trans. Bernard & Caroline Schutze) New York: Semiotext(e)

Bazin, André, (1967) "Painting and Cinema" (source unknown, not given in French edition) reprinted in Bazin, André, *What is Cinema?* (trans. Hugh Gray), London; University of California Press Ltd

Blackledge, Robin (1993) "Epitaph: Production notes" unpublished

Forkbeard Fantasy (1987) *Forkbeard: Comic Theatre and Film* Devon: Forkbeard Fantasy

Forkbeard Fantasy (1993) *Forkbeard Part 2 1988–1992: Theatre and Film Productions* Devon: Forkbeard Fantasy

Lefebvre, Henri (1991) *The Production of Space* (trans. Donald Nicholson-Smith) Oxford: Blackwell

Schechner, Richard, (1985) *Between Theater and Anthropology*, Philadelphia: University of Pennsylvania Press see especially "Chapter 7: News, Sex, and Performance Theory", 295–324

Sontag, Susan (1973) *On Photography* New York: Farrar, Straus and Giroux

Taylor, Mark C. (1990) "Back to the Future" in Silverman, Hugh J. (ed.) *Continental Philosophy III: Postmodernism – Philosophy and the Arts* New York and London: Routledge, 13–32

Contemporary Theatre Review, 1994, Vol. 2,2 pp. 115–129 © 1994 Harwood Academic Publishers GmbH
Reprints available directly from the publisher Printed in Malaysia
Photocopying permitted by license only

Photo: Roberto Caviares.

A View from the Edge

Greg Giesekam

The article documents the 1992 Tramway production of The World's Edge, devised by the Scottish performance company Clanjamfrie. The production responded to the quincentenary of Columbus' arrival in the Americas by collaging found texts, personal memories, movement sequences, video, film, and music, to set aspects of American history against issues of identity and representation in a culture saturated with media images of America. In the context of recent debates about the treatment of history and politics in post-modern theatre, it is suggested that it has characteristics of a theatre of resistance which Auslander has identitified as displacing previous models of a theatre of transgression, exemplifying a practice which, in Hutcheon's terms, is inside yet outside, complicitous yet critical of the cultural dominant.

KEY WORDS Live Art, Documentation, Clanjamfrie, Post-modern, *The World's Edge*

This article attempts to provide a trace or 'aftermath' for a production of *The World's Edge*, devised by the Scottish group Clanjamfrie for performance during Glasgow's Mayfest in 1992.[1] Although the world's edge of the title links the performance to the quincentenary of Columbus' arrival in the Americas, the piece became more than a play about Columbus, collaging found texts, personal memories, movement sequences, video, film, and music, to set aspects of American history against issues of identity and representation in a culture saturated with media images of America.

[1] Based on notes from two viewings, on 15 and 19 May, and a subsequent interview with some of the company, extracts from which accompany this account. For discussion of the difficulties associated with attempting to document performances of this sort, and yet the need to do so, see Kirby (1974); LeCompte (1981), argues that such attempts are inevitably distortions, and W.D. King (1992) provides a cautionary tale about the 'dramaturgical text' produced by such attempts. While it may be like looking at a snake's old skin after it has sloughed it off and moved on, we should recognise that the dearth of descriptive accounts contributes to the erasure of such approaches to performance from most published treatments of recent British theatre.

As a way of suggesting one of the critical areas which might be explored in response to *The World's Edge*, a brief overview of recent discussion about the way in which history and politics are represented in post-modern performance may be useful. The past decade has witnessed an urgent debate over the possibilities of a political theatre which acknowledges the problems which both post-modernity as a cultural condition and post-modern theory have posed for traditional notions of the political and the subject. In a culture marked by postmodernism's 'veer(ing) toward's playful, optative, disjunctive, displaced, or indeterminate forms, a discourse of fragments, an ideology of fracture, a will to unmaking, an invocation of silences' (Hassan 1981:36), yet also marked at the political level by conflicting tendencies towards totalisation and dispersal, can theatre find appropriate ways of dealing with historical or political concerns or is it stuck with the epic and agit-prop modes which have dominated political theatre this century and in particular shaped post-'68 work in Britain?

In an article suggesting that greater focus on visual images, deconstruction and self-reflexive processes led to a loss of moral seriousness in the American avant-garde of the 1970s, Bonnie Marranca challenges claims that ambiguous, 'open' performance works allowed a greater role for audiences' imaginations:

This opportunity for the audience to think theatre through without being presented with a closed value system, or order, seems less and less true as the author's/ group's point of view diasappears in the theatre. Because imagery is often too ambiguous, too available, and finally, technologically in advance of human capacity to assimilate it in a *critical* way, audiences are again being turned into 'consumers' – consumers of imagery that is more seductive than challenging to the intellect. (Marranca 1981: 67)

This plenitude of images may replicate the very Baudrillardian world of simulacra which some performers claimed to be challenging. Critics such as Schechner, Blau and Vanden Heuvel have argued that the deconstructive turn in much post-modern performance, rather than opening new doors of perception, has often led performers into an endless, narcissistic hall of mirrors, in which playing Lyotard's language games has descended into an onanistic solipsism. Approving Jameson's view that "History is what hurts, it is what refuses desire and sets inexorable limits to individual as well as collective praxis", Vanden Heuvel argues,

in the pursuit of *jouissance*, performances of the seventies were especially apt to ignore the reality of history. . . In doing so, these performance works pursued desire rather than what constrains it, and disregarded culture rather than seeking to understand its power structures. (55)

In contrast, Auslander suggests that old models of a theatre of transgression (associated with the historic avant-garde and programmatic left theatres) are giving way to a theatre of resistance, in which a non-charismatic approach to perfor-mance "discourages the spectator from endowing either representation or representor with authority and encourages the spectator to focus instead on the process of representation itself and its collusion with authority". (1987: 33) Discussing the Wooster Group's handling of text and performance in *L.S.D.*, he argues that their deconstruction of presence "makes its presentation self-conscious enough to resist the numbing effect of mediatization as described by Baudrillard", and suggests,

If this theatre is less programmatic than more traditional models of political theatre, if it seems to ask as many questions as it answers, it may be well to bear in mind Foster's observation that 'clearly this

is not a confrontational moment in the classical political sense' and, parapharasing Foster, to describe the Wooster Group as a 'theatre with a politic' rather than a 'political theatre.' (33)

Johannes Birringer also locates political possibilities in strands of post-modern theatre which see the body as a site of resistance to the mediatisation of experience described by Baudrillard :

We need to give more attention to those postmodern performances that do not let the multi-media apparatus represent itself to itself, but react against that *mise en abyme* by foregrounding, and experimenting with, the transformable theatricality of body and voice in real space-time – and thus addressing the actually changing conditions of representation *for* social subjects that we experience today. . . . They can be engaged differently by collaborative artistic practices that care about the context-specific, social, and ethnic identities of the body and the subject of performance, and that – even more anachronistically – insist on an ethics of (re)productive choice. (Birringer 1985 : 231)

If this account seems to be dominated by American voices, this is not so much symptomatic of the dominance of 'global posmodern American culture' as of a tendency of most publications about recent British theatre to ignore these issues and focus on the more orthodox political strategies of writers such as Edgar, Hare, McGrath et al. Furthermore, while the terms of the debate might have been applicable to some English and Welsh performance work through the 1980s, it would not have found many resonances in Scottish theatre until recently. Although the Centre for Contemporary Arts and Tramway have provided platforms for a wealth of European and American postmodern dance and theatre, and although one might detect a postmodern sensibility in some productions by companies such as the Citizens' Theatre and Communicado, it is only in the past five years that companies such as Test Department (Scotland) (now NVA), Randomoptic, and Clanjamfrie have emerged as groups adopting a more conscious post-modern approach to performance.

Clanjamfrie's approach to *The World's Edge* exemplifies a young ensemble working to find a process which might take account of their personal and political concerns, while adhering to an aesthetics of multi-media peformance which reflects their sense of ambiguity, fragmentation, and rupture in contemporary culture. With performers coming from diverse geographic and artistic back-grounds, the project bears the traces, aesthetically and politically, of the process of finding something to perform, through which their various positions might emerge dialogically, rather than setting out on a project with already defined political and aesthetic objectives and presenting them as an authorised (and authorising) totality. This processual approach was carried through in performance : the performances continually made overt their process of creation, a process of conflicting histories and desires crossing and touching, inviting the audience to examine this as much as the content ostended in texts and images.

The Company

Clanjamfrie was founded by Emma Davie in 1989. After study in Oxford and training with Philippe Gaulier and Monika Pagneux in France, she returned to Scotland with a determination to create devised theatre of a non-narrative kind, which might explore Scottish identity in a way different from companies such as 7:84 or Wildcat. With several other young performers she devised a piece, *Tam Lin*,

which used mime and clown work to explore kitsch representations of Scottish life. One of that group, Katrina Caldwell, carried on to work with Emma on subsequent shows. Jules Dorey Richmond joined for the next production; a Dartington graduate, she had previously worked with Test Department. Her interest in live art installations influenced the development of *Snapshots*, which explored photography and nostalgia, and *Desire Lines*, an outdoor production involving 60 performers creating three spectacular environments in Glasgow's Queen's Park. In 1990 Emma also performed in Robert LePage's *Tectonic Plates*, and some of his visual approach is recognisable in *The World's Edge*.

The company was commissioned by Tramway to create a show for its 'New World Order' season, which also included a Bread and Puppet performance on the Columbus theme and the Nicaraguan company Nixtayolero. (The conjunction of the Columbus quincentenary with triumphalist declarations of a 'New World Order' after the collapse of the Eastern bloc lent an urgency to counter-treatments of the Columbus myth in 1992, although the proliferation of such work may have served to defuse their impact.) Exploring the history around Columbus, they became conscious of the gap between the mythology they had imbibed as children and the story of genocide which stemmed from the European settlement of the Americas; this led further into investigating issues of representation and the impact of childhood memories and images. Wishing to involve American performers in the project, they held a week-long workshop, which led to Pepé Gudino Resendiz (a Mexican actor), Lucax Santana (a Chilean musician) and Daryl Fraser (a dancer trained in New Mexico), joining the company. After several weeks of exploration and devising, they were joined for the last month by David Richmond, who came in to apply an outside directorial eye to the material which was already taking shape.

E.D. : We thought we can't talk about Columbus, here working in Britain – it would just re-inforce certain things – so we advertised for American performers. We asked people to prepare a piece on the theme of the World's Edge : for Pepé, a lot of it was about Aztecs and his culture; for Lucax, it was his instruments; for Daryl it was about being half-Scots, half-African-American, how he felt about living in Scotland, being black, feeling out of place; he was brought up on airforce bases round the world, but spent a long time in Scotland; but even in Scotland they had American toilet paper, it was like living in a little America wherever they went.
D.R. : He thought that when he went to America, he'd go to Harlem, and he'd feel at home; but he went and he didn't feel it. He was called a yellow nigger.

The Production

Performances occurred in a derelict boilerhouse behind Tramway, a space not used previously for performance. Beyond installing temporary seating blocks and lighting rig, little was done to convert it into a more conventional theatre-space. The audience gathers in the Tramway exhibition area and is taken as a group to the space – paralleling in microcosm the journey to a 'New World' which was one of the performance's starting points. Entering, we 'discover' the space and three of

its inhabitants/performers. While people settle, the audience divides attention between watching the quietly moving performers and 'exploring' the space : observing its dilapidation, the exposed brickwork and roof-beams, the dirt floor, the half-collapsed wall (c.3m high) which forms a rear boundary to the playing space (behind which was an unseen 'backstage' area). Intruding into the atmosphere of dereliction evoking a 'poor theatre' aesthetic, the rear wall is surmounted by a projection screen, while downstage there are a television monitor and a small podium and microphone-stand backed by a spangled flat.

The notion of discovering 'inhabitants' along with the space is enhanced by the immediate 'exotic' visual and aural impressions created by the performers. Lucax plays various South American instruments including culumba and occarinas; Daryl and Pepé, in black t-shirts and khaki trousers, mould sand which covers most of space into a landscape of walls, ziggurats, pyramids. They rake out a surrounding moat and mould four entry points to the 'city' : we recall the great cities of the Maya and Aztec civilizations. As house-lights fade, the scene is dimly lit by orange floor-lights. The music shifts from woodwinds and rattles to drumbeats, which, along with the increasing pace of the 'builders', induce a mounting sense of anticipation – we are waiting for the show to move beyond this 'scene-setting'; the 'city' is waiting for . . . what? the arrival of Columbus? Already a sort of double-coding is operative, as the melodramatic shift in the music also recalls cinematic treatments of Amerindian themes.

As Lucax returns to rattles, upping the tempo, the lights fade completely. Daryl lights a candle, addressing us, "In the beginning there was an explosion". He recounts a foundation myth of the earth and the sea, culminating : "In the beginning there was the sea and on the sea was Columbus. A boat approached. . . " Smoke billows out, enveloping his final line, "This was the future."

A recording of Thomas Tallis's choral work *Spem in Alium* blasts out over the loudspeakers, drowning out the South American music. Over it, we hear the start of Genesis. Through the smoke we see a hooded figure carried on and dumped on the ground. As the text reaches, "And God said, let there be light", the lights fade up a little and we see a woman, clad in a high-necked, ankle-length black dress, flying through the air towards the audience, with her hands in praying position, intoning repeatedly, "In the beginning was God, and god created man in his own image. . . " As she hits the ground on her downward swings, the delicately built sand city is quickly obliterated. Soon, Pepé stands up, takes his hood off and begins a prayer in Spanish: "Oh senor, dios omnipotente y eterno. . . . " As he falls to the ground and prostrates himself at the end, the flying 'missionary' makes an open arm gesture of blessing. Further smoke envelopes them.

D.R.:	Columbus made up his own prayer when he arrived in America.
G.G.:	I was unsure – since he seemed to be doing The Lord's Prayer with some changes – was this an image of a humble(d) peasant taking on the Christian religion? Or was "oh Senhor" in fact addressed to Columbus as Lord?
E.D.:	I don't think it mattered – people didn't need to know it was Columbus' prayer – it was the religious imagery we wanted.
D.R.:	It was also for Pepé taking on the Spanish culture.
E.D.:	I quite like the fact that Pepé knew it was Columbus' prayer and we knew, but the audience didn't.

L to R: Emma Davie, Katrina Caldwell, Jules Dorey Richmond in Clanjamfrie's *The World's Edge*. Photo: Maggie McRitchie.

As the lights fade up again, we see that the nun (Katrina) has unhitched herself and two others (Emma and Jules) are flying through the air, in an arc out over audience, proclaiming, "In the beginning was God...", while the choral music still blasts out and the Genesis tape repeats.

As lights fade on the flying figures, Katrina appears, spotlit, in front of the star-spangled flat (tatty as though for an amateur talent hour). Taking the mike, she says, "Oh that's a relief" (indicating where the harness has been). This shift from the carefully crafted representation of history in the opening sequence to the here and now of an aching performer is lent further ambiguity by the manner of her next lines. She welcomes us in hostessy manner: "Hellow, I'm Katrina, and we'd like to welcome you to the Boilerhouse. I truly hope you have an enjoyable evening. Now I'd like to sing you a song, by Old Blue Eyes himself – one of my favourites." In one minute, she's moved from performer in role (more icon than character) to (seemingly) the real person commenting on her task, and then, at the moment of introducing herself, to a presentational self which also seems to ironise a particular type of performer/audience contact. This fluidity, even slipperiness, reminiscent of the Wooster Group, becomes characteristics of the performers through the production. Unsettling the audience response continues in her unaccompanied version of *Fly Me to the Moon*, a gauche imitation, but not overt parody, of night-club singer style: some spectators applaud at the end, while others, perhaps cued by the visual pun of Emma and Jules still flying, take the performance more ironically. Towards the end of the song, the two unhitch themselves and attach three simple wooden crosses to the ropes, which are raised again, leaving the crosses looming over the scene.

J.D.R.:	We wanted to set up things where we could explode them – at the beginning, with all the smoke and costumes, music and everything, then we break to someone saying, "Hello, welcome to the Boiler-house", and they go into a song, then that's exploded and we go into the boat and so on. . .
E.D.:	It's exciting to explore standard actor/audience relationships – seeing how you throw things back at the audience. . .
J.D.R.:	The songs I thought were really sleazy, but people clapped. Because they're aware of the conventions and they go along with them. . .

As Katrina concludes, Daryl comes down centre and describes doubts about a sea-journey he's been on – the audience is unsure whether he's in the persona of one of Columbus' sailors or just himself; soon it's revealed that the journey was a 'research' trip by the performers, to experience what it's like being at sea in a small boat – and that it was in the Sound of Jura. He proceeds to a cynical, sometimes comic, account of the ridiculousness of the exercise. Meanwhile, Emma begins to drag her feet and arms through the sand, marking out a boat shape – including Daryl in the prow; she begins an earnest account of the discomforts and dangers of embarking on a small boat in the Atlantic for months of voyaging "to the edge of the world". On the rear screen film of crashing seas and rugged coastline is projected, while Daryl mocks the expedition : "Picture it: 7.30 on a Sunday morning. It's raining, blowing a gale. . . in a stupid little dinghy. . . two of the girls singing Hawaii 5–0. . . puking over the side. . . " Meanwhile, Emma describes other Atlantic voyages : Columbus' return with captives, slave boats, 19th century Scottish and European emigration etc. Throwing herself to the ground to illustrate the confined sleeping space, she describes the deaths, the disease, the uncertainty, and the conditions at home which impelled such migration. Daryl moves to the microphone by the end of his speech, to dominate Emma's account. Paradoxically, his account of the awfulness of their mini-voyage, more than the facts contained in Emma's attempt to 'recreate' history in a demonstration, gives a more immediate sense of the discomforts of a sea-trip; the affective impact is furthered by the increasing desperation of Emma's efforts to compete with his speech and the noise of the sea-film : the process of performance itself and the conflicts behind its making are foregrounded, marking the attempt to 'present the unpresentable'.

Half-way through the Daryl/Emma sequences, Katrina and Jules appear before the rear wall screen, performing a series of movements, stretching up, opening arms out wide, touching the ground, pointing to the sky : these are eventually revealed as gestures to go with the Sunday-school hymn, "Wide as the ocean". As Emma begins to perform the gestures, and is then joined by Daryl, Jules begins a child-like rendition at the microphone:

"Wide, wide as the ocean,
High as the heavens above,
deep, deep as the deepest sea is my saviour's love.
I'm oh so unworthy, still I'm a child in his care. . . ."

Again, a double-coding implicates the audience : the fragile, child-like quality of the synchronised 'signing' of the song and Jules' singing evoke an almost

sentimental pleasure in the performance, at the same time as the context frames it with irony.

Towards the end, Pepé jumps off the wall and begins spinning, calling out, "Esta noche nos caeremos del mundo"; the others join in turn, saying it in Gaelic, Portugese and English – they spin until they drop. As Emma spins, she continues her speech about emigrants, juxtaposing the sight of the Statue of Liberty with the experience of oppression, inequality, injustice, that awaited many of them. As she drops, Jules takes up the spinning, calling out "tonight we fall off the world." Daryl moves downstage to recite Emma Lazarus' Statue of Liberty poem, leading to the famous lines,

".... Give me your tired, your poor,
Your huddled masses yearning to breathe free;
the wretched refuse of your teeming shores...."

The last verses, done in increasingly 'heroic' fashion, are accompanied on video by the advertisement featuring President Bush inviting people to visit the United States – where the Statue of Liberty becomes a commodified symbol luring the wealthy tourist rather than welcoming the poor refugee. As the 'tired and poor' are mentioned, the other performers rise slowly and move off-stage.

Having presented a compressed, though self-reflexive, picture of the earlier settlement of America, the performance now moves towards confronting the performers' own entanglement with contemporary America. While Pepé and Jules re-enter and begin a series of reaching and falling exercises down-stage, Emma's image appears on the downstage monitor : she looks at a hanging plastic globe. She begins an account of having flown the Atlantic 48 times – first when she was three, when the family moved to Toronto, then, when she was five, her mother took her back to Glasgow, leaving her father in Canada: "We used to visit him every year. Every year we said good-bye at the airport . . . The airport was always full of dramatic scenes – people saying good-bye to family they didn't know if they would see again, and the planes from Glasgow to Toronto are always full. Funny to think if I'd stayed I would've been Canadian." This last comment, throwing up the contingent nature of one's national identity in a century of migrations, is almost done as a throwaway. Her video face dips to address Pepé (live on the ground) : "It's your turn, Pepé."

Pepé tells an Aztec creation myth :

"In the beginning we came from Quetzacoatl. He went to the place of the dead, and there Quetzacoatl took the male and female bones. He fought against the Lord of the Dead and Quetzacoatl died. He was then resurrected and sprayed the bones with his own blood and so gave us life."

Significantly, he returns to Spanish as he begins to describe himself, while Jules at the microphone does simultaneous interpretation (also imitating his gestures):

"I am Meztizo. It is a mixture of Mexican and Spanish. And the result is this (points to skin). A pure Mexican has a much richer skin colour. And bigger eyes. Slanted (illustrates). And nose like this (squashes nose). I think my head shape and stature are the closest Mexican physical characteristics I have. I do not speak any of these Mexican dialects or languages – Hatwatl, Zapoteco, Purepecha. I speak Castellano."

Having signalled the problematic hybrid nature of his 'Mexicanness', he returns to English, to say, "But inside me I'm 100% Mexican", going into a parody 'film

Mexican' routine. Jules brings hime a blouson jacket and asks him to teach her a Mexican dance. He puts a mournful song on the tape-recorder; they move into a slow dance, creating a delicate, fragile mood.

As they dance, Daryl enters. Moving down right, he lights a cigarette – lighting his face in the darkness, a pastiche of the cliched cinematic shot. He speaks of his arrival in America – of the sensation of heat hitting him as he reached the tarmac, of his first breath of American air, of reaching out to touch "the big blue American sky" : the opening pose and the style of delivery suggest an ironic awareness of the romanticism of his vision. Pepé spots Daryl and gradually becomes more self-absorbed, dancing by himself. As Jules exits, Pepé kneels down and tells the story of his friend Carlos who was sent to Vietnam and was so horrified by what he did there that he ended up a drug addict, 'an old and crazy man' at 19 : "So, one day there were so many drugs, too much physical and mental pain. And now, to-day, I only have a memory. I dance this for you, Carlos. Do you remember? Ciao, Carlos."

Difficulties for performers using autobiography surface in interview:

D.R.: We changed it. He ignores Daryl completely now. We're trying to avoid Pepé going into acting mode, it's very easy to slip into it.

J.D.R.: Especially when I'm not supposed to be acting.

D.R.: We now have the dance stop, Jules thanks him, the music starts up again and then he's into Carlos' story. . .

E.D.: When he first told us that Carlos story it was really overpowering – and really overpowering – and really overpowering for him to tell it. But as it was repeated every night, it became like an act, like a number; it was the same with the Canada thing for me.

Over the end of the story, the women leap down from the wall; Daryl leads them into an energetic stamping/clapping version of 'America' from West Side Story : again, a media version of Hispanic Americans collides with and displaces autobiographical experience and the intimacy of the dance with Jules, yet the 'seductiveness' of its energy is not denied.

As the dancers exit, lights come up on the audience, and Daryl moves into it with a mike and begins a quiz on American culture. Starting with lightweight geography/history questions – the number of states in the USA, the last to join, the longest land border, he proceeds to popular culture – Wilma Flinstone's maiden name, facts about singers and film stars. While spectators are revealing the extent to which they have absorbed popular American culture, the video, in counterpoint, shows Katrina observing the hanging globe and recalling a visit to New York : she enthusiastically describes her walk through "the Metropolis", passing Macy's ("which has a whole floor devoted to pantyhose") and her excitement at being on the top of the Empire State Building : "at the top of this building that used to be the tallest building in the world, but it doesn't matter that it isn't – cos it's still tall and it's still the Empire State Building and all around is 360 degrees of America!" The performer's non-marking of the bathos of this only serves to re-inforce it.

Emma moves below the video, inflates a plastic globe and suspends it; she pinpoints various Central American and Caribbean countries, recounting facts

about their connections with early explorers and the slave trade, e.g. "in Panama, in 1513, 50 men were eaten alive by the dogs of Captain Bilbao in a spectacle put on for his soldiers three days before he discovered the Pacific Ocean". Daryl, significantly still located in/with the audience, again plays an undercutting role, regaling us with more modern 'palatable' facts, e.g. "Tobago, meaning head, is an extremely beautiful island in the Caribbean, its chief source of income is from tourism, it is where Angostura bitters are made". He raises volume and speed, as if to shut out her more violent history, eventually coming down to her and using the microphone to drown her out (she is unmiked). Meanwhile, Pepé, in chains, is thrown down from the wall onto the sand-pile in front of it.

Daryl is joined by Katrina at the star-spangled flat for a duet of Cole Porter's *Dont' Fence Me In*, performed in the style of singing cowboy movies, finally forcing Emma to leave:

"Oh give me land, lots of land under starry skies above,
Don't fence me in. . . . "

Pepé Gudino Resendiz and Jules Dorey Richmond in Clanjamfrie's *The World's Edge*.
Photo: David Richmond

Towards the end of their song, Jules appears on video telling a story of moving house when she was six, and of giving up church attendance after her father left. This leads into film of an old woman's head on the projection screen in

conversation with Jules (on video) asking, in a childlike voice, questions such as "Where did the world come from? Why do starts twinkle?"

Katrina re-emerges on the wall and throws herself onto the sand pile; she begins a reaching/falling routine. Emma enters with a plastic skeleton, inflates it, shows it to the globe and throws it down. Pepé, in chains, comes forward and starts a Houdini routine: "in not 30, not 20, but in 10 secs, I'll release myself from these chains. . ." Asking Emma to count down, he begins writhing. He fails, she starts to do minus numbers; as he struggles, the others take turns knocking him down. Emma commences a routine involving gestures of affection, tickling, cheek-pinching with Daryl – but this soon leads to slapping each other. The increasing confusion is compounded by the quickening tempi and stridency of Lucax's music. Jules runs on with a bucket of water, sticks her head in it, holds for a while, then flings her hair out; she does this repeatedly, with growing desperation, trying to hold her breath under water for longer: this is interspersed with Hail Marys, as some form of religious self-abasement seems to be implied – the return of the repressed childhood Catholicism. Pepé suddenly releases himself – he does a "Da Dah" gesture to the audience, seeking applause, but he has been marginalized; and as he turns around to show the others, Katrina downs him with a flying leap. She drags him aside and suspends him upside down from the rafters, setting him swinging like a pendulum. Daryl commences a sequence of stretches, leaps, falls. Emma, on the rear wall, throws more plastic skeletons onto the sand-pile; throughout this sequence, the other women do this also, throwing themselves onto

L to R: Katrina Caldwell, Emma Davie, Pepé Gudino Resendiz, Jules Dorey Richmond and Daryl Fraser in Clanjamfrie's The World's Edge.
Photo: David Richmond.

the pile as they do so. Emma and Daryl move into increasingly sado-masochistic routines of slapping and throwing down. Pepé, after attempting to release himself – again a failed Houdini situation – starts screaming for Katrina to let him down. She tells him to shut up and goes to the mike:

"Why was he doing that? He was hot, he was really exerting himself, he was sweating. She was waiting. He was using up his energies to contain her, eventually he would give in – it was the nature of it. She felt frustrated by his persistence. OK, she got the point, but it wasn't really what she was talking about, was it. . . . She didn't want to play his game, she wanted to say something simple and that was all it was, she just wanted to say something simple, she didn't want to play this stupid game. She just wanted to say something simple, that was all."

Both videos start playing images from a plane crash, moving onto a trailer for *Terminator One*, and other gory horror flic sequences, with spiders, a decapitated head talking etc., followed by the opening of Euro Disney, images of bombing and the Gulf War. Jules, shouting the Hail Mary even louder, begins to throw water over the others; Daryl shoves Emma's head in a bucket of water; Emma flattens Daryl into the pile of skeletons; Jules eventually releases Pepé – by now everyone is looking like a figure from a mud-wrestling bout. Daryl is then strung up centre-stage, with bare torso and arms stretched to his sides in a crucifixion pose, though he is on his knees; Jules moves the bucket down from him, flings her hair out – this time it is 'blood' which splashes her face and Daryl's torso – the tableau is held briefly, then lights fade. Katrina is spotlit in the pile of skeletons – she rises, wearing Mickey Mouse ears, and sings in cracked voice – "Happy birthday to you, happy birthday Christopher Columbus."

Daryl Fraser in Clanjamfrie's *The World's Edge*.
Photo: Roberto Caviares.

> **D.R.** : We wanted to break out of so many forms, for the show to have its own form, but in many senses it was part of this sort of neo-classicism going round with so many companies, where you spend the first third of the show contextualizing what the show's going to be about; so the first third is about us. Columbus, the process; the middle third we trash everything, we work to exhaustion, there's blood everywhere, a nightmare life for ourselves; and then the end there's the song, we do something really nice. I think there's a great beauty in the body in distress; a most moving bit of writing is Charles Olson's *Resistance*, when at the end there is only our body; we are our body, it's the one thing we have control over, and seeing it in absolute distress and seeing it performing – and the audience is not watching characters, they're watching the journey of Emma and Jules and the others through the show, seeing this person put themselves through this; there's no reason why they should, Emma could turn round and slap Daryl and just say 'piss off' . . . I find it really moving what they're going through. . . It's the constant playing between living in this bizarre landscape we've made for ourselves and then saying, "we know we are" . . . In isolation, the actions (Jules' head in the bucket, Daryl and Emma, Pepé in chains) are all a series of gags – slapstick. But they're not acting and it's the repetition that changes their meaning constantly. It becomes meaningful, it becomes meaningless. . .

As others exit, Daryl is left, strung up, with a dim spot on him. Visibly exhausted by the preceding sequence, and in a manner drained of the sort of 'acting' which characterised some previous speeches, he begins Martin Luther King's 'I have a dream' speech. The necessarily low energy of the delivery avoids competing with the rhetorical delivery of King's own performance – he does not attempt to 'play' King; it allows us to listen to the words afresh. As he concludes, "I have a dream that one day my little children will live in a nation where they will not be judged on the colour of their skin but on the content of their character. I have a dream to-day.", he undoes the ropes around his hands.

> **D.R.** : When Daryl's tied up, he's not Christ – he's Martin Luther King; but he's also Daryl, who's knackered and who's talking about his unborn child (at that point his wife was pregnant) – so he's talking about the world he wants his child to come into. Now the audience doesn't know that, but it doesn't matter. . .

As Daryl releases himself, Pepé enters, carrying a candle. He recounts a further Aztec myth, about the five ages of the sun : of water, of the tiger, of rain and fire, of wind, and the fifth age, when "the sun moved and gave us day and night. This is our sun : it will be responsible for earthquakes, hunger – the end of the world."

The Tallis music from the beginning returns and Jules, bloodied and muddy, is winched out above the audience, like some angel of death, saying the opening of John's Gospel:

"In the beginning was the word, and the word was with God. The same was in the beginning with God. All things are created by him and without him that which is created has no being. In him is the light and the light is the life of man. And the light shineth in the darkness and the darkness comprehendeth it not. There once was a man sent from God whose name was – "(the name is not uttered)

Pepé Gudino Resendiz in Clanjamfrie's *The World's Edge*.
Photo: David Richmond.

D.R.:	It was this thing "In the beginning was the word" – this whole text thing I have difficulty with – it was a play on the process – in the beginning there wasn't the word, there was activity – in the beginning was the body and the body was asked to perform in the space.
J.D.R.:	I really liked it for the light image. Light coming through the darkness – it was summing up what we'd beeen doing.
G.G.:	I found the return to the religious imagery confusing, especially given the power of the music, although perhaps the focus was more on the 'light in man' – a humanistic aspect?
D.R.:	It's still the first bit that affects me most – the authority of the author, of God, the god of text; we're trying to say, look there are people trying to claim authority over us all, but we show what this leads to: if this is what happens, then we don't need such authority.
E.D.:	It's also the beauty of the text and what it might embody. . . The piece really made us aware of our coming from a Christian background, how ingrained things were in us – like we knew the hymns; in same way as talking about Columbus, you're brought up with this mythical belief – these things form a sort of edifice that whole parts of your life, your identity have been built round. Its the intersection of the personal with that huge thing, it's the tip of that that's created the show; seeing us at the end of an historical or cultural process; that's where the show works where the personal and the historical cross or touch.

Meanwhile, dozens of candles are brought in by the rest of cast and placed around space, creating several small lit up areas, where performers eventually stand after Jules flies back. Centre-stage, Daryl begins singing "Don't fence me in" – but now in the style of a negro spiritual, coming very powerfully in the atmosphere created by his King speech and the candles. The others watch from their candle-lit circles. The lights fade on a final image of exhausted figures clasping at some sort of hope.

After the preceding cacophany of the 'pain sequence', and in contrast with the general pattern of dispersal underlying the presentation of competing images and texts so far, we find the cast assembled together around a unifying image for only the second time in the show : the first occasion has been when (all spinning in their own orbits, however) they had announced their 'fall off the world' – a moment where, emblematically, they were becoming the new 'Americans' who came in Columbus' wake. Now, having explored the ramifications of that 'fall', they come together (yet still each in his/her own pool of candle-light) to share Daryl's re-vision/re-appropriation of a Broadway song which had previously been given a rendering which parodied popular representation of the frontier myth. The re-vision, however, suggests an attempt to straddle the difficulties posed by Derrida and others over attempting to resist hegemonic discourses from within: acknowledging the seductiveness of the song, but radically changing its context and style of enunciation, they work both inside and outside the particular American dream it encapsulates.

This fragile unifying image is a only a fleeting half-lit moment, albeit one which stays on our retinas when the candles are extinguished and the house-lights come up; it is an expression of a desire that might be shared, not a totalising synthesis which might repress the differences and ambiguities which have been presented in the preceding process. Its very use of a Broadway song carries on the production's recognition of our complicity in the history and culture which it critiques. In this attempt to be "inside yet outside, inscribing yet contesting, complicitous yet critical" (Hutcheon 1989b : 158) lies the performance's potential to "set in motion the immobile, the eternal spheres of the illusory consciousness's mythical world" and contribute to the "development of a new consciousness in the spectator – incomplete, like any other consciousness, but moved by this incom-pletion itself, this distance achieved, this inexhaustible work of criticism in action." (Althusser 1969: 151)

Contemporary Theatre Review, 1994, Vol. 2,2 pp. 131–133 © 1994 Harwood Academic Publishers GmbH
Reprints available directly from the publisher Printed in Malaysia
Photocopying permitted by license only

Bibliography

Adair, C. (1992) *Women and Dance Sylphs and Sirens*, London: MacMillan Press.

Allison, D.B. (Ed.) (1988) *The New Nietzsche*, London: MIT Press.

Althusser, L. (1969) *For Marx*, London: Allen Lane.

Auslander, P. (1992) *Presence and Resistance: Postmodernism and Cultural Politics in Contemporary North American Performance*, Michigan: The University of Michigan Press.

—— (1993) Essay Review, *The Drama Review*, vol.37 no.3, 196–201.

Banes, S. (1987) *Terpsichore in Sneakers*, 2nd edition, Middleton: Wesleyan University Press.

Barker, H. (1988) *The Bite of the Night*, London: John Calder.

Barlow, W. (1973) *The Alexander Principle*, London: Victor Gollancz.

Barthes, R. (1982) *L'Obvie et l'obtus*, Paris: Seuil.

—— (1990) *S/Z* Oxford: Basil Blackwell.

Baudrillard, J. (1988) *The Ecstasy of Communication*, New York: Semiotext(e).

Bazin, A. (1967) Painting and Cinema, in Bazin, A. *What is Cinema?*, London: University of California Press.

Benamou, M. & Caramello, C. (1977) *Performance in Postmodern Culture*, New York: Coda Press.

Beardsworth, R. (1992) On the Critical 'Posy': Lyotard's Agitated Judgement. *Judging Lyotard*, edited by A. Benjamin. London: Routledge.

Beckett, S. (1963) *Happy Days*, London: Faber & Faber.

Benjamin, A. (1989) *The Lyotard Reader*, Oxford: Basil Blackwell.

Bennington, G. (1988) *Lyotard: Writing the Event*, Manchester: Manchester University Press.

Billington, M. (1993) Why the Hell? *The Guardian*, 16 June.

Birringer, J. (1991) *Theatre, Theory, Postmodernism*, Bloomington & Indianapolis: Indiana University Press.

Blackledge, R. (1993) *Epitaph: Production Notes*, unpublished.

Blau, H. (1990) *The Audience*, London: John Hopkins University Press.

Bourdieu, P. (1977) *Outline of a Theory of Practice*, London: Cambridge University Press.

Brisley, S. (1981) Conversations, *Audio Arts Magazine*, vol.4 no.4.

Carroll, D. (1987) *Paraesthtics*, London: Methuen.

de Certeau, M. (1980) *Arts de faire*, Paris: Union Generale d'Editions.

Clifford, J. & Marcuse, G. (1986) *Writing Culture*, London: University of California Press.

Copland, R. & Cohen, M. (eds.) (1983) *What is Dance: Readings in Theory and Criticism*, Oxford: Oxford University Press.

Cunningham, M. (1952) Space, Time and Dance in *Merce Cunningham: Dancing in Space and Time* edited by R. Kostalanetz, London: Dance Books.

Davis, R.G. (1988) The Politics, Packaging, and Potential of Performance Art, *New Theatre Quarterly* no.13, 17–32.

Deleuze, G. & Guattari, F. (1984) *Anti-Oedipus*, London: Athlone Press.

—— (1986) *Kafka: Toward a Minor Literature* Minneapolis: University of Minnesota Press.

—— (1988) *A Thousand Plateaus*, London: Athlone Press.

Dempster, E. (1988) Women Writing the Body: Let's Watch a Little How She Dances, *Writings on Dance* no.3, 13–25.

Deren, M. (1943) *Meshes in the Afternoon*, London: Circles Film Distribution.

Derrida, J. (1985) The Speculate – on 'Freud', in *On Signs* edited by M. Blonsky, Oxford: Basil Blackwell.

Devens, E. & Gluckman, R.G. (1982) *Field Research: A Sourcebook and Field Manual*, London: Unwin Hyman.

De Wit, M. (1992) Self as Source, a Performance Lecture, *Women and Theatre: Occasional Paper*, no. 1, 98–106 (University of Warwick).

Docherty, T. (1990) *After Theory*, New York & London: Routledge.

Elam, K. (1980) *The Semiotics of Theatre and Drama*, London: Methuen.

Eng, I. (1991) *Desperately Seeking the Audience*, London: Routledge.

Etchells, T. (1991) *Marina and Lee*, unpublished.

—— (1992a) A Note on *Emanualle Enchanted, Performance programme*, Sheffield: Forced Entertainment Theatre Co-operative.

—— (1992b) *Emanuelle Enchanted*, unpublished.

Forkbeard Fantasy (1987) *Forkbeard: Comic Theatre and Film*, Devon: Forkbeard Fantasy.

—— (1993) *Forkbeard Part 2, 1988-1992: Theatre and Film Productions*, Devon: Forkbeard Fantasy.

Foucault, M. (1970) *The Order of Things*, London: Tavistock Publications.

—— (1977) *Language, Counter Memory, Practice*, Ithaca: Cornell University Press.

Gibson, J.J. (1966) *The Senses Considered as Perceptual Systems*, London: Allen & Unwin.

Goldberg, R. (1979) *Performance Art*, London: Thames & Hudson.

Goodman, L. (1993) *Contemporary Feminist Theatres: To Each Her Own*, London: Routledge.

Halliday, M. (1987) Language and the Order of Nature, in *The Linguistics of Writing*, edited by N. Fabb, D. Attridge, A. Durant & C. MacCabe, Manchester: Manchester University Press.

Harvey, D. (1989) *The Condition of Postmodernity*, Oxford: Basil Blackwell.

Hassan, I. (1981) The Question of Postmodernism, *Performing Arts Journal*, vol.16 no. 1, 30–7.

Hay, D. (1989) Playing Awake: Letters to my Daughter, *The Drama Review*. vol.33 no.4, 70-6.

Hayles, N.K. (ed.) (1991) *Chaos and Order: Complex Dynamics in Literature and Science*, London: University of Chicago Press.

Henri, A. (1974) *Environments and Happenings*, London: Thames & Hudson.

Howell, A & Templeton, F. (1977) *Elements of Performance Art*, London: Ting: Theatre of Mistakes.

Humphrey, D. (1959) *The Art of Making Dances*, London: Dance Books.

Hunter, I. (1983) Reading Character, *Southern Review*, v.16 no.2.

Hutcheon, L. (1989a) *The Politics of Postmodernism*, New York & London: Routledge.

—— (1989b), The Post-Modern Ex-centric, *Feminism and Institutions* edited by L. Kauffman, Oxford: Basil Blackwell.

Jameson, F. (1984) Postmodernism, or, the Cultural Logic of Late Capitalism, *New Left Review*, no.146, 53–92.

Jordan, S. (1992) *Striding Out: Aspects of Contemporary and New Dance in Britain*, London: Dance Books.

Kaye, N. (1994) *Postmodernism and Performance*, London: MacMillan Press & New York: St Martin's Press.

Kaylan, M. (1989) *The Critical Language for Live Performance*, unpublished MA dissertation, University of Leeds.

Kealiinohomoku, J. (1970) An Anthropologist Looks at Ballet as a Form of Ethnic Dance, in *What is Dance: Readings in Theory and Criticism* edited by R. Copeland & M. Cohen (1983), Oxford: Oxford University Press.

Kirby, M. (ed.) (1975) *The Drama Review*, vol.19 no.1, Post-Modern Dance issue.

—— (1987) *A Formalist Theatre*, Philadelphia: University of Pennsylvania Press.

La Frenais, R. (1981) Live Art has its Day, *Performance*, no.14, 5–6.

Lauter, E. (1984) *Women as Mythmakers: Poetry and Visual Art by Twentieth Century Women*, Indianapolis & Bloomington: Indiana University Press.

LeCompte, E. (1981) Who Owns History? *Performing Arts Journal*, vol.16 no.1, 50–3.

Lefebvre, H. (1991) *The Production of Space*, Oxford: Blackwell.

Levin, D.M. (1990) Postmodernism in Dance: Dance, Discourse, Democracy, in *Postmodernism – Philosophy and the Arts* edited by H.J. Silverman, London: Routledge.

Levy, D (1992a) Forced Entertainment: *Emanuelle Enchanted, Hybrid* pilot issue, p.9.

—— (1992b) Introduction. *Walks on Water* edited by D. Levy, London: Methuen.

Lacan, J. & Wilden, A. (1968) *Speech and Language in Psychoanalysis*, Baltimore: John Hopkins University Press.

Lyotard, J-F. (1976) The Tooth, the Palm, *Sub-Stances*, no 15.

—— (1982) Presenting the Unpresentable: The Sublime, *Artforum*, vol.20 no.8, 64–9.

—— (1983) Des Dispotifs Pulsionnels, 2nd edition, Paris: Christian Bourgois.

—— (1984) *The Postmodern Condition: A Report on Knowledge*. Manchester: Manchester University Press.

—— (1993) *Libidinal Economy*, London: Athlone Press. Mackrell, J. (1992) *Out of Line: The Story of British New Dance*, London: Dance Books.

de Marinis, M. (1987) Dramaturgy of the Spectator, *The Drama Review*, vol.31 no.2, 110–12.

Marranca, B. (1981) The Politics of Performance, *Performing Arts Journal*, vol.16 no.1, 54–67.

McGrath, J. (1981) *A Good Night Out*, London: Eyre Methuen.

Melrose, S. (1993) *A Semiotics of Drama*, London: MacMillan Press.

Merkx, M. (1985) *Moderne Dans in Ontwikkeling*, Holland: New Dance Publications.

Michelson, A. (1974) Film and Radical Aspiration, *Film Theory and Criticism* edited by G. Mast & M. Cohen, Oxford: Oxford University Press.

Monod, J. (1972) *Chance and Necessity*, London: Collins.

Morris, M. (1984) Postmodernity and Lyotard's Sublime. *Art and Text*, no.16, 44–67.

Norris, C. (1990) *What's Wrong With Postmodernism: Critical Theory and the Ends of Philosophy*, London: Harvester Wheatsheaf.

Nuttall, J. (1979) *Performance Art, Volume One: Memoirs*, London: John Calder.

Parry, J. (1992) Strange Fish, *Dance Now*, vol.1 no.3, 22–7.

Paulson, W.R. (1988) *The Noise of Culture*, Ithaca: Cornell University Press.

Pavis, P. (1982) *Languages of the Stage*, New York: Performing Arts Journal Publications.

—— (1992) *Theatre at the Crossroads of Culture*, London: Routledge.

Pecheux, M. (1984) *Sur les contextes epistemologiques de lAD, Mots*, Paris: Editions du CNRS

Performance (1981) Entertainment Issue, no.9, 15–18.

Powers, J. (1982) *Philosophy and the New Physics*, London: Methuen.

Pradier, J-M. (1990) Towards a Biological Theory of Performance, *New Theatre Quarterly*, no. 21, 5–12.

Prigogine, I. & Stengers, I. (1984) *Order out of Chaos: Man's New Dialogue with Nature*, New York: Bantam.

Readings, B. (1991) *Introducing Lyotard: Art and Politics*, London: Routledge.

Sayers, L.A. (1992) The Interpretation of Movement, *Dance Now*, vol.1 no.3, 42–9.

Sayre, H.M. (1989) *The Object of Performance: The American Avant Garde Since 1970*, Chicago & London: University of Chicago Press.

Schechner, R. (1985) *Between Theatre and Anthropology*, Philadelphia: University of Pennsylvania Press.

Serres, M. (1982) *Hermes: Literature, Science, Philosophy*, Baltimore: John Hopkins University Press.

Sheets, M. (1966) *The Phenomenology of Dance*, Madison: University of Wisconsin Press.

Singleton, B. (1990) The Beauty of the Resistable Tyrant, *Theatre Research International*, vol.16 no.2, 83–108.

Sontag, S. (1973) *On Photography*, New York: Farrar, Straus & Giroux.

Steurman, E. (1992) Habermas vs Lyotard: Modernity vs Postmodernity?, in *Judging Lyotard*, edited by A. Benjamin, London: Routledge.

Taylor, M.C. (1990) Back to the Future, in *Postmodernism – Philosophy and the Arts* edited by H.J. Silverman, London: Routledge.

Tee, E. (1993) Goldberg Variations 1–15, *Notes*, no.2, 21–3.

Ubersfield, A. *L'Ecole du Spectateur*, Paris: Editions Sociales.

Ulmer, G. (1985) *Applied Grammatology*, Baltimore: John Hopkins University Press.

—— (1989) Teletheory, London: Routledge.

Vanden Heuvel, M. (1991) *Performing Drama, Dramatizing Performance*, Ann Arbor: University of Michigan Press.

Contemporary Theatre Review, 1994, Vol. 2,2 pp. 135–136 © 1994 Harwood Academic Publishers GmbH
Reprints available directly from the publisher
Printed in Malaysia
Photocopying permitted by license only

Notes on Contributors

Bobby Baker is a live artist who initially trained as a painter. She lives in London and is currently touring *Drawing on a Mother's Experience, Cook Dems, Kitchen Show,* and *How to Shop* in Britain and abroad.

Polonca Baloh-Brown trained in drama education. She works as a lecturer, adviser and projects co-ordinator in performing arts and has worked for three years with Bobby Baker and as co-director of *How to Shop*.

Geraldine Cousin is Lecturer in Theatre Studies at the University of Warwick. She is the author of *Churchill, The Playwright* and is a regular contributor to *New Theatre Quarterly*. Her most recent work *King John in Performance* will shortly be published by Manchester University Press.

Tim Etchells has been writing text and directing with Forced Entertainment Theatre Co-operative since the company formed in 1984. He has given lectures, presented papers and written extensively on new performance and installation. He serves as a member of the Arts Council of Great Britain's Live Art Advisory Group and has recently completed the third draft of an unpublished novel, *Helen*.

Greg Giesekam's interest in hybrid identities probably stems from the fact that he is half-Dutch, half-Australian, but lives in Scotland, where he is Senior Lecturer in Theatre Studies at the University of Glasgow.

Simon Jones is Lecturer in Drama at the University of Bristol and director of the Bristol-based performance company Bodies in Flight.

Nick Kaye is Lecturer in Theatre Studies at the University of Warwick. He has contributed articles to a range of journals, including *New Theatre Quarterly, Performance,* and *Comparative Criticism*. His book, *Postmodernism and Performance,* is published by the MacMillan Press and St. Martin's Press.

Richard Lowdon has been a member of Forced Entertainment Theatre Co-operative as designer, director and performer since the company's formation in 1984. He has lectured extensively and run practical workshops on design throughout the UK.

Julian Maynard Smith is a performance artist. Previously making solo work, he founded Station House Opera in 1980 in order to develop a practice which combined sculptural, architectural and theatrical elements. The company has made

over twenty productions, touring throughout Europe, as well as in Japan, Australia and the USA.

Susan Melrose teaches Performance Studies at the West London Institute and the Central School of Speech and Drama; she also tutors with the Open University. Her fiction, *Eating Out*, is published by Fremantle Arts Centre Press and her critical *Semiotics of the Dramatic Text* is published by the MacMillan Press.

Alison Oddey is Lecturer in Drama and Theatre Studies at the University of Kent. She has published several articles , and her book *Devising Theatre* is forthcoming from Routledge.

Andrew Quick is Lecturer in Theatre Studies at the University of Lancaster. He studied English at Newcastle University and Theatre Studies at University College, Cardiff. He is currently completing doctoral research at Bristol University in British experimental theatre and performance.

Tim White is completing a PhD in the Joint School of Theatre Studies, University of Warwick. His thesis addresses the disruption of form as an inherently performative practice in the work of five post-war artists.

Mara de Wit was born in Holland and has lived, studied and worked in the USA, Great Britain and on the European Continent. She is presently a 'resting' director of Research & Navigation Dance Theatre Company (Wales, 1983), and is actively engaged in Live Art practice and theory. She is currently completing a doctoral thesis at Middlesex University, London.

Contemporary Theatre Review, 1994, Vol. 2,2 pp. 137–139 © 1994 Harwood Academic Publishers GmbH
Reprints available directly from the publisher Printed in Malaysia
Photocopying permitted by license only

The Suicide at the Vakhtangov Theater: A Document

This is an extract from the transcript of a meeting of the Artistic-Political Council of the Vakhtangov State Theater on 17 September 1930. The following remarks were made about Nikolai Erdman's play **The Suicide**, shortly after a reading of the play. The complete text of the transcript will be published in an appendix to a **A Meeting about Laughter, a collection of sketches, interludes and theatrical parodies by Nikolai Erdman,** not previously published in English. **A Meeting about Laughter,** translated and edited by John Freedman, will appear as a forthcoming volume in the Russian Theatre Archive, published by Harwood Academic Publishers, and edited by John Freedman, Leon Gitelman and Anatoly Smelianksy.

KAZACHENKO[2] – Comrades, I'm not going to focus on several errors of a purely ideological order, a whole series of expressions – clearly unncessary for us and alien to our ideology – which are put forward in this play. I don't want to say that this was done on purpose, but they are alien to us. For example, taken an expression like: "Where else can an unemployed worker shoot himself, except in the bathroom," "Stores are being closed," or, "public opinion is nothing but a factory of slogans."[3] All of this wouldn't carry so much weight if something would counteract these words and ideas. But since nothing counteracts them, these expressions and thoughts are nothing but food for the bourgeoisie, which will watch this play with pleasure and laugh at it. Let's assume it would be possible to annihilate these things, which are inadmissible in a purely ideological sense. That is, speaking essentially, what does this play consist of? What is its goal, its purpose? What does it give the spectator? It's nothing but a bouquet for the bourgeoisie. Moreover, it is presented exclusively incorrectly, sort of comically. After all, in recent times, the bourgeoisie has been livng out its final days and is in no mood for comedy. Therefore, it is presented incorrectly. One wonders, is the bourgeoisie so serious in our age of industrialization that it can make us want to pay attention to it? It doesn't deserve that. We have more valuable and important problems. And, for that reason, such a play which paints a picture of the

[1] This is a raw stenographer's transcript of the remarks made about *The Suicide* shortly after a reading of the play. As such, the language is highly conversational and bears all the convolutions and peculiarities of unguarded speech. Moreover, several of the speakers are clearly uneducated. In this translation, I have attempted to find a balance between providing a coherent text and maintaining the undeniable color of the speakers' often chaotic remarks.

[2] I was unable to identify this speaker.

[3] Throughout the transcript, most quotes from *The Suicide* are paraphrases rather than faithful renditions of the text. The Vakhtangov Theater copy probably differed from those Erdman submitted to the Meyerhold Theater and the Moscow Art Theater, but most of the discrepanices here are certainly due to the speakers' carelessness.

bourgeoisie is absolutely pointless and unnecessary for us. In it, we can often see the shadow of thoughts about the problem of the intelligentsia's role in the revolution, and it is presented clumsily. Who is presented here as central figures? There isn't any intelligentsia. What we have is a bouquet, a complex, a combination of a priest, a kulak,[4] a merchant[5] and a petty bourgeois. They have to be differentiated. We have to understand that they are class enemies. Do you really think that class enemies are waging their battle by assuring the public that, as they say, "we are dying"? No. They find other methods for their struggle – elements of arson and sabotage. That is their direct method of struggle. But here, they are presented as some sort of comedians who want to do something but don't do anything. For that reason, the play does not hit its mark.

I recently compared this play to *The Warrant*. In that play the basic idea was clear. In that play the bourgeoisie sensed that it had to assimilate itself into society somehow and, in the course of the whole day, it conducted a policy of assimilation, which, in the end, is exposed. In that play you could see the basic thread. But here in this play there is no such thread. Of course, you can't deny that the play is written wittily and that we all laughed. But, I also laughed when I used to read Averchenko.[6] But whenever I read his stories – two days later I can't remember them anymore. And it seems to me that, if we were to toss such a major play out into the masses, it would be hasty and incorrect.

One has to regret that comrade Erdman, a talented author, did not direct his energy at a whole series of more timely questions which need to be illuminated for the public.

LEMBERG[7] – We are so lacking, so poor in talented plays that it seems to us that we have found an author who has a brilliant command of the pen. And it would seem that we should be happy to have found such a talented play. But, at least as it concerns me, I don't experience any such joy. The author constantly walks the sharp edge of a knife, drawing his spectator along after him. And the double-entendres, of which this play is full, invariably fall off the knife's edge – not in the direction of ridiculing the bourgeoisie – but in the direction of ridiculing the Soviet public. A demarcation line like that is very risky. It causes us to stand on guard and listen more thoughtfully and sensitively to the wisecracks of which this author has such a command. I don't think that these wisecracks are in the interests of the spectator. The working spectator will laugh at first, and then, towards the end, he will get bored of this author's wisecracks and then go home, without taking with him that significant and profound content which we would like to see in this play.

[4]　Properly speaking, the Russian word, "kulak," designates a wealthy peasant farmer, against whom the Sovient government waged a bitter battle in the late 1920s and early 1930s. In common usage it also referred to any well-off petty businessman. The speaker may have in mind Alexander Kalabushkin, the director of the shooting gallery.

[5]　In some versions of *The Suicide*, the butcher Pugachyov is identified as a merchant.

[6]　Arkady Averchenko (1881–1925) was a popular author of humorous stories and plays in the first two decades of the 20th century. He left the Soviet Union in 1920, after which is works were labeled as unfit for publication or staging.

[7]　This was probably K.-F. Lemberg, a member of the factory committee at the Moscow Regional Electric Plant, who often participated in Artistic-Political Councils at various theaters.

I suppose, that – without going into a discussion of individual details of this play – I should say that this play is inadmissible for the Vakhtangov Theater, or for any other Soviet theatre for that matter.

ARTAMONOV[8] – Whoever speaks out against this play cannot pass over its talent in silence. Therefore, before saying anything else about it, I must bow down before a talented play. The play is written with great talent, although I must admit, it's not for us. If a play like this were to be presented on stage for the spectator, it would cause a reaction that would be extremely disadvantageous for us. Whom does this play mobilize and for whom would such a production be intended? Obviously, neither the working spectator nor the Soviet intelligentsia. I would suggest the play will find resonance in those very segments of society, against whom an all-out attack of the class war has been declared in our country. So, what good would such a call to our clear enemies do the Vakhtangov Theater – when our path leads in the exact opposite direction? That is all the more true in this time of an intensified class war – a moment, when it wasn't so long ago that the Kondratyev, Groman and Sukhanov group was arrested.[9] After all, no one is so naive as to think that the arrest of this group and the liquidation of a series of seditious organizations has exhausted the class war. Imagine for a minute that you don't know the name of the play's author, and you would think that it was written by someone in emigration.

That is the situation Erdman has fallen into with this play, knowingly or not (one wants to think and believe – unknowingly). Because, in a subtly veiled form, this play contains a hidden protest of the "intelligentsia," which, in places, is invested with dual meanings. In other words: "Understand it as you will."

Every single character in the play speaks in a language which cannot be called anything other than reactionary. And this philosophy of theirs – the philosophy of an offended, dissatisfied, intellectual philistine – is the play's essential leitmotif. . .

[8] Georgy Adamovich Artamonov was the deputy director of the Vakhtangov Theater in 1930.

[9] Nikolai Kondratyev, Vladimir Groman and Nikolai Sukhanov were prominent economists accused of belonging to the so-called Working Peasants Party, the falsified case against which eventually entailed 100,000 arrests. The case went to "court" September 2, 1930 amidst a vitriolic publicity campaign mounted by the OGPU, i.e., the secret police.

Contemporary Theatre Review, 1994, Vol. 2,2 pp. 141–143 © 1994 Harwood Academic Publishers GmbH
Reprints available directly from the publisher Printed in Malaysia
Photocopying permitted by license only

Index

CONTEMPORARY THEATRE REVIEW
AN INTERNATIONAL JOURNAL

Notes for contributors

Submission of a paper will be taken to imply that it represents original work not previously published, that it is not being considered for publication elsewhere and that, if accepted for publication, it will not be published elsewhere in the same form, in any language, without the consent of editor and publisher. It is a condition of acceptance by the editor of a typescript for publication that the publisher automatically acquires the copyright of the typescript throughout the world. It will also be assumed that the author has obtained all necessary permissions to include in the paper items such as quotations, musical examples, figures, tables etc. Permissions should be paid for prior to submission.

Typescripts. Papers should be submitted in triplicate to the Editors, *Contemporary Theatre Review, c/o* Harwood Academic Publishers, at:

5th Floor, Reading Bridge House	820 Town Center Drive	3-14-9, Okubo
Reading Bridge Approach	Langhorne	Shinjuku-ku
Reading RG1 8PP or	PA 19047 USA or	Tokyo 169
UK		Japan

Papers should be typed or word processed with double spacing on one side of good quality ISO A4 (212 x 297 mm) paper with a 3 cm left-hand margin. Papers are accepted only in English.

Abstracts and Keywords. Each paper requires an abstract of 100-150 words summarizing the significant coverage and findings, presented on a separate sheet of paper. Abstracts should be followed by up to six key words or phrases which, between them, should indicate the subject matter of the paper. These will be used for indexing and data retrieval purposes.

Figures. All figures (photographs, schema, charts, diagrams and graphs) should be numbered with consecutive arabic numerals, have descriptive captions and be mentioned in the text. Figures should be kept separate from the text but an approximate position for each should be indicated in the margin of the typescript. It is the author's responsibility to obtain permission for any reproduction from other sources.

Preparation: Line drawings must be of a high enough standard for direct reproduction; photocopies are not acceptable. They should be prepared in black (india) ink on white art paper, card or tracing paper, with all the lettering and symbols included. Computer-generated graphics of a similar high quality are also acceptable, as are good sharp photoprints ("glossies"). Computer print-outs must be completely legible. Photographs intended for halftone reproduction must be good glossy original prints of maximum contrast. Redrawing or retouching of unusable figures will be charged to authors.

Size: Figures should be planned so that they reduce to 12 cm column width. The preferred width of line drawings is 24 cm, with capital lettering 4 mm high, for reduction by one-half. Photographs for halftone reproduction should be approximately twice the desired finished size.

Captions: A list of figure captions, with the relevant figure numbers, should be typed on a separate sheet of paper and included with the typescript.

Musical examples: Musical examples should be designated as "Figure 1" etc., and the recommendations above for preparation and sizing should be followed. Examples must be well prepared and of a high standard for reproduction, as they will not be redrawn or retouched by the printer.

In the case of large scores, musical examples will have to be reduced in size and so some clarity will be lost. This should be borne in mind especially with orchestral scores.

Notes are indicated by superior arabic numerals without parentheses. The text of the notes should be collected at the end of the paper.

References are indicated in the text by the name and date system either "Recent work (Smith & Jones, 1987, Robinson, 1985, 1987) . . ." or "Recently Smith & Jones (1987) . . ." If a publication has more than three authors, list all names on the first occurrence; on subsequent occurrences use the first author's name plus "*et al.*" Use an ampersand rather than "and" between the last two authors. If there is more than one publication by the same author(s) in the same year, distinguish by adding a, b, c etc. to both the text citation and the list of references (e.g. "Smith, 1986a") References should be collected and typed in alphabetical order after the Notes and Acknowledgements sections (if these exist). Examples:

Benedetti, J. (1988) *Stanislavski,* London: Methuen

Granville-Barker, H. (1934) Shakespeare's dramatic art. In *A Companion to Shakespeare Studies,* edited by H. Granville-Barker and G. B. Harrison, p. 84. Cambridge: Cambridge University Press

Johnston, D. (1970) Policy in theatre. *Hibernia,* **16,** 16

Proofs. Authors will receive page proofs (including figures) by air mail for correction and these must be returned as instructed within 48 hours of receipt. Please ensure that a full postal address is given on the first page of the typescript so that proofs are not delayed in the post. Authors' alterations, other than those of a typographical nature, in excess of 10% of the original composition cost, will be charged to authors.

Page Charges. There are no page charges to individuals or institutions.

A recent title from the Contemporary Theatre Studies bookseries

Volume 2

THEANDRIC

Julian Beck's Last Notebooks

Edited by **Erica Bilder** with notes by **Judith Malina**,
The Living Theatre, New York, USA

A volume in **The Living Theatre Archive** section

"Gasping for air - that's how the public comes to the theatre, wrapped stiff in the corset of convention (law and conformity). The audience can scarcely breathe. It senses itself dying. The whole theatrical act is a ritual designed to renew our vitality, to deliver us from death, and this is accomplished by taking a breath.

This breath begins as a gasp, like that of the newborn infant. Theatre without gasps is stifling us - no matter how diverting, we always leave with our spirit further deadened by disappointment.

But we go to it seeking a new breath, a moment to make the body jerk and gasp, a gasp to perforate the blocked bronchia, the rigid thoracic cavity, the plated torso, the fear-taut body, a little truth in the dynasty of lies, a flash of light in the murk, an indication that after the winter-death life comes back again." - **Julian Beck**, *Theandric*

"Julian Beck was an obsessive writer. Often working on several projects at a time, he numbered his notebooks or gave them titles. As soon as *The Life of the Theatre* was published in 1972, he started thinking about a sequel. *Theandric* was largely written between 1975 and 1985, the year Julian Beck died. He was particularly involved with it during 1982 and 1983, while The Living Theatre was based in Rome and travelling around Italy and the rest of Europe. In his last years, his diaries and workbooks offer insight into a sad reality: he was terminally ill and very often he was too weak to write. *Theandric* is very much about fighting death, about dying and not dying, till the very last moment. In that sense, this book becomes a testament, a kind of ultimate statement on the "philosophy and metaphysics of the theatre" a sub-title that Julian Beck frequently used with regard to *Theandric*. His life-long concerns - the structure of the relationship between audience and theatre workers; the relationship of the artist to the political time in which he lives - are crystallized. He was very happy to have found an existing word (theandric) that expressed the presence of the divine in the actor, the divine in Man." - **Erica Bilder**

1992 195pp + xii
Hardcover ISBN: 3-7186-5192-0 I List price: $40.00/£22.00 (ECU 32.00)
Softcover ISBN: 3-7186-5193-9 I List price: $16.00/£9.00 (ECU 13.00)

For further information, price details and/or a Performing Arts catalog, please contact:

harwood academic publishers

P.O. Box 90, Reading, Berkshire RG1 8JL, UK *OR*
P.O.Box 786 Cooper Station, New York, NY 10276, USA
US Inquiries - tel: (212) 206 8900 fax: (212) 645 2459
Inquiries elsewhere - tel: (0734) 568316 fax: (0734) 568211